BARROCO AND OTHER WRITINGS

Cultural Memory in the Present

Hent de Vries, Editor

BARROCO AND OTHER WRITINGS

Severo Sarduy

*Translated by Alex Verdolini, with the
collaboration of Iván Hofman*

STANFORD UNIVERSITY PRESS

STANFORD, CALIFORNIA

STANFORD UNIVERSITY PRESS
Stanford, California

© Severo Sarduy and Heirs of Severo Sarduy, 1974.

English translation and Introduction © 2025 by the Board of Trustees of the Leland Stanford Junior University. All rights reserved.

No part of this book may be reproduced or transmitted in any form or by any means, electronic or mechanical, including photocopying and recording, or in any information storage or retrieval system, without the prior written permission of Stanford University Press.

Printed in the United States of America on acid-free, archival-quality paper

Library of Congress Cataloging-in-Publication Data
Names: Sarduy, Severo, author. | Verdolini, Alex, translator. | Sarduy,
 Severo. Barroco. English. | Sarduy, Severo. Essays. Selections. English.
Title: Barroco and other writings / Severo Sarduy ; translated by Alex
 Verdolini, with the collaboration of Iván Hofman.
Other titles: Cultural memory in the present.
Description: Stanford, California : Stanford University Press, 2024. |
 Series: Cultural memory in the present | Translated from Spanish. |
 Includes bibliographical references.
Identifiers: LCCN 2024025735 (print) | LCCN 2024025736 (ebook) |
 ISBN 9781503640573 (cloth) | ISBN 9781503641136 (paperback) |
 ISBN 9781503641143 (epub)
Subjects: LCSH: Sarduy, Severo—Translations into English. | Arts,
 Baroque—Philosophy. | Arts, Modern—Themes, motives. | LCGFT: Essays.
Classification: LCC PQ7390.S28 B3713 2024 (print) | LCC PQ7390.S28
 (ebook) | DDC 863/.64—dc23/eng/20240621
LC record available at https://lccn.loc.gov/2024025735
LC ebook record available at https://lccn.loc.gov/2024025736

Cover design: Michele Wetherbee
Cover photograph: Antonio Galvez
Typeset by Newgen in Adobe Garamond Pro 11/13.5

Contents

Note on Texts and Translation	ix
Introduction	xi
ALEX VERDOLINI	

Barroco 1

 ONE 7
 0. Echo Chamber 7
 I. The Word "*Barroco*" 9
 II. Cosmology before the Baroque 16
 III. Baroque Cosmology: Kepler 38
 IV. Cosmology Since the Baroque 64
 V. Supplement 74

 TWO 79
 I. Zero 79
 II. Circle 83
 III. Cycle 86

Other Writings 91
 Metaphor Squared: On Góngora 93
 Cubes 100
 The Fury of the Paintbrush 102

Furious Baroque	108
The Heir	112
Fractal Baroque	124
Notes	131

Note on Texts and Translation

Many of Sarduy's texts exist in both Spanish and French versions. To determine, in a given case, which one should count as authoritative involves both questions of fact and questions of principle. François Wahl, the person who was perhaps best placed to answer the former, addresses the matter as follows in the postface to his and Gustavo Guerrero's critical edition of Sarduy's *Obra completa*: "I am [...] incapable of recalling, faced with the numerous texts [...] of which both versions exist [...] which one was the original. *C'est selon*."

Sarduy oversaw the publication of three distinct editions of *Barroco*: the original Spanish edition of 1974, reprinted essentially unmodified in *Ensayos generales sobre el barroco* (1987); the French edition of 1975, co-translated by Sarduy and Jacques Henric; and the French edition of 1991. For the present translation, we have closely consulted the French version, but where the texts differ we treat the Spanish as authoritative.

Included in this volume are two texts added by Sarduy to the 1975 French edition: "Metaphor Squared: On Góngora" (1966) and "Cubes" (1968). The Góngora essay appeared concurrently in *Tel Quel* and *Mundo Nuevo*. "Cubes" appeared in French in *Tel Quel* and in Spanish in Sarduy's first book of theoretical texts, *Escrito sobre un cuerpo*, both in 1968. In the case of these two canonical *Tel Quel* texts, we have consulted both versions but followed the French.

From *La simulación* (1982; *La doublure*, 1981) we have included two texts, "The Fury of the Paintbrush" and "Furious Baroque." Here we have consulted both versions but followed the Spanish.

"The Heir" appeared first as "Un heredero" in Cintio Vitier's 1988 critical edition of José Lezama Lima's *Paradiso* and again as "El heredero" in *Filología* in 1989; Sarduy published this text only in Spanish.

Also included is the text "Fractal Baroque" (1989 in *Alliage*, 1990 in *Art Press*), which appears as the epilogue to the 1991 French edition of *Barroco*. Sarduy published this text only in French. We have, however, also consulted the unpublished Spanish-language first draft, "El fin de siglo será fractal" (1988), held in the Roberto González Echevarría Collection on Severo Sarduy and Other Latin American Writers, 1951–2013, in the Special Collections of the Princeton University Library.

Introduction

Alex Verdolini

I

When Severo Sarduy left Havana for Europe, what he had in hand was something short of an ordinary passport. This was toward the end of 1959, the year that began with Castro's victorious entry into Havana. In the euphoria that followed, a new literary generation had made its presence felt. Sarduy, twenty-two years old, found himself in the pages of *Revolución*. A clandestine publication before the fall of the dictatorship, this was now the most important newspaper in Cuba; Sarduy was appointed a regular art critic for its cultural supplement, *Lunes*. Together with nine other young Cubans, he was awarded a government scholarship to study art history in Europe. They made the journey as third-class passengers on an old steamer soon to be scrapped. By way of documentation, each one carried what Sarduy's life partner, François Wahl, remembered later as "a letter of recommendation addressed to the goodwill of the border authorities."[1]

Sarduy spent a month in Madrid and then traveled on to Paris. On the eve of the Revolution, he had been a medical student with ambitions as a poet and a part-time gig in advertising. In February 1960, filling out the paperwork to exit Spain for France, he could give "writer" as his profession and keep a straight face.[2] Nonetheless he was green. That month in a letter to his parents he floated a "book of poems, which I might call *Here*, where I talk about the Francoist dictatorship and the marvels of Spain, in particular the cooking."[3] Soon after, he took a short trip to Amsterdam. Back at the Cité

Universitaire, he declared, "I know that what I'm writing, the poems that the 'presence' of Anne Frank inspired in me, in her house damp with the flowers of Holland, is going to be read by many people."[4] But in June already he was writing "poems of a different kind, and a novel *without characters* that seems to be turning out well."[5]

Later that year, the scholarship recipients were summoned home. The Cuban Ministry of Culture could no longer afford to support them. Sarduy, so the story goes, marked his decision to stay behind by burning his guayabera in the courtyard behind the Maison de Cuba.[6] His letters from the time betray more by way of ambivalence. He breaks the news to his family only gradually, by means of repeated postponement. In June he wants to stay a few more months, to finish his novel and see it to press. This "would be of great utility to Cuba, and of course to me as well."[7] In October he pleads for their patience, in the name "of this double and difficult project [. . .] the salvation of Cuba and the publication of my novel."[8] Then another deferral—this time to May, for the sake of his course at the École du Louvre.[9]

In the meantime Sarduy was consolidating his position in Paris. He lunched with the likes of Nathalie Sarraute.[10] François Wahl, soon to be the editor behind Lacan's *Écrits*, became his lover, and Roland Barthes befriended him. In the years that followed he would attend Barthes's seminars assiduously, Lacan's sporadically. *Gestures*, his novel "without characters," came out in both Spanish and French in 1963, then later in Danish, Italian, Polish, and German, the first in a series of successes. His role was increasingly that of a relay point between French and Latin American literary scenes, as an editor at Seuil, then the director of its Latin American section, and as a host of "Literatura en Debate" on Radio France Internationale. By the second half of the decade, he was a fixture in the groups associated with Emir Rodriguez Monegal's Paris-based *Mundo Nuevo* and Philippe Sollers's *Tel Quel*.

It was in *Tel Quel* that Sarduy's first significant theoretical effort appeared, a 1966 essay on figurality in the poetry of Luis

de Góngora.[11] The theme that gives "Metaphor Squared: On Góngora" its subtitle is an old one in Góngora criticism. Góngora's disparager Juan de Jáuregui complained already in 1624 that the Cordoban poet had not been content to conceal his literal meaning under a layer of metaphorical language; even his metaphors get buried beneath metaphors.[12] Góngora's world is, in Sarduy's telling, a world with no fixity of reference, a world of ceaseless fungibility, incessant refiguration. In this world, language never mirrors nature. It shatters nature into shards and recomposes these shards, if at all, in its own image: landscape as language. In this, Sarduy proposes, the Baroque Góngora is "the most contemporary of all poets." His sketch of the Baroque as artifice and excess is thus also the statement of a program. This maneuver—the vindication and analysis of Góngora, pressed into service as a manifesto—was in no way a new one. Sarduy was working in the rich vein of the Generation of '27 and, more ambiguously, his Cuban precursor José Lezama Lima, who in an incandescent 1953 essay had described the Gongorine metaphor as "a metaphor that advances like a hunt and then self-destructs in the light of a relief more than that of a meaning."[13] But performed in an exquisite *Tel Quel* French, with a vocabulary drawn from semiotics and a syntax more Mallarmean than Gongorine, the maneuver had new meaning.

Landscape as language, place as text. This is what Barthes, in an enthusiastic review, saw as the principle of Sarduy's 1967 novel *From Cuba with a Song* (*De donde son los cantantes, Écrit en dansant*). In its original title—"where the singers are from"—the novel poses something like a question, one it answers only periphrastically. The name of Sarduy's native island never appears.[14] Barthes, for his part, insists that "this book has come not from Cuba [. . .] but from the Cuban language, from that Cuban text (cities, words, drinks, clothes, bodies, odors, etc.) that is in itself an inscription of various cultures and epochs."[15] To designate the nature of this language, the nature of this Spanish and the hidden

"face" of French that its translation into French reveals, he takes recourse to a "provisionally useful word"—"Baroque."[16]

"Severo Sarduy's text," Barthes writes, "merits all the adjectives that form the lexicon of literary value: it is a brilliant, agile, entertaining, inventive, surprising text and yet it is clear, even cultural, and continuously tender."[17] But it surpasses these as pure *écriture*: it is a "hedonist and therefore revolutionary text."[18] In Cuba the Revolution had different ideas about the relation obtaining between itself and such pleasures, and by the end of the decade Sarduy had earned the outright hostility of literary critics on the island. "Franco-Cuban writer": such was the slur with which Ambrosio Fornet, "setting himself up as a border policeman," sought to tar him.[19] For Roberto Fernández Retamar, Sarduy's writing was nothing but "neo-Barthesian butterflying about [*mariposeo*]," a term whose homophobic tenor Fernández Retamar would later attempt to deny.[20] These insults had their official counterpart in a bureaucratic silence. When around the time of the Góngora essay the replacement passport he had requested failed to materialize, Sarduy thought at first that the reason for this must be "a paper lost at the bottom of a drawer, a young lady doing her lipstick while she reads Françoise Sagan or Marx, etc."[21] He realized only gradually that it had "to be considered the rejection, on the part of Cuban bureaucracy, of my status as citizen."[22] This state of affairs furnished the material for another form of epithet. The critic Leonardo Acosta writes of "the affected inanities expounded by the mediocre and stateless novelist Severo Sarduy."[23]

The context in which this appears is instructive. What Acosta is calling "inanity" is a piece by Sarduy in *La Quinzaine littéraire* heralding the French translation of José Lezama Lima's magnum opus, *Paradiso*. Sarduy begins by proclaiming the novel "baroque—for once here the word [. . .] has its pertinence."[24] Acosta, for his part, wants to exonerate Lezama from what Sarduy had intended as a compliment. The Baroque, for the critic on the island, is "a style imported by the Spanish monarchy as part of a

culture closely bound up with its imperialist ideology" and thus worse than unserviceable as the prototype for any "decolonizing" aesthetics.[25] The "political, economic and cultural" liberation of Latin America demands "new forms [. . .] forms that will, in a series of aspects, be the dead opposite of the Baroque."[26] The literary eminence Lezama, still resident in Cuba, thus should not receive the moniker. Over the course of the 1960s, "baroque" had become increasingly current as a byword for anything intricate, luxuriant, or difficult in Latin American writing; by 1972 it was taking on the power of a shibboleth.

If Acosta had waited to publish his essay until later in the year, he would have found much more in Sarduy to excoriate. "The Baroque and the Neo-Baroque," Sarduy's contribution to a UNESCO survey of Latin American literature, announces already in its title his ambition to declare a new era and give it its name.[27] He proposes to reduce the Baroque to a "precise operating schema" and to prove the "pertinence of its application to contemporary Latin American art." What results is an ambitious "semiology of the Latin American Baroque," illustrated by readings of a set of Sarduy's contemporaries (Lezama Lima, Carpentier, Cabrera Infante, García Marquez . . .). The essay culminates in something like a slogan. After praising the syntactic subversions of "the Neo-Baroque sentence—Lezama's, for example," he evokes a Baroque in whose power it is to subvert "logocentr[ism]," to undermine authority, a Baroque that "metaphorizes the order disputed, the god called to judgment, the law transgressed. Baroque of the Revolution."[28]

Sarduy's third novel, *Cobra*, published the same year, is revolutionary in just this anti-logocentric sense. In its first part, a drag queen named Cobra and her mini-me Pup—Pup = \sqrt{Cobra}, in one of the novel's mathematizing flourishes—head to Tangier for her sex-change operation at the hands of a Moroccan Lacan stand-in, Dr. Ktazob (more or less Darija for "dick-cutter"). Later Cobra will reappear elsewhere, among drug-dealing bikers and Tibetan monks. The novel ends with a travelogue—Sarduy's "journal"

from a recent trip to India—with excerpts of the diary of Christopher Columbus spliced in. Barthes greeted *Cobra* as "a paradisiac text, utopian (without site), a heterology by plenitude: all the signifiers are here and each scores a bull's-eye."[29] The French version, a co-translation with Philippe Sollers, earned Sarduy the Prix Médicis étranger. This meant big sales and TV interviews. The waiters at one place where the writer was a regular chanted "Champion!" when he came in. To his family in Cuba he wrote that if "the gods kept smiling" a "movie in color" would come of it.[30] His next major prose work, *Cobra*'s conspicuous anagram, was the text at the heart of the present volume: *Barroco*.

For a reader adopting a customs officer mentality, the contents of this book will at first blush be as inscrutable as the young Sarduy, dubious document in hand, must have been to the actual border police. The term *neobarroco*, introduced in the UNESCO survey essay, would go on to make its fortune as the watchword for a "New World discourse of countermodernity."[31] But in *Barroco* Sarduy turns away from the New World to articulate a planetary—in a certain sense cosmic—Baroque. This concept, he will argue, belongs intimately to the history of cosmology: the canonical Baroque is for Sarduy the age of Kepler, the age of a cosmos whose single center has split in two, into the twin foci of the orbital ellipse. Kepler's kinematics is subjected, in Sarduy's hands, to a series of prestidigitations. Its split center reappears in Gongorine ellipsis as the split subject of language. The curve of the planets' paths dictates the secret law of Baroque paintings. The Neo-Baroque, in turn, will be defined in terms of the "new instability" of twentieth-century cosmology.[32] *Barroco* thus mixes cosmology, art history, and literary theory indiscriminately, to name a few of its discourses. Sarduy subjects Foucault's reading of *Las Meninas* to a kind of critical pastiche. Cassirer's symbolic forms lurk as a latent presence. Lacan appears, sometimes butchered.[33] The technique is novelistic, in Sarduy's sense: set pieces assembled into a whole more mandalic than narrative.

Introduction xvii

In this assemblage, Latin America is conspicuous by its absence. Sarduy's gaze is fixed upon the cosmos, whose patterns are the same in Paris and Havana. And when this gaze returns to earth, the objects that it favors are overwhelmingly European. The colonial Baroque goes very nearly unmentioned, and Sarduy draws more examples of the Neo-Baroque from France (Philippe Sollers), Spain (Luis Feito), and the United States (Robert Morris) than he does from Latin America. At the same time, as we will see below, the present volume represents a kind of clandestine maneuver with regard to the two major authors who, together with Sarduy, form the "Cuban triumvirate of Baroque theorists."[34] In redefining the "founding Baroque" of the European seventeenth century, Sarduy will seek to exclude Alejo Carpentier from the Neo-Baroque and to establish himself as the rightful heir to José Lezama Lima, whose *Paradiso* stood for Sarduy as the Neo-Baroque work par excellence.

2

The title sets the tone. No article, no *el* or *lo*, only a naked name. Not the Baroque, *el barroco*: not a period in the history of styles, a block of time complete in itself and available now for recovery (*recobro*: the pun is present in *Cobra*). Nor the baroque in the sense of a stylistic essence, *lo barroco*. This is a subtly polemical move. In "The Baroque and the Neo-Baroque," Sarduy had given pride of place to an illustrious antagonist, the Catalan philosopher Eugenio d'Ors, in whose work—which Sarduy calls the "best Spanish-language grammar [. . .] of the concept"—the Baroque is presented as a "historical constant."[35] Here he takes up the title of d'Ors's book, *Lo barroco*, and—striking the article, the *lo* that gathers scattered phenomena under the sign of a stabilized essence—makes it his own.

Early in the book, Sarduy sets about dismantling the concept "baroque." His aim, he writes, is to "motivate the sign *barroco*, to give it a foundation."[36] But first this sign must pass through

purifying fire. Writing in the structuralist koine that characterizes his theoretical writings, Sarduy announces a stringent semantic asceticism: the suppression of any possible signified (which is to say, any version of *lo barroco*) in favor of a direct encounter between the signifier—the word's form—and its referents. Thus, for example, the vowels *a* and *o*—sparkling in the word *barroco* like gems in their setting—are made to correspond to the light set, gem-like, into the black marble cupola of the Chapel of the Holy Shroud. Such onomastic games serve to shake up the concept "baroque," to break it up into a field of floating realia: poems, paintings, chapels. This field will then crystallize into an order under the catalytic action of a second concept: *retombée*.

In Sarduy's hands, *retombée* names something like an echo—specifically, echoes of cosmological models (Plato, Copernicus, Kepler . . .) in works of literature, art, and architecture. Wending his way from Plato and Aristotle to the twentieth century, Sarduy traces a double history, mapping events in the history of science onto events in the history of styles. Thus he will see reflected in the single-centered composition of Renaissance paintings the form of the Copernican cosmos. In the ellipses that structure the paintings of Rubens, in the ellipsis that governs the poetry of Góngora, he will detect echoes of Kepler's cosmology, in which the single center splits, giving way to the double focus of the orbital ellipse. These two histories will be coupled together—the periodizations internal to each allowed to play off against one another—in accordance with a logic not of mere analogy but rather of reciprocal and repercussive causality.

Sarduy's decision to introduce a French term as his text's central methodological concept—along with his statements in subsequent texts and interviews that he could not find an "effective" Spanish equivalent—has endowed this concept with the mystique of untranslatability.[37] Thus mystified, some readers have resorted to forced explanations, seeking the meaning of the term in Mallarmé or etymology.[38] The gnomic, poem-like definition

that Sarduy himself offers ("Achronic causality, / non-contiguous isomorphism / or, / consequence of something that has yet to occur, / resemblance to something that has yet to exist") has not always helped to clarify matters. What is clear is that *retombée* does not only name a correspondence (a likeness, say, between ellipse and ellipsis). It involves a sense of causality—a curious kind of causality in which cause and effect can get shuffled (*se barajan*) like playing cards.[39] This is Sarduy's central wager in the game that is *Barroco*:[40] to refer the "Baroque effect," as he will put it in a later interview, to a causality—without, however, reducing it to a state of dependence on a single heteronomous cause.[41] Everything depends, then, on pinning down what he means by this concept, one on whose value and whose irreducibility to other adjacent terms he will insist for the rest of his career as a theorist of the Baroque.[42] Faced with these apparently paradoxical formulations, some of Sarduy's more sober readers have sought refuge in common sense, either playing down causality in favor of echo or likeness or reframing *retombée* in terms of a more orderly pattern of causation. In a book partly indebted to Sarduy's, *The Poetic Structure of the World* (1987/1990), Fernand Hallyn chooses the latter alternative, writing, "Less paradoxically it seems to me that *retombée* can be defined as the production of analogous effects from common presuppositions forming part of the anonymous intertext [. . .] two noncontiguous positions, not influencing each other directly, but sustained by the same presupposition."[43] Less paradoxical—but lacking in the specificity on which its author insists.[44]

It may be useful, then, to trace in a few schematic steps how the term acquires the meaning with which Sarduy invests it. Three English words—*fallout, upshot, feedback*—serve well to specify the scope of *retombée*.

Fallout. The usage upon which Sarduy draws is not an old or esoteric one. *Retombées* (plural) simply names what in English is called "fallout": nuclear fallout, *retombées radioactives*; fallout

shelter, *abri anti-retombées*. Then, as in English, the term receives a derived sense. It comes to name the diffuse set of indirect effects arising out of a given event: e.g., the fallout (*les retombées*) of a political scandal.[45] At first approximation, Sarduy's claim would seem to be that the artistic, architectural, and literary phenomena gathered under the name "Baroque" form, together, the fallout of a detonation elsewhere—the collapse of the Galilean circular cosmology in favor of Kepler's ellipses.

Upshot. "Fallout" is grammatically singular. In ordinary usage, the French term is plural. But for this very reason, it becomes possible, by speaking of something as *une retombée,* to pick out a distinct and singular indirect effect against a background of causal diffusion. This usage is attested in the shoptalk of mathematicians from the 1960s on. Thus one speaks of the *retombée* in theory B (the implication, the upshot) of a development in theory A. That is, a specifiable instance of—possibly reciprocal—fallout as a relation obtaining between two formal structures (for instance, between the space of perspectival figuration and the space of Copernican cosmology). In the late 1960s, a similar usage appears in Sarduy's immediate French-language "speech community": in the notoriously mathematizing language of the *Tel Quel* milieu.[46]

Feedback. Here the term passes out of the history of common or coterie language and into Sarduy's personal *parole*. Another word is audible beneath the French word *retombée*—its Spanish cognate, *retumbo.* Boom or rumbling, as of thunder: a resounding. And indeed wherever Sarduy speaks of *retombée* he speaks always in the next breath of acoustic phenomena. In *Barroco*'s "Chapter 0," devoted to a preliminary explication of *retombée,* Sarduy takes up the conceit of the echo chamber, one in which the echo "sometimes comes before the voice," in order to name the discursive space that, in subsequent chapters, he will set about constructing. Commenting on this passage in a 1975 interview for *Le Monde*, Sarduy states that he had been "much influenced" by the technical language of radio production.[47] Later, in the 1979 interview that contains his

clearest elaboration of the concept, he will explain that one aim of *retombée* is to place "on a single plane [. . .] the effects of a given [e.g., cosmological] model and the model itself as affected dialectically by those effects, absent temporal, conceptual, or spatial priority":[48] that is, to set up a feedback loop. So, for example, Sarduy will seek to show how the moon as seen by Galileo, pockmarked, corruptible, passes over into the realm of fine arts (Cigoli's fresco in the Pauline Chapel, which shows a Virgin with the Galilean moon beneath her feet); how this disruptive image worms its way under the iconographical signifier (the moon's image) to undermine its signified (the moon as the immaculate); and how it thus saps the theological foundations of Galilean cosmology (the circular as the natural), preparing, indirectly, its collapse—preparing the ground for the ellipse of Kepler (or Rubens, or Borromini), for Góngora's ellipsis, for the *eccentric* world of the Baroque.

3
"The term 'Baroque' is beginning to stink." Such is the verdict rendered by José Lezama Lima, in a 1975 letter, on the use of this word as a name for the Boom. "García Márquez is not baroque, neither are Cortázar or Fuentes; Carpentier is neo-classical."[49] The Sarduy of "The Baroque and the Neo-Baroque" would appear to be party to the crime in question. Carpentier serves there as Sarduy's second example of the Latin American literary Neo-Baroque (the first is Lezama). Later in the essay, he will give García Márquez's strategy of borrowings (from Carpentier, Cortázar, Fuentes . . .) as an instance of Baroque textuality. And yet, in interviews and essays from the 1960s on, Sarduy had been decrying the overbroad use of the term and denying its pertinence to Carpentier's work in particular. In a 1966 interview with Emir Rodríguez Monegal, he insists that although "there has been much talk of the Baroque of Carpentier [. . .] the only Baroque writer [. . .], the true Baroque writer in Cuba is Lezama. Carpentier is Neogothic, which is not the same as Baroque."[50]

Gustavo Guerrero proposes one way of resolving the contradiction: to read "The Baroque and the Neo-Baroque" as a manifesto concealed within an ecumenical survey: a "secret palimpsest in which we must read, between the lines, the radical opposition of Sarduy to the thesis of the Carpenterian Baroque." Instead of "openly attacking Carpentier's ideas," Sarduy takes as his target "their source: Eugenio d'Ors."[51] Indeed the presence of d'Ors is a red thread running through the postwar Cuban engagement with the Baroque.

To the received idea of the Latin American Baroque as imposed and derivative, both Carpentier and Lezama respond with variations on the same retort. Lezama: the Old World Baroque is deficient and the New World Baroque its fulfilment. Carpentier: the genuine home of the Baroque, its "chosen territory," is none other than Latin America.[52] When Carpentier first sketched the contours of this argument, it was not the Baroque he had in mind but Surrealism with its manufactured marvels—costume jewelry in contrast to the gems of the Americas, where the marvelous is real. The New World is marvelous, first of all, for its history. Carpentier writes that he had his "first inkling" of the marvelous real in Haiti in 1943, on a visit to the "poetic ruins" of Henri Christophe's kingdom.[53] The New World is Baroque, by contrast, for its nature: its botanical excess and, associated to this by a kind of semantic contagion, the "fecund *mestizaje*"[54] that eventuates in the syncretism of its art forms. It is in regard to nature in the sense of the land that d'Ors becomes relevant.

In a short 1926 text on the theme of "History and Geography" d'Ors writes that "in the secret logic of its forms [. . .] the Baroque can be summed up as the deformation brought upon the great lines of European tradition by the illusion and enchantment of the vegetation of the tropics."[55] Baroque columns, twisting like tree trunks or braided like vines, hail not from the forests of Europe but from another landscape, an *ultramar* "half-glimpsed in

a daydream, or recalled."[56] D'Ors thus introduces a significant wrinkle into the idea of the New World Baroque as an imposed and derivative style: "It was Europe, to be sure [. . .] that brought the Baroque style to the Indies; but before that the Baroque had already encountered the secret of its rhythms in a diffuse influence exercised by the Indies upon Europe."[57] In a French version of the same text published later that year, d'Ors spells the thought out more explicitly: "Because *every colonization is always reciprocal.*"[58]

The Baroque as influx and reflux of form: this idea, and others like it, were beginning to be formulated in Latin America as well. The year before d'Ors's little text, the Argentinian architect Ángel Guido had published a small volume on *Hispano-Indigenous Fusion in Colonial Architecture*, the first in a series of efforts culminating in *The Rediscovery of America in Art*.[59] Guido saw in the history of Latin American aesthetics an alternating pattern of Old World conquest and New World reclamation. The imposed European Baroque was the first aesthetic *conquista*; the *reconquista* came with the "inoculation of indigenous sap," the pre-Columbian forms worked into Baroque façades by the likes of the Quechua sculptor Kondori.[60] Not dissimilarly the Hungarian-American art historian Pál Kelemen would later glorify a Latin American Baroque invigorated by hybridity, "[j]ust as the tulip bulbs we brought from Holland produced within a few years a changed flower in our Florentine garden."[61]

This botanical picture of cultural mixing—sap and soil—prepared the subsumption of the *mestizaje* theme under the d'Orsian theme of the Baroque as the return to nature, to prehistory, as "secretly animated by nostalgia for the Lost Paradise."[62] Carpentier's theory depends on the identification, adumbrated already in d'Ors's 1926 text, of this Lost Paradise with the New World, and on the thesis that the nature of the New World is, in its intricate proliferation, itself already Baroque. On a page of the 1962 novel *Explosion in a Cathedral* that echoes more than one d'Orsian

passage, Carpentier writes of the coral forests of the Antilles as preserving "the earliest *barroquismos* of Creation [. . .] a figuration, close by and yet inaccessible, of the Lost Paradise."[63] From this premise Carpentier arrives at the necessity of the Baroque by two forms of argumentation. The more straightforward is the argument from mimesis: "the description of a baroque world is necessarily baroque."[64] The more interesting—because it endows the verbal Baroque with a distinct stylistic content—is the argument from Genesis. Baroque language is language faced with a world unnamed, or a nature in excess of any imaginable lexicon. "The Baroque is engendered by the need to name things," writes Carpentier; and since, like Adam, "we Latin American writers, too, have to name everything," it follows immediately that "legitimate style of the contemporary Latin American novelist is Baroque."[65]

Characteristically, the Sarduy of "The Baroque and the Neo-Baroque" will affirm just the opposite. The polyglot New World, in the wake of the Conquest, is marked by a "*trop plein* of the word," an excess of language, "an abundance of the naming in relation to the named."[66] Baroque language comes as "the solution to this verbal saturation."[67] More generally, insisting that the Baroque is not nature but "on the contrary, [. . .] the apotheosis of artifice, the irony and mockery of nature,"[68] the Sarduy of the 1972 essay is seeking to cut Carpentier's Baroque off at the root. In *Barroco* he repeats the gesture, cutting deeper. Carpentier goes unmentioned here: Lezama is the only Latin American writer who figures in the book. Nor does d'Ors come in for explicit criticism. But in the conceit that gives *Barroco* its structure—the ellipse of Kepler as the emblem, the diagram, the fundamental form of the Baroque—Sarduy silently takes up an *idée fixe* of d'Ors, in the process inverting its significance.

In a short 1918 Catalan-language text, d'Ors adopts the Keplerian ellipse as a heraldic device for his own philosophical position—for the form of synthetic, ironic intelligence that he advocates as a restoration of the *nous*, the "living reason" of the

ancients, a reason that would include and sublate the irrational. Faced with the destruction of the circular cosmos, with a nature apparently inimical to geometry, Kepler, as ventriloquized by d'Ors, responds: "The overly simple regularity of the ancients, no: but nevertheless a certain regularity; a rigid symmetry, no: but yes, a more elastic, more flexible harmony; Pythagorean circles, no; but, if you please, graceful ellipses."[69] In 1947, d'Ors will still be writing of his intellectual venture as the attempt at a "Keplerian reform [i.e., as opposed to Kant's Copernican revolution] in philosophy."[70]

In the intervening years, however, the ellipse of Kepler comes to serve, for d'Ors, as a kind of key to the Baroque. In several texts of the late 1920s he takes up the language of Heinrich Wölfflin, for whom the terms *tektonisch* and *atektonisch* (the third major opposition in *Principles of Art History*) characterize, respectively, the classical and the Baroque. D'Ors calls for a "tectonic [elsewhere "structural"] explication of the Baroque":[71] a theory of the Baroque that would bring out the structure concealed beneath its "atectonic" chaos. This structure will turn out to have, as its shorthand, the Keplerian ellipse:

> If, then, the unity of design that governs any composition—any tectonic realization—in which the classical spirit prevails can be represented symbolically by the circle, it is proper to Baroque composition to be representable, in its essence, by the ellipse. What, in [classical] composition, is unity of design, appears to us, in the second, as duality, obeying the double rule of a double center. Logic, which is reason, which is spirit, establishes beyond doubt the absolute authority of the *principle of contradiction*. But the inspiration of the Baroque does not come from the spirit, it comes from nature. Nature does not know the principle of contradiction. She mocks it, mocks it with her *Werden*, her dynamism, her movement. Nature, to use a vulgar expression, does not know what she wants.[72]

As Kepler finds in the orbital ellipse the form of what seems to be formless, so d'Ors finds in the ellipse of Kepler the form of a Baroque that, in its imitation of nature, inherits nature's apparent formlessness.

For d'Ors, then, the ellipse is a symbol of the Baroque as subdued, the Baroque as mastered by the ironic intellect. According to Enric Jardí, his biographer, he liked to repeat the claim that "European culture is polarized between two essential nuclei, Greece and Portugal," the former standing for the classical and the latter for the Baroque;[73] d'Ors regarded himself as Greek in outlook, as an Odysseus to the "delicious siren" of the Baroque.[74] The political pendant to this aesthetic attitude is encapsulated neatly in the preface he wrote in 1935 (the same year he published his major work on the Baroque)[75] for the Spanish edition of a book of interviews with the Portuguese dictator Salazar: "to achieve a civilized decorum, a Baroque people with a tendency to abandon itself to the disorder of nature must come into opposition with itself."[76] Hence the necessity of Salazarism, whose coming Spanish incarnation he heralds as "our best collective hope for decorum"—hence the necessity of a "missionary politics" that "in operating upon a civilized country, even upon a country with a long cultural tradition, does so in the manner of a missionary engaged in redeeming a barbarous people from its barbarity."[77]

Where Carpentier excerpts from the d'Orsian dialectic the characterization of the Baroque as the idiom "by means of which culture imitates the procedures of nature,"[78] revalorizing it in the light of a very different politics, Sarduy, seeking the basis for a "Baroque of the Revolution,"[79] takes up the dialectic as a whole and reverses it. Sarduy follows d'Ors in identifying Kepler as the Baroque moment in the history of cosmology, and he takes the conceit of the ellipse as the "tectonic" key to the Baroque more seriously, perhaps, than did d'Ors himself. But for Sarduy the ellipse does not formalize nature in her double intentions, nature that makes a mockery of the principle of noncontradiction and that

"does not know what she wants." It stands instead for artifice—the ellipse as anamorphic circle[80]—and, through the equation of Kepler's ellipse with Góngora's ellipsis, it comes to formalize the split subject (in orbital terms: one luminous center, occupied by the sun, and another one "elided, excluded, obscure") as the subject of language.

Lezama, here as elsewhere, cuts a more ambivalent figure.[81] His seminal 1957 lecture "Baroque Curiosity" begins with a mild mockery of d'Ors as "a critic who, outdoing himself in the art of generalization, claimed that the earth is classical and the sea is Baroque."[82] This ought not to be read as an outright dismissal; Lezama is in any case as inveterate an exaggerator as d'Ors. He is more adept, however, in the arts of dialectical specification. Two years later we find him writing in the pages of *Lunes de Revolución* that "in the landscape of the Americas, and now we insist again on this, what is baroque is nature."[83] But what he means is different. He is commenting here on the "Baroque treatment of fruit." Góngora, faced with a pippin, belabors the preliminaries (the cutting of the fruit), exaggerates its subtleties (the yellow that fades), and thus betrays a "lesser encounter."[84] The "excess," here, is in verbiage. Not so in the Americas, where the fruit is already rhetorical: "if a papaya, butter among fruits, or a guanábana, silvered haunch of sweetness, were to receive the trident of baroque hyperbole, this would make for a grotesque."[85] The American Baroque is instead in "the festival of the fruit's excessive brouhaha [. . .] the opulent subject in his gourmandise."[86] Nature, here, is no longer code for innocence or fecundity, nor is the theme of *mestizaje* folded into it. This is instead a nature saturated with excess and artifice; it appears not as Eden or jungle but under the double guise of the fruit seized at the banquet and the landscape worked over by leisure ("the art of enjoying a landscape and filling it with artificial, metrical and voluptuous instruments").[87] Its order is less one of reproduction than one of simulacrum and squandering.

xxviii *Introduction*

Hence Lezama's enthusiasm—derived from Roger Caillois and passed on to Sarduy—for phenomena of hypertely among plants and insects, instances in which mimesis exceeds any purpose of seduction or camouflage, in which the "excessive drive to simulation" can become a "lethal supplement":[88] moths so adept in the imitation of leaves that others of their kind attempt to feed on them. What for Lezama serves as the model for a poetics of excess becomes in Sarduy's hands the proof that nature itself is not natural. Where the Baroque, for d'Ors, evokes the Eternal Feminine of Goethe and the "hot moaning of turtledoves" in the Jardim Botânico in Coimbra,[89] Sarduy's own free associations lead him from the Botanic Gardens of Kandy, in Sri Lanka, where he remembers having seen an "orchid that simulates a butterfly," to the premature death of Candy Darling, Warhol's trans superstar.[90] It is to this "series of excessive and lethal phenomena" that the Baroque, for Sarduy, belongs.

4

Sarduy, speaking in a 1986 interview of his attempt to "give the Baroque a foundation," states that he took, "to some degree, French structuralism as [his] point of departure."[91] Within the heterogeneous formation that went by this name, it is possible to draw some distinctions.

From psycho- and semanalysis, from Lacan and Kristeva, the Sarduy of *Barroco* derives his working vocabulary and his articles of faith (the split subject, the genotext . . .).[92] These commitments will predominate in the indirect intervention that this book makes upon the discourse of the Latin American Neo-Baroque. (To borrow from Sarduy a Lacanian borrowing: "the appearance in one signifying chain of a term originating in another [. . .] sends on not only to another register of meaning but also to another site at which to find the subject.")[93] But in the book's other context they are more like the ordinary furniture of an ongoing discussion, lexical and theoretical equivalents of the little round tables and

Introduction xxix

the rattan bistro chairs at the Café de Flore, where Sarduy would sit drinking afternoon bloody marys with a Barthes who, for his part, confined himself to coffee.[94] As a meditation on the European Baroque, this text owes its central problem to the discussions unfolding around the concept of the *coupure épistémologique,* the epistemological break.[95]

The problem of *Barroco* is announced in extreme compression in a 1971 *Tel Quel* text entitled "Tangier." There Sarduy takes the square in Tangier known in French as the Petit Socco as the occasion for a series of fragmentary reflections. In the second of these he proposes to

> see in the form of the [Petit Socco] the figurative correlate of the rhetorical ellipsis, and in the maximal extension of the latter—Baroque poetry—the textual *"retombée"* of the model that gave its form to the era's cosmology: the planets, for Kepler, trace an ellipse around the sun. Caught in the ideology of the reflection, the theological tic of correspondence [. . .] Galileo refuses this ellipse: the members of the human or animal body [. . .] trace circles and epicycles.[96]

Galileo's refusal marks a fault line: "Circle/ellipse: this cut [*coupure*] runs through the entire symbolic production of the era." On one side of the divide is Galileo's circular cosmology, along with a set of literary and artistic works (ranging from Raphael to Lope de Vega) whose "composition" is "imaginary, circular, unifocal, aesthetic." On the other side, together with Keplerian cosmology, are those works (Caravaggio, Bernini, Góngora . . .) whose "organization" is "open, dyadic, bifocal, dynamic." Sarduy closes his summary development of this theme with the claim that in the Baroque the ellipse/ellipsis, "both rhetorical and geometric," constitutes a "real, scientific design [*tracé*], whose ideological, imaginary underside remains circular precisely inasmuch as it is only a reflection."[97] That is, Baroque artistic and literary practice—revolutionary in the sense of the "scientific revolution"—nonetheless

remains conjoined with the ("circular, unifocal") schema in which God or King occupies the single center. The Baroque, in this sense incomplete, awaits the Neo-Baroque as its actualization.

The "scientific" as that which breaks with ideology, "ideology" as the name for what does not attain to the status of science: the language here is Althusser's. But where for Althusser and his disciples art—at least "real art"[98]—takes up a somewhat ambiguous intermediate position between science and ideology, Sarduy is bold enough in "Tangier" to assign Baroque artistic and literary practice to the side of science. A year later, in "The Baroque and the Neo-Baroque," he is more circumspect. There he refers to the Baroque break as an "epistemic" one (*un corte epistémico*), specifying in a footnote that it "concerns a shift from one ideology to another, and not from an ideology to a science: not, that is, an *epistemological* break like the one that occurs, for example, in 1845 between Ricardo's ideology and Marx's science."[99] Enumerating a series of shifts, from the form of the city and the organization of the church to Kepler's and Harvey's discoveries of the orbital ellipses and the circulatory system, Sarduy here gives a sense of the Baroque as a sea change surging indiscriminately through all zones of human endeavor; it takes on, as it did for Heinrich Wölfflin, the appearance of a "force of nature, irresistible, laying low everything before it."[100]

This position too turns out to be untenable. After all, it is in part the specific efficacy of the scientific model upon other regions of "symbolic production" that Sarduy wants to capture with the concept of *retombée*.[101] If the Baroque break, taken as epistemological, elides the difference in question by including the production of a Caravaggio or a Góngora within the realm of the "scientific," the Baroque break as merely epistemic dissolves this difference in the homogeneity of a cultural shift. The logic implied by "a notion like that of *retombée*," Sarduy will ultimately conclude, is incompatible with the one implied by the concept of the break, which, for its part, "cannot be applied" to the case of the Baroque "without a prior *remaniement*." One would have to speak instead

of the "interaction and pulverization of different models or nuclei in a space of relativity."[102] *Barroco* is Sarduy's attempt to map this space, to render it intelligible.

It is thus also his attempt to answer the question with which Wölfflin opens the second part of his inaugural work on the Baroque: "Why did the Renaissance come to an end? Why is it the Baroque style, precisely, that follows it?"[103] In his answer, Sarduy maintains a "difficult equilibrium."[104] He refuses to attribute to any form of "symbolic production" the role of ultimate cause: under the regime of *retombée*, which shuffles causalities "like playing cards," any given cause-effect pair is reversible. But he concedes a special role to cosmology, the mixed discourse in which—by reason of its scope: the universe as a whole—all others are at least virtually included. In tracing the repercussions of the new cosmological model upon other discourses, other practices, we can watch the Baroque, as a still unrealized whole, bring its component parts into being. The Baroque, so to speak, as its own cause.

5
Sarduy would never return to Cuba. But toward the end of his life—he died of complications due to AIDS in 1993—he was drawn toward other islands in which he glimpsed its likeness.[105] Two short texts from 1991 document a visit to the now-defunct radio telescope at the Arecibo Observatory in Puerto Rico, whose enormous reflector dish served to gather radio signals arriving "from the cosmos [. . .] in the silence and transparency of the island night."[106] In the first text, "Arecibo," Sarduy takes pleasure in describing how the "handsome Boricua" at the control board "looks lethargically toward the limpid sky of Arecibo and with his index finger, as if he were pointing out a flight of migratory birds, traces a line" to illustrate the passage of pulsars in the invisible distance. But what strikes Sarduy as "the most fabulous thing" about Arecibo is the 450,000-watt radio message transmitted into space by the SETI (Search for Extraterrestrial Intelligence) program "with the hope—why not?—that someday someone will

receive it and respond."[107] In the closing lines of the second text, "In the Shadow of Arecibo: Myth and Novel Today," this message comes to serve as a metaphor for the writer, "who transmits signals, signs, without knowing whether, from the other side of space, someone is going to answer."[108] As with Adorno's famous "message in a bottle," what elsewhere might have registered as Romantic cliché draws its force from the pathos of exile—in this case from the conjunction of the unimaginably distant and the irretrievably familiar: "this town lost in the north of Puerto Rico, under the downpour of the eternal island summer, where the sea cannot be heard."[109]

Sarduy does not mention that the transmission of the Arecibo Message—1,679 bits of data that encode the numbers one to ten, the atomic numbers of the component elements of DNA, and rudimentary graphic representations of the double helix, a human being, the solar system, and the Arecibo telescope—took place in 1974. This is, in a nice coincidence, the year he published *Barroco*, whose later chapters represent his first sustained attempt to theorize the Neo-Baroque as a form of artistic production conditioned by the changes that twentieth-century cosmology has wrought upon the world picture. But the message of *Barroco* makes for a striking contrast with the transmission from Arecibo. In the Arecibo message, with its digital glyphs of the human form and that form's genetic basis, humankind asserts itself as the sovereign subject and ultimate object of science. Such self-assertion belongs, for Sarduy, to the ideology of Copernican heliocentrism: "the center is exiled, Man sets up shop."[110] Our own proper precursors are to be found instead in the age of Kepler; our texts, then, should resemble Baroque texts, in which "the adding up of quotations, the multiple emission of voices, denies the possibility of a single, natural broadcasting center."[111] Certainly this description holds true of Sarduy's own writing: in scanning the lines of *Barroco*, the reader is also scanning a spectrum, picking up one station after another. It can take a moment to register who, exactly, is speaking.

Introduction xxxiii

If the century of great "Baroque books" stretching from Wölfflin's *Renaissance and Baroque* (1888) to Deleuze's *The Fold* (1988) were to be shelved not by theme or by discipline but in accordance with their affinities on the level of textual construction, the present volume would perhaps have Walter Benjamin's *Origin of the German Trauerspiel* for its immediate neighbor. Both texts owe their form to what François Wahl, writing of Sarduy's method in *Barroco*, calls a "taste for *montage*."[112] The language Benjamin uses in a letter to Gershom Scholem to describe his book's compositional principle ("the craziest mosaic technique you can imagine," resulting in a text that "consists, as it were, almost entirely of quotations")[113] would serve just as well to define the textual bricolage employed in *Barroco*, whose characteristic procedure is that of assemblage, the piecing together of fragments drawn from other schemes of periodization: Koyré's history of science, Mumford's history of the city, the history of the art historians . . .

This shared technique arises out of shared methodological commitments. For Sarduy, as for the Benjamin of the *Trauerspiel* book, the task is not taxonomic. The task is not to subordinate the phenomena of the Baroque to a concept that would subsume them as a species does a class of individuals. It is, instead, to coax out of the mass of material the constellation in which an idea becomes legible.[114] The use of montage answers, in both authors, to the same underlying desire: the desire for an immanent analysis of the Baroque, for a text in which the puzzle of the Baroque could, through the sifting and resifting of its elements, be forced to furnish its own key.

In the "Epistemo-Critical Preface" to his Baroque book, Benjamin writes that "in everything essential, singularity and repetition are reciprocally determined."[115] It is Sarduy's sense of the Baroque as both singular and repeatable that sets him apart from the two classes of theorists responsible for most writing on the subject: those for whom the Baroque is a timeless essence, one whose flickerings in and out of existence we can trace through time and space, and those for whom it is firmly confined to its place in early

modern history. Among the former class are those for whom the Baroque is a fixed position in a recurring cycle, those for whom, in Nietzsche's words, "the Baroque arises inevitably with the decline [*Abblühen*] of every great art."[116] This first class also includes, as a special subset, those for whom the Baroque is a persistent trait of Latin American cultural production. To the second class would belong authors like Werner Weisbach or José Antonio Maravall, whose landmark *Culture of the Baroque* was published one year after *Barroco*. Neither of these classes satisfies the desiderata put forward by Deleuze: "to account for [both] the extreme specificity of the Baroque and the possibility of extending it beyond its historical limits."[117] If Sarduy has his place among "the best inventors of the Baroque,"[118] it is in part because his account of it, precise enough to do justice to the verbal proliferation of a Góngora, is at the same time capacious enough to include within itself the minimalism of a Robert Morris.

For Sarduy the Baroque is singular: inextricably attached to an unrepeatable moment, the moment in which the single center of the cosmos enters into a process of scission. But this very singularity makes it possible for him to theorize the return of the Baroque as a repetition with a difference. His Baroque does not belong to a recurring cycle; it does not belong to the classical as its inevitable decadence. This Baroque belongs instead to its future, to the Neo-Baroque that will actualize its revolutionary potential. Sarduy's book is reminiscent, in this sense, of a later Benjamin. In the differential pairing *barroco/neobarroco*, "what has been comes together in a flash with the now to form a constellation."[119] The present volume is that constellation's diagram.

6

Cobra was never made into a movie, in color or otherwise. But that disappointed hope found unlikely compensation in the form of a 1976 film by the auteur André Téchiné. Its official title is *Barocco*, the Italian spelling, but in the opening credits it is the Spanish word *barroco* that appears, superposed upon a cobra.

Téchiné's film is in part a queered version of *Vertigo*, in part an adaptation to the screen of Rubens's "Exchange of the Princesses" as read by Sarduy in *Barroco*.[120]

The painting commemorates the double marriage of the Spanish royal siblings Anne and Philip to the French Elisabeth and Louis. In the heavens, cherubim join hands in an elliptical roundelay; on earth, a grouping of figures likewise forms an ellipse, bounded on either side by allegories of France and Spain. Sarduy guides our eye to the focal points of the earthly ellipse, where we find the French and Spanish princesses: "One is luminous, slender and shimmering—solar—; the other, of course, is smaller, subdued, discreet."[121] In *Barocco*, Gerard Depardieu plays a double role. He is Samson, a copper-haired boxer, and also Samson's nameless and dark-haired assassin. One is shimmering and solar, the other subdued and discreet, and like the princesses of Rubens, they are the pawns in a game of political symmetries. In the crucial scene Depardieu shoots Depardieu through the plate-glass window of a railway station café; the boxer's Delilah, played by Isabelle Adjani, seeks to remake the doppelgänger in the image of his victim.

Doubles and makeovers, mirrors and mimicries: the film anticipates Sarduy's subsequent work on the Baroque. His next volume of theoretical writing after *Barroco* came out in 1982 under the title *La simulación*; the French version appeared a year in advance as *La doublure—The Body Double* or *The Understudy*. There Sarduy evokes a Baroque of painted skin and surfaces, anamorphoses and *trompe-l'oeil* effects, mirages that supplant reality. In one bold subchapter, Rubens returns.[122] This time, Sarduy is less absorbed in the detection of ellipses; he moves with ease through the discursive space pried open by *Barroco*. What he discovers there is an erotics of the paintbrush. Rubens, he writes, "gets hard" tracing his ellipses, but the ellipses are not everything. Uncovering "successive scenes within the scene," thematic frameworks that slide apart like stage flats, Sarduy arrives at a dripping and spattering degree zero of the painterly, "the seminal fury of the paintbrush."[123] The Baroque as a passage through structure into bliss.

The same theme of stagecraft permeates the 1988 essay "The Heir."[124] In this, his last and most substantive engagement with Lezama, Sarduy meditates on "the possible inheritance of his word" and the "probable emergence of the Neo-Baroque out of his work, in the Caravaggio light of his scenography, or in the incandescent ellipse of his theatricality."[125] Sarduy finds the key to Lezama's textuality in the "theatrical and pedagogical crusade" of the first Baroque, the Baroque of the Counter-Reformation. He finds Góngora's mythological "props" in *Paradiso* in the form of the traits, tics, and shifts of focus that transform "plain Cuban reality into a *grotesque* scenography, marvelous and teratological."[126] And he himself appears as the understudy in something like a passion play. Defining Lezama as the heir and decipherer of the "island night," Sarduy claims his place as Lezama's decipherer and heir, the heir to a passion and a solitude. As the essay draws to its somber, tender close, he evokes Lezama's "dectractors," for whom "any detail whatsoever can serve as a bloodstained banner [. . .] his sexuality for example."[127] Sarduy then imagines a critic disparaging Lezama's work as a "butterflying about." But it was Sarduy's writing, not Lezama's, that Roberto Fernández Retamar had once called a *mariposeo*. It is a banner stained with his own blood that the heir drapes around the forebear's shoulders.

Those years were a time of summations. In 1987, he published a book of autobiographical sketches, *Christ on the Rue Jacob*, and collected his four volumes of theoretical work under the title *Ensayos generales sobre el barroco*. These essays are indeed general in scope, but the title conceals another meaning. *Ensayo general* is a term from the performing arts. It refers to the last practice performance before the premiere, when nothing is left of the tentative. The actors know the fit of their costumes and the feel of each phrase; they have their makeup on. Everything is in place, except for the audience and other such appurtenances of official reality. The spectacle in its intimacy, the virtual in its most vivid form. That is how these texts should be read—as dress rehearsals for a possible Baroque.

BARROCO AND OTHER WRITINGS

Barroco

For Roland Barthes

retombée: achronic causality,
 non-contiguous isomorphism,
 or,
consequence of something that has yet to occur,
resemblance to something that has yet to exist

0

Echo Chamber

The notes that follow seek to point up the *retombée* of certain scientific (cosmological) models upon nonscientific symbolic production, contemporaneous or otherwise. The resonance of those models can be picked up absent any notion of contiguity or causality: in this chamber, the echo sometimes comes before the voice.

Lapsed history read in reverse; narrative without dates: dispersion of ratified history.[1]

Boomerang: tracing a survey of the echo chamber, the map of reverberations. Certain models whose *retombée* is detected will show their reverse: neither pure, abstract operative schema nor minimal scientific unit but rather—patent in Galileo's circle, or in Lemaître's Big Bang theory—the imaginary core, the theological mark.

In order to elucidate the symbolic field of the Baroque, *retombée* will be defined through the opposition of two forms—Galileo's circle and Kepler's ellipse—; and, summarily, as the mark of another opposition—that of two current cosmological theories: the Big Bang and the Steady State—in a few contemporary works.

If the space set forth as exemplary is the one described by cosmology, it is simply because this science, insofar as its proper object is the universe considered as a whole, synthesizes, or at least includes, the knowledge of the other sciences: its models can, in a certain sense, *figure* the episteme of an age—even if we consider cosmological inquiry as a mere region of a datable discourse, those schemas will remain valid: as reflections of other ones, generators of the episteme in question, *sinopia* of the visible fresco.

In the symbolic space of the Baroque—in that illusory space upon which page and canvas open, but also in the physical space, traversed by the symbol, of city and church—we would find the textual citation or the metaphor of the founding space postulated by contemporaneous astronomy. And in current artistic and literary production, we would find the expansion or stability of the universe presumed by today's cosmology, indistinguishable, now, from astronomy: we can no longer make observations without the data obtained sending us back, by its very magnitude, to the "origin" of the universe.

I

The Word "*Barroco*"

Any text about the Baroque gets underway by considering the word's origins. In criticizing this mania, the present text confirms it: this vertigo of genesis that grants excessive knowledge to philology and underscores its logocentric limits. The nature of things—one supposes, in proceeding thus, that they have one—would be written, substantially, in the words that name them: as a signified that even if forgotten still subsists. Thus, of the Baroque there remains the knobbly image of the large irregular pearl—from the Portuguese *barroco*—, the rough rock conglomerate—from the Spanish *berrueco* and subsequently *berrocal*—, and later, as if disavowing the character of the brute object, of coarse, unworked matter, *barroco* appears among the jewelers: inverting its initial connotation, it will now no longer designate the immediate and natural, stone or pearl, but rather the elaborate and meticulous, the finely chiseled, the goldsmith's fastidious effort. Subsequent, questionable attempts to establish its heredity have insisted on the sense of rigor, of patient assembly: *barroco*, figure of syllogism—precision of mental jewelry-making—; *Baroccio*, a mannered producer of madonnas.

Scholars have exhausted the history of *barroco*; only rarely has the persistent prejudice been denounced, one maintained above all by the obscurantism of the dictionaries, that identifies the baroque with the extravagant, the eccentric, and even the cheap, not to mention its most recent avatars, camp and kitsch. This rejection, innocently aesthetic in appearance, conceals a moral attitude:

> *Bizarrerie,* feminine noun: term expressing, in architecture, a sense of taste contrary to received principles, an affected pursuit of fantastical forms, one whose sole merit is the very novelty that constitutes its vice. [. . .] One distinguishes, in moral philosophy, between caprice and bizarrerie. The first may be the fruit of the imagination; the second, the result of character. [. . .] This moral distinction may be applied to architecture and to the distinct effects of caprice and bizarrerie that occur in this art. Vignola and Michelangelo sometimes admitted capricious details in their architecture. Borromini and Guarini were the masters of the bizarre style.[1]

To the history of the baroque we could add, as its punctual and inseparable reflection, that of its moral repression, the law, manifest or otherwise, that marks it as deviation or anomaly with regard to a previous form, balanced and pure, represented by the classical. Only beginning with d'Ors is this anathema tempered, or rather dissimulated: "If one speaks of illness with regard to the Baroque it is in the sense in which Michelet would say, 'La femme est une éternelle malade.'"[2]

To motivate the sign *barroco*, to give it a foundation today, without the operation entailing a moral residue: impossible, if the aim is semantic concordance, an agreement of sense between word and thing. Where an ultimate sense is instituted—a full and central truth, the singularity of the signified—there guilt and the Fall will have been instituted as well. To the mania of definition, the vertigo of genesis, we would oppose a structural homology between the paradigmatic Baroque product—the jewel—and the

form of the expression *barroco*:³ an analogy that links the referent up with the signifier, considering first the distribution of vocalic elements, and then its written form [*grafismo*].

"The word *baroque* has two clear vowels *set* nicely into it; they seem to evoke its breadth and brilliance":⁴ the support, then, is opaque, narrow; on that consonantal surface, mounted nicely, like pearls in their setting, the clear elements sparkle.

In that abrupt distribution of light, in that clean break whose edges separate, without nuance, the authority of the motif and the neutrality, the indistinction of the ground, there comes a herald of the zenith point of the Baroque: Caravaggism. Immediate contrast between field of light and field of shadow. Suppressing all transitions between one term and another, bringing opposites into dramatic juxtaposition: in this way—Aristotle's *Rhetoric* had already prescribed as much—one achieves greater didactic impact; to learn with ease is a pleasure consubstantial with man: one instructs by means of rapid syllogisms, without verbal ligature, putting subject and predicate in antithetical relation.

Encoded, then, in *barroco*, is the method, the mode, but also the first calling of that style, one that has been regarded, and not by happenstance, as related to the expansion of the Jesuit order: pedagogy, energetic expression that not only makes visible but "puts the matter right before one's eyes." Art of *sophistry*: its visual syntax is organized on the basis of unheard-of relations: hyperbole and distortion of one of the terms, abrupt night upon the other; nakedness, ornament independent of the rational body of the edifice, adjective, adverb that twists it, volute: any artifice imaginable in order to drive the point home, to demonstrate despotically. No vacillation, no nuance. *Anything in order to convince.*

—*Barroco*: amid the muted consonantal flow, the *a* and the *o*; the Baroque, like Ponge's *Abricot*, runs from *a* to *o*. *Barroco*,

> to the ear, opens and closes with a loop [*boucle*]: the letters *a* and *o*: the word folds back on itself in a circular figure, snake biting

its tail. Beginning and end are interchangeable. The titled word, in its scription, is the sensible image of this reversal, this turn. The figure of the loop [. . .] designates as much the activity of the letter [. . .] as it does its semantic effects—cycle of the seasons, gyration of the stars, forms of fruit—and their backstop: "meanings locked up with two turns of the key [*bouclées à double tour*]." This loop [*boucle*], if we are to believe the proofs furnished by etymology, is a mouth [*bouche*]: *boucle*, from the Latin *buccula*, diminutive of *bucca*, *bouche*. The figure of the loop, tied to that of the turn or trick [*tour*] (turn of the key, trick of writing, tumbler's turn) is overdetermined: it is to be found at a semantic crossing, a crossroads where writing, geometry, astronomy, rhetoric, music, and painting are all superposed, "closed up [*bouclée(s)*] in the form of the fruit" [. . .]. All these paths cross, inevitably, at this crossroads, they pass through the title's doubled letter, as in the circus lions pass—one after another—through the hoop held up, with manes of flame.[5]

Abricot/barroco: "It is in the eye of the letters that the theme of gold appears and gets criss-crossed: in the letter *O*, gaping loop of a mouth."[6] *Barroco* goes from the *a* to the *o*: direction of gold: from the loop to the circle, ellipse to circle; or in reverse: direction of excrement—gold's symbolic verso—from the circle to the loop, circle to ellipse, from Galileo to Kepler.[7] *Abricot*: sun seen in eclipse, *placé en abîme*; *barroco*: sun in the zenith—in the circular *o*—and then, double center—the loop of an *a*, the ellipse's double center—, one of which is the sun itself.

This transcription of the Baroque calls for its referent: one such, architectural, corresponds to it without remainder: the Chapel of the Holy Shroud by Guarino Guarini, in Turin, is the mounting for a jewel: the task was to find a *setting* for the stained shroud, for the face's imprint on the linen.

The chapel is subtly assembled: its structure is not limited to the naïve relation support/motif, but rather, fulfilling the Baroque's pedagogical vocation, it realizes this relation literally and

at the same time, repeating it, offers its metaphor in marble. The support and motif, that is to say, the baldachin and the chest it covers, the case for the Shroud, are reduplicated and covered in turn by a meta-concretion of the project, by the definition, on a higher, metaphorical plane, of the notion *barroco*: the black cupola, *visible* mounting, learned superposition of star-shaped structures, where, *precious,* the light has found its setting.

From its construction to the present day, the darkness of the chapel, the opacity of its materials, the lack of windows, and the use—considered excessive—of black marble have been the object of intrigue, criticism, and even mockery. The explanations to which historians have seen themselves obliged to take recourse in order to justify this somber structure are convoluted or else of a great symbolic density. One has perceived, in the plan, "an intentional contamination, at least in their affective signifieds, between the crypt and the cupola [. . .] the shroud of Christ, left behind in the moment of his resurrection, is proof of his humanity and his divinity. The association is thus altogether pertinent. Death and eternity are conjoined in the sacred cloth like the light and shadow in the luminous black chapel."[8]

This "key for interpreting the building" would anyway be implicit in the path that the faithful must follow in order to reach the Shroud: dark, steep stairs that accentuate the sense of effort, of fatigue, as though one would have to ascend on one's knees, as though, beneath the curve of the vaulting, one were ascending to Calvary.

Other equally symbolic readings have seen in Guarini's geometric diagrams and in his plans for the cupola evident analogies with horoscope "themes," of which the architect was fond, inferring from this that the distribution of luminous effects is governed by zodiacal configurations. One can also expatiate, with Wittkower, on the chapel's structure as an emblem for the dogma of the Trinity. Finally, in the very fact that the relic is displayed aloft in the apse one can read a political significance.

The members of the House of Savoy, in whom its ownership continues to reside, do not keep the cloth in the privacy of the palace but instead generously extend its beneficial effects, its irradiations, to the people, demonstrating with this "sumptuous reconstruction of the Holy Sepulcher of Jerusalem how false Luther's assertion was, that God takes no more care for that than he does for oxen."[9]

The approach that we are proposing here does not aim to confirm or refute the preceding ones. It is not a new interpretation, on the basis of a novel key, nor is it a fresh reading. Nothing prior or exterior to the building justifies it, no symbol; nothing is made to sustain the black architecture, nor is anything added onto it. Nothing seeks to clear away its opacity. What is postulated here is a *conformity* between this exemplary product of the Baroque and the word that designates it, *barroco,* a conformity that touches the word on two levels: its form of expression—the distribution of its consonantal and vocalic elements; the written form [*grafismo*] of the latter—and the symbolic site where it makes its appearance, the technical lexicon of jewelry.

If the Holy Shroud corroborates, in its signifying organization, the form of the expression *barroco* and the place of its appearance, there remains another mark, no less structural, of this emergence: the residue of a signified, a purely mechanical vestige, with no assignable link to its referent, *emptied out*: in Baroque poetry, the words designating the canonical materials of fine metalworking do not function as full signs but rather, in a formalized system of binary oppositions—antithesis is the central figure of the Baroque—, as "markers" bearing a plus or minus sign, that is to say, as pure *valences*: "The Baroque poet's predilection for the terms of fine metalworking or the jeweler's trade is not substantially expressive of a *profound* taste for the materials they designate. There is no need to go looking, here, for one of those reveries of which Bachelard speaks, in which the imagination explores the hidden strata of a substance. These elements, these metals,

these gems are made use of, quite to the contrary, only for their most superficial, their most abstract function: a sort of *valence* defined by a system of discontinuous oppositions, which sooner evokes the combinations of our atomic chemistry than the transmutations of the old alchemy."[10]

II

Cosmology before the Baroque

1. Geocentrism

There emerges in the *Timaeus* a metaphor whose ideological resonance will persist right up to the Baroque: the heavens as the place of the Ideas: the equator—plane of the fixed stars, which travel from east to west at a uniform speed, the greatest of all the celestial bodies—is the circle of the Same; the ecliptic—great circle of the annual rotation of the sun—is that of the Other. The two cosmic circles correspond to the two elements required for the functioning of the Platonic dialectic. The figure traced, in their motion, by the celestial bodies, living bodies, testifies to "the kinship between the perceptible appearance of the heavens and the intelligible structure of the Ideas."[1]

The demiurge takes pleasure in ideograms: that of the heavens is formed of two bands crossed over one another in the form of an X and curving back in such a way that their ends meet at a point opposite that of their intersection; the result is two circles sharing a center: exterior-Same-equator/interior-Other-ecliptic; the sky is also like an armillary sphere whose meridians are the ties that bind it to the world's axis. When a planet travels an arc of the ecliptic, that is to say, when it moves from west to east at its own angular

velocity, it is at the same time dragged from east to west by the regular motion of the sphere of the fixed stars. The planet seems to describe a curve, helix, or spiral, similar to that of the tendrils on the vine.

The cosmology on display in the *Republic,* an earlier one, "shakes up" the ideogram: converts it into a scene, turns the divine forces into deft Fates. The vision of Er the Pamphylian complicates the functioning of the concentric circles, maintaining them, however, as the natural and perfect form of the celestial bodies' motion:[2]

> He could see, at first from afar, a light like a rainbow's but brighter and more pure, which stretched through heaven and earth from one end to the other. From this light came the ties that bind the heavens, which are fixed to the axis of the world, like the undergirders of a ship. This luminous axis of the world is the "spindle of Necessity," which towers from top to bottom, from the ends of the universe, and around which the celestial revolutions take place. Now, this spindle consists of an axis of diamond, pointed at the ends and encircled by a whorl, itself formed of eight whorls or rings, differing in brightness and color, contained one within another like vessels of decreasing diameter. These rings spin at different speeds, in the direction opposite that of the fastest-turning, outermost ring, which Clotho drives with a movement of her right hand.[3]

In this vision, the rings correspond to the sphere of the fixed stars and to the spheres of the planets—including the moon—; at the center of this spectacle is the Earth, sphere imitating the sphere of the world.

It is not the perceptible heavens, it would seem, that are at issue here but rather "a mechanism fit for figuring the celestial motions, a planetarium for teaching purposes."[4] But above all: from this pedagogical theater—from this machinery, as polished and precise as an automaton—the text passes, imperceptibly, to the ideal, paradigmatic heavens.

The first cosmology is a mere didactic representation, a model. This reduction is a graph not only of the universe but also of speech—foreign speech: the tale of a Pamphylian—; two anteriorities, two exteriorities condition, then, the execution of this scale model [*maqueta*], which "gives no more than a cursory and inexact representation" but whose prestige would remain in force up to the time of Galileo.[5]

Two theaters, their scenes imbricated and consecutive, confront and counter one another, reciprocal reflections and yet asymmetrical, in the biunivocal space that stretches out—toward death and the tale on the one hand, toward the machine and the ideal heavens on the other—between the armillary sphere and the voice of Er.

The constitution of the cosmological model reposes on a tale, to which, in turn, it gives its structure. The exteriority indicated here—the "cosmos" of the foreigner has alien elements grafted onto it: Iranian, Zoroastrian—appears within the limits of another exteriority, which contains it: Er "returns" from death. He had been left behind lifeless on the battlefield, among the bodies of the defeated; "when the dead were taken up for burial ten days later, his body alone was found undecayed. They carried him home, and two days afterwards were going to bury him, when he came to life again as he lay on the funeral pyre. He then told what he had seen in the other world."[6]

On the other side, in the material—non-narrative—dimension of this double space, the first scene is constituted by the scale model—the armillary sphere—, the second by the celestial sphere, insofar as it is possible, on the basis of the first, to conceive a figure of the second unconditioned by the image, taken for deceptive, of the visible heavens, a figure not deformed by the mobile canopy of night and day but instead intact in the numerical harmony of its perfection. Reality does not contaminate this sphere; it reposes in the pure Idea, in the Pythagorean measure. And it is this conformity between the sphere—the armillary one, of wood and

Cosmology before the Baroque

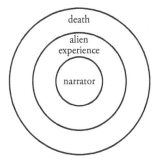 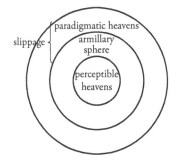

metal—and the Sphere—the heavenly one, paradigmatic—that permits, in the description in the *Republic*, a constant rhetoric slippage: their respective elements are exchanged, seem to become confused, as if uttered by a narrator inclined to distraction or clumsiness, or by a man who has just come back to his senses: the model's axis of diamond or metal becomes the brilliant light that stretches through the heavens, and in place of the meridians of copper or wood, there appear the luminous ties that bind the pole to the equator. It is as toponymic license that this slip comes to pass, not as conceptual imprecision: something sustains both spheres and permits the passage from the planetary "machine" to the heavens that are more real than any possible experience, permits the expansion, to the point where it coincides with what "only the intellect can imagine," of the pedagogical automaton: the faith in Numbers, in Forms. Plato's trust in ideal proportions was such that he took for mathematical laws the calculable cycles that govern the movement of the heavenly bodies and saw as shoddy, careless illustrations the heavenly bodies themselves.

At the center of the scale model–sphere, whether "packed, globed, balled up" around the axis or "oscillating, moving to and fro around it"—depending on the translation one adopts—is the Earth, little double of the celestial sphere.

The doubled theater of the *Republic* is structured, then, in two spatial systems, which, moving toward the narrative on the one

hand and toward the model on the other—toward the word and toward the object—, contain one another; topological *retombée* of the cosmos they postulate.[7]

Sustained by the Pythagorean stratum—or foundation—of Platonism, by the enthusiasts of Number, the cosmological reduction of the *Republic* and the *Timaeus* will achieve its fullest definition some centuries later: the *Almagest*, apogee of mathematical harmonies, Ptolemy's skillful composition, to which the Arabs gave its name and its authority. Everything is measure, music; all things are in concordance; each emits light or receives it, according to its place—embossed, geometric reality: chess—as in the stucco cupola star-shaped polygons, reflecting the fountain's continuous murmur, measure and abolish time: the Earth is at the center, fixed; around it, in perfect, which is to say *circular* and *uniform*, motion, the heavenly bodies travel, placed in their respective spheres.[8]

In Aristotle, spherical cosmology is confirmed. The universe is a system of concentric orbs: each has its proper motion. The outermost orb, which propels all the others, is that of the stars; that of the sun and those of the planets spin around the same axis; the sphere of the moon has its own separate axis. At the center of the whole mobile structure, the Earth. The action of the prime mover is exerted, far away, upon the outermost sphere, as can be seen in its uniform and perpetual rotation, a natural motion whose analysis will not transcend tautology: definition of a full and central signified by a paraphrase that designates it. To this motion there corresponds no prior changeable cause. Or rather, its cause vanishes into the unmoved mover, cannot be told apart from it. No Fate's hand drives us on. The system of rotation is as autonomous as it is eternal. What is often defined as theology is nothing but tautology.

Eighteen centuries in advance of Copernicus, an astronomer, Aristarchus of Samos, ventured a theory, precise and fated for

rejection, to which, today, we have nothing to add: Earth is a planet like the others and turns not only upon its own axis but also around the sun.

If Aristotle's ideological reduction—resting on an appropriate celestial mechanics—prevailed, eclipsing the heliocentric model, this is because, even though it added in invisible spheres, it maintained the spherical schema that corresponds to the overall appearance of the heavens and which our reason finds much more satisfying than the disorder of terrestrial appearances. Yet another argument shores up the Aristotelian system and the authority of geocentric cosmology: "The first physics, that is, the first coherent rational theory of natural phenomena that was constructed, was almost exactly in agreement with it and in disagreement with the other hypotheses, notably that of Aristarchus."[9]

2. The Geometricization of Space: Copernicus/Uccello

The order of spheres, flawless: this eurythmia remains intact. Copernicus disturbs it: his is not a scientific deconstruction, only a radical deposition of the center.

The system of spheres, together with their motions, persists, but with a different axis—the sun. The earth, which has lost its power of absolute reference, no longer usurps the center.

The Copernican ouster—resurrection of Aristarchus' program—destroys the Ptolemaic superstructure, energetically unsettles the model set down by Platonic tradition, although not its epistemological foundation: it decenters, institutes, after its fashion, a relativity of centers, but it leaves untouched the area that encompasses them. In regarding the outermost sphere, that of the fixed stars, as situated at an "incommensurable" distance, Copernican cosmology dilates the fundamental structure but respects its basic constitution. The system is modified, not overthrown; this is not revolution but reform.

This modification can be interpreted as a metonymy—a displacement of the center of attention, a slip of the gaze toward the

contiguous—in the symbolic topology of the ancient cosmos; its metaphor will be Galileo.

The universe has a center, although the sphere of the Cosmos grows wider, effacing its contours. All that remains is for it to become infinite.

De Revolutionibus prefigures Galilean thought in preparing the *material metaphor* that will constitute its nucleus. This prefiguration—the first that passes from the text to the symbolic field—its first *retombée*—is to be found in the response that Copernicus makes to the Aristotelian argument regarding the immobility of the Earth. In order to demonstrate that the Earth is fixed, Aristotle invokes the motion of bodies separate from it: the flight of birds, the gliding of clouds, the perpendicular fall of heavy bodies. Motion is a process that affects what moves, expresses its nature and has its existence in the moving body itself. If the Earth were in motion, a body let drop from the top of a tower would never touch the ground by its base; a stone thrown straight up in the air would never return to the exact place from which it departed; a cannonball falling from the top of a mast would never fall, if the ship is moving, at its foot.

> But what do we say about the clouds and other things suspended in the air, and about things which fall or those which, on the contrary, tend upwards? Quite simply that it is not only the earth, together with the element of water which is connected with it, which move thus [i.e., naturally] but also a considerable part of the air and everything else which has the same relation as it has to the earth. Either the air which is close to the earth, mixed with earthy and watery matter, has the same nature as the earth, or the air's motion is acquired and shared without resistance because of the contiguity and the perpetual motion of the earth. [. . .] This is why the air which is closest to the earth appears to be at rest, as do things suspended in it, unless they are moved about by the wind or by some other force. [. . .] As for falling and rising things,

we believe that their motion must be double in relation to the world, and must in general be composed of both rectilinear and circular motion [joined "as the illness to the animal"]. Because things which are drawn downwards by their weight are the most earthy; now it is certain that the parts keep the same nature as the whole. And it is for the same reason that this happens to things which are drawn upwards by the force of their fiery nature. For terrestrial fire is above all nourished by earthy matter; therefore it is said that flame is nothing but burning smoke.[10]

What is important in this reasoning is that it applies to terrestrial phenomena the laws of "celestial mechanics": the division of the Cosmos into supra- and sublunar regions is implicitly abandoned.[11]

Movement frees itself from the bodies that had contained it, it becomes autonomous. Moreover, the Cosmos begins to disarticulate itself, space begins to become homogeneous—geometrical—, to move toward the infinity of Bruno's universe, abolition of privileged place and direction, the open set, held together only by the unity of its laws, soon to displace the notion of the Cosmos, the closed, hierarchical entity.

It is this undifferentiated space—extension, Archimedizable object—conducive to ordered division and to the metrical distribution of figures, that serves as support to the checkerboard floor of Renaissance interiors, tiling, lines that, meeting at the horizon, codify and regulate the measure of bodies; marble, gridded surface devoid of cracks, from Uccello to Picasso: like that of Copernicus, the space that permits the construction of perspective is ordered, finite and closed.[12] "The painter deals only with visible things, things that—as Kepler, again, puts it—can be seen by their extremities, and each of which must find the place that belongs to it as a function of its importance and its role in the *istoria*; and even if, in the new depth instituted by trompe l'oeil, quantities regularly diminish *quasi per sino in infinito*, the vanishing lines

still converge at a visible point, the point that—once again—seals the closure of the system,"[13] in the specular coincidence of the vanishing point and the point of view.

In the geometrization of space as the basis of representation, of perspectival figuration, we detect an epistemological effect, a *retombée* of the Copernican reform; another such effect is the construction of the cupola of Santa Maria del Fiore: "For the first time employing mathematical calculations to resolve a technical problem—how to cover a space so vast that the use of scaffolding was ruled out—Brunelleschi replaced medieval procedures of trial and error by a rational method founded upon the geometrization of space and the assimilation of the architectural space to Euclidian space."[14]

Just as the sun, the earth, and the concentric spinning spheres all the way to the fixed stars are classed according to their situation in the Cosmos, so perspective catalogues figures, classifies them by their dimensions and relations in the fictitious depth of the canvas. Its power of distribution is that of a hierarchy of functions. Illuminating-illuminated sun out in front of the foreground, the eye; and, in the background, the convergence lines meet, the farthest point of space and the eye's virtual obverse: marked by a hollow, a fixed star.

The "prime mover"—Aristotle's more comprehensive name for Clotho, the Platonic Fate—imparts directly upon the Heavens a motion of uniform, natural, and eternal rotation; indirectly, filtered through the celestial strata and thus attenuated, this impulse works upon the Earth, but inexactly, as if blurred, "for on earth phenomena are less regular, less well ordered than in the heavens; they depend partly on chance, which is to say that they partly elude reason."[15]

The Copernican reform and the submission of space to the law puts an end to this conception of the Earth as a zone favorable to chance phenomena, to the discreetly irrational. The planet will cease to be a blurry scene where the scene of the heavens finds its

artless duplicate, the precinct of obscured, of overcast phenomena—overcast, as one says of the sky. At the same time as it postulates the Earth's marginality, the Copernican cosmos, heliocentric, asserts its autonomy: it reflects nothing outside itself, it is not a region; what occurs in it is not a degraded repetition. No ideal sphere is its model.

The *retombée* of this epistemological gesture—its mediate preparation, its unlinked etiology—is to be found, rigorous isomorphism, in the radical transformation of meaning that occurs in urban space and, especially, in the discourse that articulates and thereby objectifies it:

> The Italian fifteenth century produced, with regard to the city, an original discourse, because the city ceases at that time to be regarded as the reflection of a divine city, as a residence in exile, and because, for the first time since Antiquity, it becomes again possible to take interest in human creations and necessary to probe their rational foundation, more precisely because the city comes into view as a zone of creation, a place of creativity. [. . .] Illustrating the birth of a new *episteme* with the same status as philological research, the reflection on art, or historical realism, but also the discourse on hygiene and the first attempts at planimetry, which develop in parallel, this discourse establishes a first objectification of the urban.[16]

As will come to pass with the space that serves as its support, the city ceases to be a reflection; as will later befall bodies and places, it becomes representable, *ergo* measurable: first, in the space left behind by the gradual disappearance of the celestial image, imaginary cities get sketched out; the nascent code of figuration dares not alight upon entirely real, terrestrial objects, or these, on account of their density of information, are resistant to the law, to representation. Next, a single pattern[17] (exterior wall, central dome, towers: the legible city, in sum) subjected to almost imperceptible deformations can represent, arbitrarily, a variety of cities; the template need only be altered in a pertinent feature.

Finally, planimetric representations of real—defensive—sites are produced; rather than maps of the urban system, these are enumerations or graphic catalogues of fortresses.

Alberti introduces into the space of representation a geometrization analogous to the one that, from Copernicus to Giordano Bruno, will take effect little by little in astronomical space: he creates the ground plan, uses longitude and latitude to assign buildings their precise locations within the city.[18] Leonardo associates measure, coordinate vision, with the global view: with the spoken city, the measured city appears.

To measure, to situate: to indicate a point of reference or spatial unity exterior to the object thus coordinated. Thus earth and space will be localizable entities: the standard, the center will be expelled to an outside from which it will govern seasons and movements. Life and limit, heat and measure, are imparted from the exiled center.

Later, the proclamation of the infinity of the universe by Giordano Bruno will entail the total survey of a space without privileged places or directions, but already the heliocentric system of Copernicus, solar unity, along with its graphic correlate, the map, postulates and practices a measurable, geometrized space.[19]

The city ceases to be an imperfect double, a reflection: terrestrial existence is no longer considered merely a stage on the way to celestial life: *man the measurer* is not just passing through, his life is not a forgettable prologue, it is worth taking the trouble to improve it, to prolong it: *De vita longa, De triplice vita*—Ficino—, *Trattato della vita sobria*—Cornaro—, *Liber de longa vita*—Paracelso.

With the heliocentric universe, hygiene emerges, manuals and treatises proliferate: *the center is exiled, Man sets up shop.*

The geometrization of the universe, that "migration of metric space, which comes to be displaced from that exact place where it lived apart, into the marrow of nature itself"[20] will precipitate in parallel, as the conclusion and foundation of its laws, a sense

of geometry as axiomatic speculation, as discourse that enunciates its own rules and at the same time breaks free of any empirical bond of visibility. Subversion of the classical language: nonphonetic notations can reduce to a formula the constitution of the most complex structures; geometry ceases to be "a means of reducing the complexity of natural experience to a few fundamental forms, becoming instead a means of extending to ever vaster fields the rationalization of visual consciousness."[21] Orthogonal projections and the foundations of projective geometry are studied; with analytic geometry, the convertibility of geometric into algebraic problems is demonstrated; geometric magnitudes are represented as aggregates of primitive elements, the *indivisibles*, which the fluxion brings to life, and from whose sum the rules for the calculation of the area of curvilinear figures are derived.[22]

In line with this reduction, but also its obverse, an expansion in another place inverts it: the development of the nuclei that govern the process of projection: there, bodies and volumes were concentrated into formulas, flattened onto the surface of the page; here, the simplest geometric forms, juxtaposed or intersecting in planimetric matrices, engender bodies and volumes: syntactic combinations of simple units, which at a light touch—like crystals in kaleidoscopes—refract and subdivide, develop, reverberate, enlarge and burst apart. The best illustration of this process is provided by Borromini. San Carlino is generated from a geometric schema constituted by simple units—which we might call planimetric morphemes—: four intersecting equilateral triangles that produce, in their intersection, first the oval of the cupola and then—thanks to the introduction of a second morpheme, the rectangle—the curve of the apses and the placement of the columns. Sant'Ivo: generated, in a similar fashion, from a triangular base. The symbolic implications of these primary figures are, it must be said, of scant importance—the Trinity in San Carlino, hope and industriousness in the heraldic bee formed by the triangles of Sant'Ivo—; what matters is the manner of their assembly:

the moment of production, of germination, taken hold of in the thickness of the plane and whose interlacing belongs to the interior of the language—a moment that, transposing a dichotomy put into practice by Julia Kristeva, we could call geno-plane, *planimetria operans*, as opposed to the pheno-plane, constituted by the *planimetria operata* of the design to be constructed, the fixed schema.

3. Matter: Galileo/Cigoli

Galileo's metaphor is that of corruption.

The rupture that breaks up the well-oiled action of the spheres is that of degraded—fallen, mute—matter: the sun is not a polished, uniformly brilliant globe—gold sheeting of the Byzantine disk; orange circle of the Flemish—it is stained; the moon is not smooth, not a small white poreless sphere: like the earth, it is irregular and mountainous. The Milky Way is not a single heavenly body, resplendent and continuous, but a vast conglomeration of stars. Jupiter, in its movements, comes with "moons" in tow: the matter from which the celestial spheres are formed—these apparently impeccable and unveined bodies, revolving in space—does not differ from the kind clumped together into Earth. It is constituted in the same way, in the same way *corruptible*.

Homogeneous matter: the same mathematical and physical laws are applicable to the phenomena that occur around us and to those that take place in celestial objects; Aristotelian physics, founded on this difference and thus also on the filtering or deformation that the Earth imposes on the perfection of movements, reveals itself to be unworkable: no cosmic space divided by qualitative differences but instead a universe, indefinite and without regions; the concrete space of physics is as continuous as the abstract space of geometry.

The observation of the second nova—in the constellation Serpentarius—, and that of the moon, permit *Sidereus Nuncius* to proclaim the metaphor of corruption.

Its first *retombée* appears in the most severe iconography of the Renaissance: the representation of the Virgin. The slipping of the scientific *datum* into a marginal detail of the emblematic Renaissance image illustrates not so much an isomorphism as the *first-degree* transposition, naïve and citational, of an element belonging to a de-constituting symbolic network (the Galilean scientific discourse de-constitutes the epistemology of the cosmos in order to found that of the universe) into a symbolic space constituted indirectly by that same network: the discourse of the fine arts.

A friend of Galileo's, the Florentine painter Ludovico Cardi, il Cigoli, who in his own right had carried out significant observations of the sunspots, illustrated, only two years later and in the most literal fashion, the observations made in *Sidereus Nuncius*: in 1612, in the Pauline chapel of Santa Maria Maggiore, in Rome, he painted a Virgin of the Assumption. In accordance with the subject's iconography, her feet rest on the moon, but a moon—like the one photographed by Apollo—riddled with craters, mountainous and arid, callused, rough. It is the moon of Galileo that, as a textual citation, crosses past reported observation, empirical literalism, and bursts into representation.

This transposition is in yet another sense exemplary: beneath the literalized signifier—the observable moon—the subversive power of scientific discourse, its rupturing energy, saps the foundations of the signified imposed by iconography: the Moon ceases to be *an immaculate circle, epiphany of heavenly purity*, becoming instead *a worm-eaten sphere, representing the corruptibility of matter*.

4. The Circle: Galileo/Raphael

To make matter homogeneous, space Archimedean: Galileo, observing, retraces, erases, but does not manage to formulate a modern cosmological theory, to reject the Aristotelian postulates.

Koyré judges that "the astronomical part of the *Dialogue* is particularly weak. Galileo completely ignores not only Kepler's

discoveries but also even the concrete content of the works of Copernicus. The heliocentrism offered us here by Galileo is of the very simplest form (the sun in the center with the planets in circular motion around it), a form which Galileo knew to be false."[23]

Galileo's fidelity to the Aristotelian tradition, his stubborn adhesion, can be summed up in the persistence, spanning his discourse, of the notion of the *natural*, confounded with that of the *rational*; the Baroque will be extravagance and artifice, perversion of a natural and balanced—moral—order. For the Aristotelian dichotomy natural/violent, as applied to motion, the repressive routine that begins with the moralizing interpretation of the Galilean text will gradually substitute the opposition natural/artificial.

For Galileo, there is one sole *natural place*: the center of the world; there is also one sole *natural motion*, motion toward the center according to the Aristotelian law of heavy bodies—from which Copernicus had broken free—. Only movement downward, *deorsum*, is natural, because it has a natural terminus; movement upward, *sursum*, is unnatural. All bodies are heavy; thus this motion is violent and has no natural end: one can ascend indefinitely.

This assertion of *De motu* dovetails with another one in the *Dialogue*, an assertion that completes it:

> Rectilinear motion is impossible in reality. There can be no natural rectilinear motion. "Straight motion being by nature infinite (because a straight line is infinite and indeterminate), it is impossible that anything should have by nature the principle of moving in a straight line; or, in other words, toward a place where it is impossible to arrive, there being no finite end. For nature, as Aristotle well says himself, never undertakes to do that which cannot be done, nor endeavors to move whither it is impossible to arrive."[24]

If all cosmic bodies are mobile by nature, their motion cannot be anything but circular. A body in rectilinear motion grows ever more distant from its point of departure; if such movement were

natural, it could be deduced from this that, from the beginning, this body was not in its natural place and, in consequence, that the parts of the world were not disposed in perfect order. Seeing as they are, it is impossible that they should be required by nature to change place and thus to move in a straight line.

The circle, which does not move a body further from a given point, is the privileged physical line; the straight line is not. A conclusion to which we are led by a simple line of reasoning:

> On a horizontal plane of this kind (i.e., a geometrical one), on the earth, for example on a plane tangential to the earth's surface, a heavy body would be in quite a different situation [than if it were on the horizontal plane of Archimedean geometry or physics]. For in moving on such a plane it would move away from the centre of the earth (or of the world) and consequently would be raising itself. Its motion would therefore be violent, and would in fact be comparable to that of a body going up an inclined plane, i.e., on an upward-sloping plane. Therefore not only would it not be prolonged indefinitely, it would, on the contrary, necessarily come to a halt. The only real motion which would be neither natural nor violent, the only motion which would neither raise nor lower any weight, the only motion which would not take the body away or towards the centre of the earth (or of the world), is motion along the circumference. Consequently, it would be a circular motion. In other words, the *real* horizontal plane is a *spherical* surface.[25]

For Galileo, the priority of the spherical surface serves to maintain one of the residues of the cosmic order, the concentric disposition of the elements. Heavy bodies are situated where there is least room for matter—in the center of the globe of the Universe—; the lighter ones are grouped in strata around it.

Galileo holds fast to the circle and thus to the notion of the natural consubstantial with it in Aristotelian tradition; the fetishization of this figure partakes also of the mirage arising out of the last, mechanical readings of this tradition: the mirage of

similitude, which runs from *convenientia, aemulatio*, the analogy and the play of sympathies—in the sixteenth century still the semantic web of the similar—up to the "correspondences" of Breton, final fulguration of this prestige. The authority of similitude, in its most deeply rooted variant—Man/Cosmos; Microcosm/Macrocosm—is fully operative in Galileo: the members of the human body, he had observed, describe circles and epicycles in their rotations around the concave and convex joints; the planets, then, must trace these same figures in their trajectory around the sun.

If the moon of Santa Maria Maggiore is a literal (first-degree) transcription of the *datum* furnished by *Sidereus Nuncius*, two levels of *retombée* are inscribed in the work of Raphael, two planes on which the scientific model is converted in symbolic space: the first, in evidence throughout his work, and earlier in the work of Perugino and Pinturicchio, could be considered an *analogical*—second-degree—*retombée*.

The circle—as has been remarked by Charles Bouleau—will never again be used with Raphael's exactitude. His predilection for "the simplest and most perfect [. . .] figure"[26] was such that, aside from the *tondo*, an ancient form that he took back up masterfully, he frequently inscribed one or even several circles into the rectangular space of his Madonnas, whose lines follow their contours. The same schema serves for the treatment of other themes. The circle organizes the entire composition, requires other figures to find their place within it, emblematic form, sole reflection of order. One circle: the *Bridgewater Madonna*; the *Deposition*, in Rome. Two equal, intersecting circles: the *Ansidei Madonna*, in London; *the Marriage of the Virgin*, in Milan; the *Mond Crucifixion*, in London; the *Triumph of Galatea*. Two concentric circles: the *Madonna del cardellino*. Three circles: *La Belle Jardinière*, in the Louvre; the *Madonna of Foligno*. The great fresco of the *Disputation of the Holy Sacrament* is ordered by circular arcs whose center lies, high up, beyond the limits of the work; finally, three

tightly overlapping circles structure the complex organization of the *Transfiguration*, in the Vatican. Each of the figures, despite the spontaneity of its gestures, the freedom of its depiction, is inserted into this geometry with perfect rigor and, in yielding to that geometry *naturally*, without effort, vouches for the generating circle: for eurhythmy as its implicit quality, for its theological power.

The third level, *metaphorical*, is present in the last works of Raphael: the circle of rotation performs its organizing function, but apart from that its effect is one of symbolic motion—movement equidistant from the center of reason—: one "feels" the rotation in the Sistine Madonna "the way one feels," in the *Disputation*, the "rotation" of subjects around the center that is "truth."[27]

5. Allegory: Galileo/Tasso

The tyranny of the *natural* forces Galileo to proclaim himself an agent of *terror*, as the tradition in question has been called:[28] the moral and denotative tradition that considers rhetorical figures tantamount to a perversion of the natural course of a narrative, a tradition whose space extends from Saint Thomas to the early Robbe-Grillet. Using arguments that could serve as models for the resistance to the Baroque, Galileo advocated against allegorical poetry, and in particular against Tasso's. Allegory forces spontaneous narration, "originally perfectly visible and designed to be seen face on," to adapt itself to "a meaning aimed at obliquely and no more than implied";[29] allegorical poetry obscures the original meaning and deforms it with its convoluted and useless inventions like "[t]hose paintings which, observed sideways and from a predetermined point of view, show us a human figure, but one constructed in accordance with a rule of perspective such that, when seen from in front, as is natural and usual for other paintings, presents to us nothing but a confused and disordered mixture of lines and colours in which, with much application, one may form an image of sinuous rivers and roads, deserted beaches, or clouds or strange chimeras."[30]

Anamorphosis appears then as the perversion of perspective and its code—show from in front, see from in front—, in the same way that allegory appears as the degradation of natural narration.

What Galileo condemns is not just the marginal allusion to something else—faces in the water, sinuous roads; a virtual beneath a present sign—but rather the fact that to perceive it the spectator must displace himself to a given point, the point where, "[t]hrough this variation in the writing, it reveals the limits that the code imparted to perspective construction, and the prohibitions that govern its 'normal' functioning. Rather than annihilating the system, anamorphosis works at its systematic deregulation, and does so—it must be emphasized—using the means of the code itself, which is defined as a regulator."[31] If Galileo's reproach against allegory and anamorphosis constitutes a formal rejection of polysemy—support of the Baroque—, then his rejection of the anamorphic image, straightened out by means of a displacement of the point of view and the adoption of a second, lateral center, reveals a phobia of decentering, as if this decentering, "the possibility of which is recognized from the start by the 'code,' could only operate within very narrow limits beyond which the image will seem to disintegrate although it has, in truth, merely been *transformed*."[32] The exclusion of decentering, the censure of that marginal point through which the perspectival code reveals its factitiousness, its flaws, and, breaking the continuity of its contours, throws into disarray the system of linear perspective, the appropriation and ordering of reality: do we not see here, in yet another guise, Galileo's stubborn adhesion to the single center—the circle—and his aversion to the ellipse's double center?

Tasso's tale, thus Galileo's assertion, more closely resembles a piece of marquetry than an oil painting: *precise limits,* absence of relief, *elements too numerous* and merely juxtaposed, as if the poet had wanted to *fill in all the empty spaces systematically.*

For Damisch, this critique demonstrates the nexus that exists between the procedures of allegory and an artisanal practice—marquetry—that was associated, in its beginnings, with the establishment of the perspectival code.

Precise limits, elements too numerous, the desire to fill in all the empty spaces systematically: in his characterization of marquetry, Galileo unwittingly formulates the prejudices against the Baroque.

One is canonical: horror at the "horror of the void," fear of that uncontrollable proliferation that covers the support and reduces it to an uncentered *continuum*, a dense texture of signifying matter with no interstitial space for the insertion of an enunciating subject. The horror of the void expels the subject from the surface, from the *multiplicative extension*,[33] in order to indicate in its place the specific code of a symbolic practice. In the Baroque, poetics is a Rhetoric: language, as autonomous and tautological code, does not admit into its dense, its *overloaded* web the possibility of a generating *I*, of a centered individual referent, one that would express itself—the Baroque runs on empty—, that would orient or halt the flood of signs.

Marquetry is also *citation*: juxtaposition of different textures, of contrary grains: precise contours, an absence of relief: Baroque mimesis.[34] More than the depth of the landscape, the geometry of instruments, or the volumes of fruit, what marquetry shows, combining heterogeneous segments, is the varnished artifice of trompe-l'oeil; pretending to denote something else, marquetry indicates—upon itself—the conventional organization of representation. Likewise Baroque language: a turning back upon itself, the mark of its own reflection, the *mise-en-scène* of its own theatrical props. There, the adding up of quotations, the multiple emission of voices, denies the possibility of a single, natural broadcasting center; pretending to name, it erases what it denotes; it annuls: its meaning lies in the insistence of its play.[35]

The stress falls, in marquetry, less on the work itself than on its *operativity*—this, whether or not trompe-l'oeil is employed; less on the imitation of a canonical work—or illusionistic reproduction—than on production as the mimicry or activation of a *code*. Thus it metaphorizes, above all, metaphor itself, signifier one of whose connotations is the Baroque, art of

> making *tout court*, making *in accordance with rules internal to* the making itself. But *making* means *signifying*. Metaphor, which intervenes in signification, prolongs and suspends it, is the model by means of which the Baroque system finds it most convenient (easiest, most necessary) to describe, invent, plan, institute this autonomous making, bound by no prior decision, this making for the sake of making, a making that makes the *what* and the *in what way* that renders the literary message possible (the aesthetic message in general) and guarantees the meaning that this message is able to communicate to us [. . .]; Metaphor—in the metalinguistic description given to it by the Baroque—is not charged with metaphysical and cognitive intentions but instead represents the moment of excellence (and ostentation) in the operativity into which Baroque ingenuity resolves.[36]

This band of isomorphisms *allegory-anamorphosis/allegory-marquetry/marquetry-(citation)(saturation)(Baroque metaphor)*, closes around a nodal generating image: the circular rotation of the Galilean system: metaphor is transfer, the shift par excellence in rhetoric, the passage of an (inalterable) signifier from its "original" chain to another, noncontiguous one, and out of whose insertion the new sense arises—logocentric figure: it supposes that there is meaning and that it is displaced, but even within this displacement logocentrism comes out unharmed insofar as there subsists a proper sense, a center: figure of conservation.

Like metaphor, circular rotation is the only translation of bodies that guarantees their changelessness, the invariability of their distance from a center that puts them into motion and determines

their nature; this displacement permits, as in symbolic space, the production of sense: the functioning of the—rhetorical or solar—system.

Metaphor/circular rotation: sense and planets remain self-identical in the pre-Baroque universe: everything turns without changing, everything is translated, always at an equal distance, around a resplendent center—the Sun, the Logos—with no change, in this displacement, to their identity. *Metaphor is the* retombée *of the circle—the circular orbit—, as the ellipsis is that of the ellipse—of the elliptical orbit—*: Baroque space is the space of Kepler.

III

Baroque Cosmology: Kepler

Such is the theological connotation, the iconic authority of the circle, natural and perfect form, that when Kepler discovers, after years of observation, that Mars describes not a circle but rather an ellipse around the sun, he attempts to deny what he has seen; he is too faithful to the conceptions of ancient cosmology to strip circular movement of its privilege.[1]

The three laws of Kepler,[2] disturbing the scientific basis on which all the knowledge of the age rested, create a point of reference in relation to which, explicitly or not, all symbolic activity is situated: something is decentered, or rather, it doubles its center, divides it into two; the master figure is no longer the circle, single-centered, radiant, luminous, paternal, but rather the ellipse, which opposes to the visible focus another one, equally operative, equally real, but sealed off, dead, nocturnal, the blind center, obverse of the germinating *yang* of the sun: the absent one.

This double focalization takes place within a space that remains delimited—by the sphere of the fixed stars—, a cavity containing the earth, the sun, and the planets, a space that—however far the stars may seem—is finite. The thought of infinitude, of what is

without center, without precise places or densities, the thought of Baroque topology, traces its border, logical limit.[3]

The thought of finitude demands the impossible thought of the infinite as the *conceptual closure* of its system and the guarantee of its functioning. The threat of the inexistent outside—the void is *nothing* for Kepler, space exists only as a function of the bodies that occupy it—, the outside of the universe, the outside of reason—the unthinkability of nothingness—, governs at the same time the closed economy of the universe and the finitude of the logos. Conversely, the "immense empty center, vast cavity" of our visible world, where the planets trace around the sun the concentric ellipses of their orbits, demands its *physical closure* in the "vault" of the fixed stars.

Rather than consider the ellipse a finished, paralyzed form, one would have to liken its geometry to a given moment in a formal dialectic: multiple dynamic components, projectable into other forms; generators. The ellipse, conceived of as definitive, could in turn be decomposed, turn into other conics; it could be reduced to the interaction of two nuclei or the scission of a central one, which disappears; to the dilation of a circle, etc. These moments, by definition, know no closure: geometric form would, on this reading, function as a "mobile *gramme*."[4]

We shall situate the *retombée* of the ellipse, but not only as a representable mark, attending to the register that constitutes it as such, geometry and the figurative arts. We shall also project it into another space, that of Rhetoric, to show, through this displacement, the coherence of the logos that, as difference, generates the two versions of the *figure*.

A projection of the *conics*, their insertion into another discourse—that of Rhetoric—would demonstrate this coherence in the grammar of the Baroque: *the ellips(e/is), the parabola/parable, and the hyperbol(a/e) belong to both spaces:* that of geometry and that of rhetoric. It is not by chance that Aristotelian tradition

names and distributes these *figures* that assert, in their coinciding names, the compactness of a single logos.[5]

1. Decentering: Caravaggio/The Baroque City

The *retombée* of Keplerian cosmology can be situated, if we read the ellipse as decentering and "perturbation" of the circle—with all the theological resonances it involves—, in one precise moment: the geometric organization of the canvas, its internal structure, becomes decentered—ex-centric—; the gestures, in their excess, can no longer fit themselves into a circular rotation of elements around their axes, a rotation in line with Galilean cosmology, with the circular rotation of the planets. These gestures have dilated, grown broader, their curves are as "imperfect" as the porous, lunar matter of the bodies that execute them. Starting from the top—from the upper right corner, for example, in Caravaggio's *Entombment of Christ*—, an abrupt movement throws the figures depicted off balance, forcing them toward the lower left—Bouleau calls attention to the connotations of the word *sinistra*—; weight degrades them, gravity tears them away, as it were downstream. The solar center (the circular *charpente*), golden, singular, no longer draws them in magnetically or brings them into order; they drift, they fall or rise, they flee toward the edges. "Brought down, debased," they inhabit our space now: callused feet, rumps, rags; the clinking of coins or the snap of a whip overtakes us. Theological decentering, theological Fall: the saints are incarnated among the Roman plebs, the scene of the miracle is a tavern; the model for the virgin's lifeless body is a dropsical cadaver.

This decentering—the annulment of the single center—has its repercussions in the symbolic space par excellence: urban discourse. The Renaissance city is Galilean, inscribable in a circle; its plan alludes to an explicit anthropomorphic metaphor, and also to the cosmological metaphor that serves as its substrate: that of the heliocentric universe. It matters little, at the level of the Renaissance *episteme*, that the center has been displaced from the

earth to the sun: something unifies the two systems, endows them with their infallibility and equilibrium: the full and structuring presence of Man:

> For the architect-theorists of the Italian Renaissance, buildings and cities have to be conceived on the model of animate bodies, the most perfect among which is man's. Their organization will thus be dictated by the same harmonic relations, the same rules of proportion that join the parts of the body to one another and to the body as a whole. The center of the body and the site of its meaning cannot yet be the heart, motor of a hidden process of organization. This will be discovered much later: for now, it is the umbilicus. For Francesco di Giorgio Martini, this navel of the city is constituted by the main plaza, around which are clustered the cathedral, the Prince's palace, and a series of institutions. Alberti and Filarete, too, compare the city to a body with its bones, flesh, skin, and limbs. For all these Neo-Pythagorean authors, the center of the city—a city ideally inscribable in a circle—draws its value equally from its geometric and its metaphysical properties.[6]

This centered space is semantic: it provides redundant information regarding the known set of social structures and promotes the integration of the individual into them. In the omphalic city, *lodging*, ethological insertion, is also a *dwelling*, symbolic insertion; the Galilean city functions, as far as its semantic space is concerned, like the primitive village: the hut's position confers and expresses an economic status, a ritual activity, and even regulates the possibilities of conjugal selection. The village and the pre-Baroque city do not merely situate man in the interstices of their circular and motivated system, but rather in so doing they guarantee him a relation to the universe—or to the space of the dead—, they insert him into a signifying topology, into a spacing [*espaciamiento*] within which the distance from the navel, from the constitutive maternal anchoring, is emblematic: there, to live is to speak.

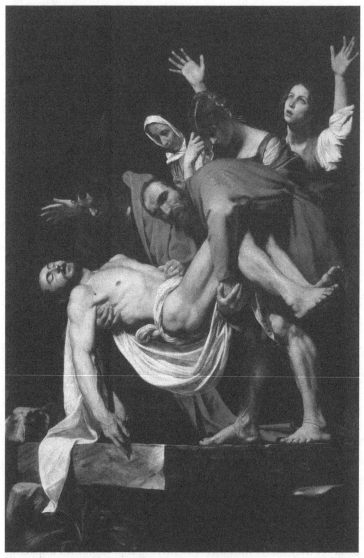

FIGURE 1: Caravaggio, *The Entombment of Christ*. 1600–4. Oil on canvas, 300 cm x 203 cm. Vatican Museums. Source: Wikimedia Commons. CC BY-SA 4.0.

Pre-Baroque urban discourse, even the most reformist or critical, always operates on a logic of "centering"; its distribution is motivated. Thus the Sistine reform arranges signifying edifices in relation to a single monument—Santa Maria Maggiore—and merely "adapts to the situation, orographically complex and conditioned by its pasts, the radial plan of the utopians";[7] the Baroque city, in contrast, presents itself as an open texture, one that cannot be referred back to a privileged signifier that exerts upon it its magnetism, gives it meaning: Pietro da Cortona "extends architectural discourse into the surrounding urban scene and thus expresses, in the clearest way, the new conception of the monument as an element of a continuous fabric, with which it combines dialectically."[8]

Decentering: repetition. Let nothing disturb the insistent uniformity of façade and ornament, receding toward the horizon along straight convergence lines, as in the perspective of Renaissance landscape painters. Let nothing interrupt the syllogistic continuity of the urban text, its sidewalks and cornices, just as nothing, from the minute to the immense, breaks up the lithic continuity of mensurable space, or that of time, perpetual succession of identical instants, unrelated to the experience of living: a clock ticks it out in every bourgeois living room.

Perspective, time, money: everything is measure, quantity, repetition; everything can be analyzed, broken apart: the body into organs, morality into cases—the Jesuits codified them—, commerce into operations of calculation and bookkeeping, gold into uniformly calibrated and minted coins; land into precisely delimited states; architecture into its five orders; the city into fragmentary units, reducible to geometric figures: avenues that advance, unmeandering, toward no matter where; what matters are the series, the obsession with alignment, the repetition of columns and moldings and even of men who, likewise identical, imperturbable, mechanized, make their way down the avenues, dressed in their Sunday best for the military parades. "The act of passage is more

important than the object reached: there is keener interest in the foreground of the Farnese Palace than in the gawky façade that caps the hill."[9]

But the insistence on rectilinear uniformity is not only a contempt for the monument that terminates the series—reduced to a triumphal arch or to a mark of the lines' convergence at the horizon, reduced to a confirmation of the functioning of perspective—, but also a suggestion of movement, of speed. Baroque: space of the journey, transit of iterations.

The city, which institutes the quantifiable and the repetitive, which gives, in its syntax, the metaphor of an infinity articulable into units, establishes at the same time the unexpected and as if theatrical rupture in that continuity, insisting on the unusual, valorizing the ephemeral, threatening the perpetuity of every order.

Everything can go on and on—the constitution of things permits as much—, *ergo,* everything can bore. Nearly hysterical apotheosis of the new, of even the outlandish: obelisks, *grotesque* fountains to subvert the monotony of the avenues, ruins or fake ruins to deepen and deny the past, mute riverbed, for "it is in the imprint it has left on living forms that its history is to be found."[10] In the newspapers, yesterday's item goes yellow under the galaxy of today's events, unconnected but for their simultaneity; fashion, ever-changing, ridicules any outfit already seen: it is impossible—there is no degree zero of the wardrobe—not to follow it.

Baroque urban space, syntax of decentering as repetition and rupture, is also semantic, but in a negative sense: receiving man into succession and monotony, it does not guarantee him a symbolic inscription; to the contrary, dis-situating him, knocking him off balance, depriving him of any reference to an authoritarian and singular signifier, it indicates to him his absence in this order, which at the same time it unfolds as uniformity: a space of dispossession.

2. Double Virtual Center: El Greco

The reflected ʃ (ʃʅ) with which Lomazzo traces the secret monogram of perfection structures several of El Greco's works.[11] Serpentine line, flame: every movement "ought always to be represented in such a way that the body has something of the *serpentinato*, to which nature lends itself."[12] Furious figures: ascent that twists them, forcing them to find an order, to fit into a rigorous ornament in counterpoint with their gestures, helical.

Two virtual centers—those of the upper curves—, in specular correspondence, magnetize the composition. They are revealed only by the painting's invisible scaffolding; they are occupied by no figure: the figures turn toward them, a crossing of gazes.

In this double focalization, specular and negative, in this surveilled symmetrical void, we can read a "moment of passivity" in the dialectic that generates the ellipse, a *gramme* of retraction and absence.

A virtual, feminine—metonymic—moment in the germination of the figure: the unoccupied centers do not merely take turns totalizing the composition, displacing the gaze from one term to another, contiguous with it, but they also mark the function of the organizing lack within the signifying chain, the importance of denied focalization in the metonymic network of representation.[13]

Its dialectical reverse: real, masculine—metaphorical—can be found, perfectly legible, in the work of Rubens.

3. Double Real Center: Rubens

The Exchange of Princesses, by Rubens, illustrates literally the moment of positive double focalization, another possible constituent of the generation of the ellipse.

Two strapping youths in helmets—allegories of Spain and France, the same figure in its two *solstitial* positions—, turn, tracing a careful, open ellipse—their hands do not quite touch: a nude, angel or zephyr, scarcely visible, attempts to close the perimeter.

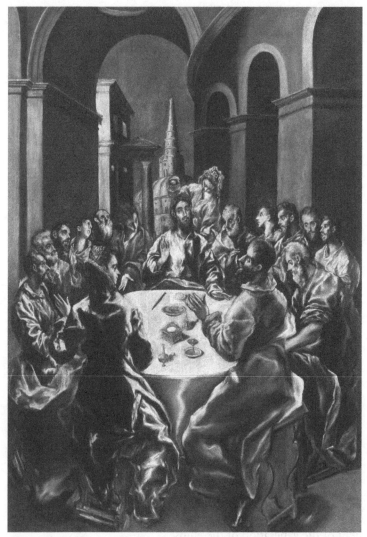

FIGURE 2: El Greco, *The Feast in the House of Simon*. 1608–14. Oil on canvas, 143.3 cm x 100.4 cm. The Art Institute of Chicago.

A whirlwind of cherubs, above—a round dance, hand in hand—causes a perfect celestial ellipse to appear and frames a cornucopia—the gold it spills rains down on the princesses.

The upper ellipse duplicates, in the allegorical space par excellence—the heavens—, the rotation staged by the earthly allegories—Spain and France—, just as these duplicate, on Earth, in the elliptical trace of their displacement, the order of the astronomical heavens and the trajectory of the planets—among them the Earth itself.

The organization of the real astronomical heavens—the Keplerian orbit—is reflected in the allegorical figuration on Earth—the curve traced by the youths—, as this last is reflected in the symbolic sky—the spiral of cherubs.

Two real centers—occupied by figures—: the centers of the earthly ellipse. The princesses being exchanged coincide with them. One is luminous, slender and shimmering—solar—; the other, of course, is smaller, subdued, discreet.

4. Anamorphosis of the Circle: Borromini

Among the possibilities for generating the ellipse, one has a particular geometrical verisimilitude: the one that confers upon the circle a power of elasticity and upon its center—as upon a cell nucleus—the capacity of division.

Dilation of the contour and duplication of the center, or rather, planned slippage of the point of view, from its frontal position to that point of maximal laterality that permits the real constitution of another regular figure: anamorphosis.

The process likely employed by Borromini in the drafting of his plan for San Carlino retraces these dynamic possibilities of the circle. Michelangelo's original design for St. Peter's—a central circle inscribed in a Greek cross with arms ending in circles—suffers an initial mutation, thus Portoghesi, when all the elements of pause are eliminated, that is to say, the rectangular arms that delay the contact between the central space and the curvilinear endings of

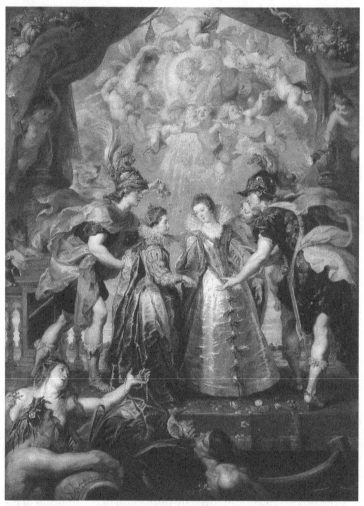

FIGURE 3: Peter Paul Rubens, *The Exchange of the Two Princesses from France and Spain upon the Bidassoa at Hedaye, November 9, 1615*. Early seventeenth century. Oil on canvas, 384 cm x 295 cm. The Louvre. Source: Wikimedia Commons.

the apses. The resulting design is longitudinally deformed through a process of anamorphosis that grants matter a kind of elasticity: the semi-oval apses are derived from the projective transformation of the semicircular apses of the original design; the ellipse emblematic of the Baroque, the Borrominian ellipse, central form of the final plan, makes explicit, here, one of its probable etiologies: the anamorphosis of the circle.

Plan of Borromini's San Carlino, obtained by anamorphosis of the circle

Generated from the circle by longitudinal dilation, the planimetric ellipse, formal basis of the pheno-plan in Borromini's practice, can illustrate the validity of this figure in the projective geometry of the Baroque; that the ellipse is derived from the circle ought not lead—as it did for the idealist tradition, from Plato to Galileo—to its being considered "degraded," an anomaly or residue with regard to an earlier and perfect form. *Derivation* is taken here in the lexicological sense of the term: the forms thus obtained, which we call secondary only out of prejudice, have "performative" power equal to that of the infinitive forms, supposedly basic, whose priority (in time) has endowed them with *priority* (one is dealing, here, in the language of the stock exchange): something like "prior preferred stock [*acción*]," which takes precedence over others. Chronological priority—which is arbitrary: we could generate the circle by contracting the ellipse—has been granted authoritarian normativity in a hierarchy of values whose maniacal reference is that of the origin.

5. Ellipsis: Góngora

Ellipsis sets up the terrain, the ground of the Baroque, not only in its mechanical application according to the prescription of the rhetorical code—suppression of one of the elements necessary for a complete construction—but also in a wider sense: suppression in general, theatrical occultation of one term in favor of another, lit up abruptly, Caravaggism. The background degraded, shoved back into darkness; the object raised up to the zenith. "Góngora's light is a lifting up of objects and a time in which their incitement is seized. In that sense we may speak of the Gothic quality of his light as it lifts up. A light that absorbs the object and then produces an irradiation."[14] Ellipsis operates as refusal of one element and metonymic concentration of light upon the other, a *laser* that attains in Góngora its maximum intensity: "His luminosity, the most concentrated luminous beam that ever operated in any Romance language."[15]

Or if one prefers: suppression, dry or deficient landscape; joyous exaltation of the still life that occupies the foreground:

> The circumstance of the Counter-Reformation makes of Góngora's work a Counter-Renaissance. It removes the landscape whose center his luminosity might occupy. The Jesuit baroque, cold and ethical, willful and entwiningly ornamental, emerges and spreads in the decadence of its poetic word, but it had already surrounded him with a cold circle and a landscape in plaster, opposing cardboard hands to his lances [. . .] the banquet where the light presents the fish and the turkeys.[16]

In setting off the object's momentary incandescence, its crackling before one's eyes, pulling it abruptly out of opacity, tearing it forth from the dark night,[17] its complement, Baroque discourse, thus showing its respect for the didactic slogans of Aristotelianism, reproduces a technique for the sharpening of vision, one that Lezama locates in falconry: "At times Góngora's treatment of verse recalls

the practices and rules for handling birds of falconry. The heads of such birds are covered with hoods that create for their senses a false night. Once released from their artificial nocturnal coverings, they still retain the memory of their adjustment to night vision, so as to see in the distance the incitement of a crane or partridge."[18]

The apogee of the ellipsis in the symbolic space of rhetoric, its Gongorine exaltation, coincides with the imposition of its geometrical double, the ellipse, in the discourse of astronomy: the theory of Kepler. In the rhetorical figure, in the economy[19] of its signifying power, privilege redounds to one of the foci in this process of double focalization, to the detriment of the other. *The ellipsis, in its two versions, is drawn around two centers: a visible one (the marked signifier/the sun), resplendent in the Baroque phrase; the other sealed (the hidden signifier/virtual center of the planetary ellipse), elided, excluded, obscure.*[20] The notion of lack, of defect, is to be found in the etymology of the term; it anticipates the prejudices to which it will be subjected: "ἔλλειψις, meaning lack, is applied to the ellipsis, as in it something has been suppressed, and also to the ellipse, as it is lacking something if it is to form a perfect circle: from ἐν and λείπειν, to lack."[21]

The ellipsis, in Baroque rhetoric, coincides with the mechanics of obscurity, the foreclosure of a signifier, which is expelled from the symbolic universe. In Góngora's poetry, as is well known, this occultation is not fortuitous; it corresponds, as in any organized discourse, to inflexible although unformulated laws: the "ugly, the uncomfortable, the unpleasant" disappear by means of a "skillful sleight of hand" that permits a flight from "the coarse name and the horrid detail."[22] This work of repression, and projection of the metaphorical ray upon the substitute of the repressed term, is patent in light of the revisions undertaken between the first and final drafts of the *Soledades*. Thus, in the *Soledad primera* (291–96), the terms *chickens* (inauspicious animals) and *Medicine* (bearing unpleasant connotations), have been elided.

First version:[23]

> Quien las no breves sumas
> de pendientes gallinas baja a cuestas
> —si corales las crestas,
> azabache las plumas—,
> tan saludables en edad cualquiera,
> que su borla creyera
> les dio la Medicina
> a ser gualda la que es púrpura fina.
>
> [One of them doth the not slender sum
> of chickens, slung, bear down upon his back
> —if crests of coral,
> feathers of jet—
> so hale at whatsoever age
> that one might the tassel take
> for conferred on them by Medicine
> if it—in truth purpure—were or.]

Definitive version:

> Cuál dellos las pendientes sumas graves
> de negras baja, de crestadas aves,
> cuyo lascivo esposo vigilante
> doméstico es del Sol nuncio canoro,
> y—de coral barbado—no de oro
> ciñe, sino de púrpura, turbante.
>
> [Such among them doth the grave slung sums
> bear down, of black, of crested fowl,
> whose lustful spouse, their sentinel,
> the hearth's sun-herald is, melodious,
> who—coral-bearded—not of gold
> doth gird, but of purple, his turban.]

Alonso's paraphrase:

> These chickens bearing crests flaming like coral and feathers black as jet, I might think they owed their health to their medical knowledge (that their crest was the doctoral tassel of Medicine, were it yellow instead of purple).

Elision is frequently brought to bear upon the names of animals considered inauspicious or vulgar; the turkey is signified thus:

> Tú, ave peregrina,
> arrogante esplendor—ya que no bello—
> del último Occidente:
> penda el rugoso nácar de tu frente
> sobre el crespo zafiro de tu cuello,
> que Himeneo a sus mesas te destina.
>
> [O thou, bird of pilgrimage,
> arrogant splendor—if unlovely—
> of the furthest West:
> let the wrinkled nacre of thy brow
> fall o'er the frizzy sapphire of thy throat:
> Hymen doth intend thee for his tables.]

Alonso's paraphrase:

> Oh turkey, oh you! bird that has reached us by pilgrimage from the West Indies, their arrogant splendor by reason of your size (though for your form one could not call you lovely), you can let hang (as it is said you do in anger) the wrinkled and nacreous skin of your brow over your bluish frizzy throat, but all this shall be to no purpose, for the god of matrimony, Hymenaeus, has favored you already for the wedding feast.

Finally:

> Al Sol levantó apenas la ancha frente
> el veloz hijo ardiente
> del céfiro lascivo
> —cuya fecunda madre al genitivo
> soplo vistiendo miembros, Guadalete
> florida ambrosía al viento dio jinete—,
> que a mucho humo abriendo
> la fogosa nariz, en un sonoro
> relincho y otro saludó sus rayos.
>
> [As soon as sunward his broad brow
> he raised, swift ardent son
> of the lecherous zephyr
> —whose mother, fecund, clothing the genitive
> breeze, gave it limbs; so the Guadalete gave
> flowery ambrosia to the wind, fleet steed—
> his fiery nostrils flaring, spewing
> smoke, with a sonorous and then
> a second whinny he greeted its rays.]

Beneath such brilliance, *mares* and *horses* are hidden, since

> no sooner does the fecund Andalusian mare (mother of horses that are the wind itself), with iris-colored coat, conceive by the purest breath of the engendering wind, than the horse and his mother alike (he breathing fire, she smoke) are champing already at the golden bit.[24]

The grass of the banks of the river Guadalete is like ambrosia, on which the horses of the Sun feed, according to Ovid.

The classical mechanism of ellipsis is analogous to what psychoanalysis knows by the name of *suppression* (*Unterdrückung*, *répression*),[25] a psychic operation that tends to exclude from consciousness an unpleasant or inconvenient content. Suppression,

like this ellipsis, is an operation that remains within the system Conscious-Preconscious: the suppressed signifier, like the elided one, passes into the zone of the preconscious, not that of the unconscious: the poet will always keep the signifier expelled from his legible discourse *more or less present* to mind.

In the extremely "culturalized" world of the Baroque, the mechanism of metaphor is raised to what we have called its square power.[26] Other poets start from the linear, informative utterance. Góngora departs, taking it as his basic terrain, from an already metaphorical stratum pieced together out of figures of Renaissance provenance which, for earlier poetry, had constituted discoveries. These he considers "sound," "natural" utterances; by means of a fresh metaphorization, he affords them access into the register of textuality proper. We may consider the absent, doubly distanced tenor of these metaphors to be "unknown"[27] to the Baroque poet in his labor of codification, which belongs to a cultural unconscious concealed beneath the process of naturalization and to which not even the codifier himself has access; in this case, Baroque metaphor would coincide with a mode that differs radically from that of *suppression*, one consisting in a change of structure: *repression* (*Verdrängung/refoulement*). It is on the level of the system Unconscious that this process unfolds in its entirety, a process by means of which the representatives-of-representations linked to certain drives find themselves shoved back or kept at a distance.[28] Insofar as it amounts to an organization of lack—and above all as an "originary" lack—repression sets in motion a functioning of the metonymic type involving the indefinite flight of a drive-object; but, insofar as through the symptom the return of the repressed peeks through—the symptom[29] is its signifier in the economy of neurosis—it coincides *precisely* with metaphor.[30]

Baroque language, reelaborated by the double work of elision, acquires—like the language of delirium—the quality of a shimmering metallic surface, without apparent underside, upon which signifiers—for their semantic economy has been repressed to this

degree—seem to be reflected in themselves, to refer to themselves, to be degraded into empty signs; metaphors, precisely because they find themselves now in their own space, which is that of symbolic displacement—the mechanism of the symptom as well—lose their metaphorical dimension: their sense does not precede production; it is their *emergent* product: it is the sense of the signifier, which connotes the relation of the subject to the signifier.[31] Such is the functioning of Baroque language; such, also, the functioning of delirium:

> All the verbal allusions, cabalistic relationships, homonymic play, and puns [. . .]. And, I might add, [. . .] the singular accent whose resonance we must know how to hear in a word so as to detect a delusion; the transfiguration of a term in an ineffable intention; the fixation [*figement*] of an idea in a semanteme (which tends to degenerate into a sign here specifically); the lexical hybrids; the verbal cancer constituted by neologisms; the bogging down of syntax; the duplicity of enunciation; but also the coherence that amounts to a logic, the characteristic, running from the unity of a style to repetitive terms, that marks each form of delusion—the madman communicates with us through all of this, whether in speech or writing.[32]

The terms elided, in both discourses, are few in number: those "representatives-of-representation" linked, directly or otherwise, to certain drives: the death drive—not by chance, in the Baroque, which, out of denial, multiplied funerary ornamentation; the scatological drives, as has already been remarked, in that squandering of gold. The symbolic means to which elision can take recourse are, by contrast, as unlimited as language—the synonymy of expulsion is vast—; it is the constitutive character of the symbols, however, that draws them together and reduces them: just as the prime numbers are to be found within the array of all the others, so the symbols of a discourse underlie all its semantemes: a *discreet* investigation—that is to say, attentive to discontinuity, to

difference, to the points of rupture in the signifying chain, where meaning surfaces—an investigation of "their interferences, following the course of a metaphor whose symbolic displacement neutralizes the secondary meanings of the terms it associates."[33] Lacan adds that "this technique would require a profound assimilation of the resources of a language [*langue*] especially those that are concretely realized in its poetic texts."[34]

In both discourses the signifying charge of terms, their power of referring to the dark center—the "ugly, uncomfortable, unpleasant" signifier, "horrid detail" of the Baroque; the "pathogenic nucleus" of psychoanalysis—, is governed neither by the work of textual elaboration to which these terms have been submitted nor by their almost always deceptive semantic dependence on the virtual center but rather simply by their *position* with regard to that center, that is to say, their insertion into the properly symbolic topology of the ellips(e/is): thus, a discreet listening—deciphering discourse on the basis of sound—a *musical* listening, the truth of the ear, makes it possible to detect, *radially*, the presence and proximity of the "pathogenic nucleus"—or the elided signifier. The metaphor for this detection, Freudian in origin, "evokes the staves on which the subject unfolds the chains of his discourse 'longitudinally,' to use Freud's term, according to a musical score whose 'pathogenic nucleus' is the leitmotiv. In the reading of this score, resistance manifests itself 'radially'—a term which is opposed to the preceding term ["longitudinally"]—and with a strength proportional to the proximity of the line being deciphered to the line that delivers the central melody by completing it."[35]

These radii are isomorphic to the axes of the ellipse, as longitudinal discourse is to the perimeter, conceived of as uniform, around its double center. In appearance only the manifest, solar center imparts upon this discourse its signifying splendor, carefully ordering the distribution of figures and gold; in reality, if we listen *discreetly*, there soon appear points, preaudible and hence locatable, where the theme returns, regularly repeated points,

absences, flaws in the orbit, marks that must be bypassed, moments in which speech hesitates or, conversely, recurrences, in the unfolding of the same signifying elements: "overgrown parentheses in the period of the stream"—like the river islands of the *Soledades*—shimmering, anagram, work of the tympanum.

One place in this discursive functioning remains to be elucidated: that of the subject. The subject, if indeed that is what is at issue, *is* because it *is not* where it is expected, in the place where an "I" visibly governs the discourse being uttered—the whole of Lacanian topology has no other aim than to prove this—, but rather there where one does not know to look for it—beneath the elided signifier that the "I" believes it has expelled, from which the "I" believes itself expelled.

Thus, in the very moment in which the subject "arises" as sense at a given place in the text (for which it must already be a minimal element in the language, a "unary trait" in the field of the Other) it vanishes in another place—*fading*—, there where something gets lost or falls out of language: the "representative-of-representation." In this sense, the two centers of the ellipse perfectly illustrate the subject in its constitutive division. And moreover: one can see how metaphor, in bringing about the appearance in one signifying chain of a term originating in another, is, as Lacan says, a metaphor of the subject: it sends on not only to another register of meaning but also to another site at which to find the subject.

On this level, it may also be said that Baroque writing, with the squandering it performs in service of repression, is the truth of all language. The object of repression is not meaning itself (nor affect, which will simply be displaced) but rather an (overdetermined) signifier, which, because it serves as a representative, Lacan likens to an ambassador.

Insofar as the subject circulates beneath the chain, insofar as it shines within the orbit's trace as its supposed center, it seems foreign to the other, dark center, but when one signifier more, or one less, comes to mark the lack—detectable in the

representative-of-representation—, then the chain drops the subject from its singular place, throws it *out of orbit*, and it comes to situate itself, like the inverse of its brilliance, in the night of the second center.

6. Ellipsis of the Subject: Velázquez

Las Meninas would figure, would present to the spectator, condensed into the instant of the glimpse, into that first instant, in which the painting is structured as a totality, the entire process—the squaring—of Baroque metaphor: its double elision, its insistent labor. And then, in the brevity of a reflection, in the fortuitous coincidence of the eye and the mirror image, it would provide the frontal revelation—virtual but clear as noon—of the elided subject: the *extraction of the root*.

Double ellipsis: absence of the named, erasure of that invisible exterior that the painting organizes as a reflection, of what the canvas reproduces, what everyone is looking at, what everyone turns to see; absence underscored here by the very structure of the work, absence that bursts in, in semi-*sfumato*, at the center of the painting, restored by the mirror: what in the painting, as Foucault notes, is of necessity "doubly invisible," "metathesis of visibility."[36]

But out of this ellipsis, at once inherent to the picture—by reason of its existence as a painting—and constitutive of this picture—by reason of its particular composition—, another is produced, one that raises the work (in the sense of an exponential) to the power of the Baroque, marking it as a model of the Baroque encoding of codification: the subject (theme) elided here is also the subject, the foundation of representation, the one "it resembles and in whose eyes it is only a resemblance": organizing center of the logos in its solar metaphor: the king, around whom everyone turns and whom everyone sees; his metaphysical correlate: the master who represents, the gaze that organizes, the one who sees.

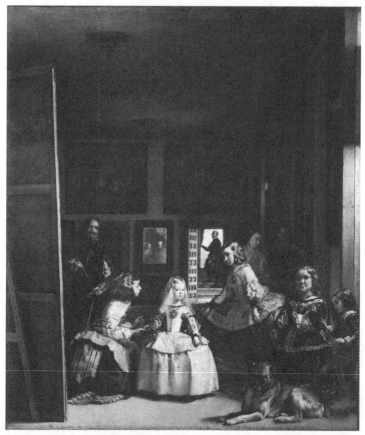

FIGURE 4: Diego de Silva Velázquez, *Las Meninas*, 1656. Oil on canvas, 320.5 cm x 281.5 cm. Museo del Prado. Source: Wikimedia Commons.

In simple terms, the possibility of a frontal—not radial—reading, the emergence of the subject, doubly elided, as mirror image, its conception as undivided entity, and its extraction without remainder (in the sense of a square root): all of this situates us entirely in an idealist reading, whose own admirable functioning would suffice to guarantee its fallacy. Such a deciphering, in

Baroque Cosmology: Kepler 61

offering up its crisp clarity, reveals its exact function, the same one that the dream, as screen, uses to show and, in showing, conceal.

To venture another interpretation of *Las Meninas*: unimaginable, except under the ceaselessly stammering heading of the hypothetical: "And what if . . . ?"

And what if Velázquez, in *Las Meninas*, were not painting, as the theory of the mirror image holds, the portrait of the static and admired sovereigns but rather, in a tautology emblematic of the Baroque, precisely *Las Meninas*. We are led to suppose as much by the fact that the dimensions of the represented painting are the same as those of the real painting as seen from the distance at which the spectator stands—the empty place of the models—; there is also a visible correspondence between the two canvases' stretchers.

Proof by analogy: finding himself one day in the Alcaná market of Toledo, among the notebooks and old papers that a boy is about to sell to a silk merchant, Cervantes takes interest in a manuscript whose characters he knows to be Arabic: thanks to a Morisco conversant in both tongues, and an allusion to Dulcinea—to her hand for salting pork—he discovers that this is nothing but the *Quijote* itself, in its original version, written by Cide Hamete Benengeli, Arab historian (I.IX). Cervantes is disconsolate to learn that its author—the author of *El ingenioso Hidalgo*—"was a Moor, as suggested by the name Cide, and one could not expect truth from the Moors, because all of them are tricksters, liars, and swindlers."[37]

The *Quijote* appears in the *Quijote*—like *Las Meninas* in *Las Meninas*—*in reverse, turned around: of the painting in the painting we see no more than the stretcher; of the book in the book, its reverse: the Arabic characters, legible from right to left, are the inversion of the Castilian ones, their mirror image*. Islam and its "tricksters, liars, and swindlers" are also the reverse, the Other of Christianity, the stretcher of Spain.

Supplement: a mirror "placed so that, seen from the point at which its frame and the painting's coincide, it creates an astonishing perspectival effect"[38] comes to occupy, in the room where it hangs in the Prado, and with the intention of achieving this effect, the place where, in order to realize the tautological work, Velázquez had to position an identical one. To enjoy this surprising effect, we must turn our back to the painting, give up its gaze upon us. Indeed we have said nothing of the reflection—including that of the work within the work—so long as we see in it a displaced double. What takes place in the mirror is not merely the return of the absent one: there is also a mercuried tain to the mirror, a verso to the painting, a direction to the script; the reflection is not produced without something getting lost, without something slipping from the manifest center to the black center. Every reflection has its opaque double, lost to decryption.

We have not wondered enough about what Velázquez is painting in *Las Meninas* and about the false innocence of mirrors. Such curiosity would have brought us to understand that the subject does not come back as *one*—full, undivided—at a precise point; that we cannot apprehend it frontally.

And what if the structure of the painting—another analysis coincides here with ours—and its perspectival setup did not recede, as toward its vanishing point, toward the mirror (and the king), but instead toward two noncoinciding points? On the one hand, the door, through which a man who has seen the scene and its figures on the level of representation "flees" toward the exterior. This man, homonymous with the one who organizes the representation—his name is Nieto Velázquez—is the one who has seen, the reverse of the one who, as if absently, looks on. More than the models in the room, what he contemplates is the Gorgorine *disegno interno*, more than the scene, the plane, reversed, of the painting in the painting. The one who is leaving, says Lacan, is the one who is seen and has seen; the one who stays is the gaze—Velázquez, the other vanishing point—the gaze that will come to paint in our place, the place of

the point of view, but only insofar as the view does not include the gaze; the master leaves it on the canvas.

In primitive painting the painter is present as donor; in classical painting, as the center of perspective, the eye that organizes the convergence of lines at the vanishing point—the code of representation—; in *Las Meninas* as represented gaze (vision) and as presenting act: the two in alternation. The painting—Lacan adds—is a trap: it asks the eye to deposit in it the partial object of the gaze—interior of vision—, which "gets spread in brushstrokes on the canvas to make you drop yours before the painter's eye."[39]

And what if everything could be read in terms of the gap, the slit; the constitutive flaw of the subject whose metaphor resounds in every illusion of unity: that of the author, the spectator, the logos; the eyelid's slit, division into two of the name Velázquez and even—beyond the reach of mirrors, hidden under the shimmering skirt—the sex of the Infanta; Lacan puns on Infanta and *fente*, slit.

In showing itself in reverse, the representation turns around, becomes double: two spaces, divided subject (the author and his homonym), double ellipsis, half of the representation given over to representation (since the upper part of the picture is occupied exclusively by other pictures and by a window that, though just an invisible frame of diffuse light, still suffices to indicate them as such), half to what is represented in representation (the lower part of the painting, occupied by the represented figures, including the master representing them); painting—almost the entirety of the picture—and non-painting: the citation of the picture itself, which shows, of the representation, no more than its framework, its support.

The double scene indicates nothing more than its own flaw: impossibility of access to what has been elided, even as mirror image. This tautology cannot be reduced without remainder: *the work is there in the work, it is true, but—as in the* Quijote *and in* Las Meninas—*only in order to underscore its alterity, untranslated work, work turned around, forever illegible.*

IV

Cosmology Since the Baroque

1. Special Relativity[1]

Nothing can situate us, define our place in an "absolute, true, and mathematical"—that is, Newtonian—space. The uniform container, the infinite, imperturbable bearer of things, is devoid of any reality, nothing is guaranteed for us, not even whether we are at rest or in motion—unless we are revolving around something or are the center of a circular rotation—nor when it is that this being at rest or in motion takes place: local temporalities, fragmented, contradictory, co-enveloping; variable spaces, conditioned by the location of the one who measures them. Only one certainty prevents total dispersion, the coming out of concert of the frames of reference: the speed of light in a vacuum, constant no matter the relative velocity of the body that emits it or the body that receives it. Outside of that abstraction, impossible to determine a point, to situate a reference: on this side, in space-time, all that exists are event-points, which can be drawn out into world-lines: their continuing to exist, their stretching out in time; the point would be an instantaneous event, without origin or trace: emergence of the body, instant disappearance.

A synthetic step will allow us to "recuperate" this theoretical transgression: the notion of the *space-time interval*: spatiotemporal "distance" between two "event-points," invariant over two "inertial systems" in uniform rectilinear translation relative to one another. Space-time, for some physicists, would be a new absolute, the "recuperation" of two obsolete notions, Space and Time.[2]

The painting in which this relativity would be revealed, would find its structure—or, rather, its de-structuring—as a continuity of juxtaposed and autonomous spaces, each valid only for the figure that forms its center—*Les Demoiselles d'Avignon*—, with no possible measurable common denominator. If the frame, or the beholder's gaze, brings the "points of view" into a totality, their particularity, far from being dissipated, is, on the contrary, conserved. These spaces are not comprehended in a universal space—frame and gaze find themselves referred to a new "point of view"—each one implies the generation of its own geometry, its own distribution of matter, its own flowing of time: coexistent and variable geo(chrono)metries.[3]

2. General Relativity

The relativistic theory of gravitation postulates a "universe [that], instead of being a more or less indeterminate object located in a framework defined *a priori*, becomes a spatial and temporal structure whose metrical properties cannot be exactly known unless the properties of the distribution of the matter it contains are also known."[4] That is to say, a mathematical and causal relationship is discovered between the material "content" and the spatiotemporal "form": space is not independent of the bodies it contains—the verb *contain* becomes an obsolete notion—, the metric properties of the container are associated with those of its contents; general relativity rules out the classical idea of a universal frame within which, theoretically, any imaginable set of objects could be included, or whatever sequence of events. "The world is no longer taken as a world of constant 'things' whose 'properties'

change in time; rather, it has become a self-contained system of 'events,' each of which is determined by four equivalent coordinates. And now, there is no longer an independent world-content that is simply taken up into the finished 'forms' of 'the' space and 'the' time; rather, space, time, and matter are indissolubly linked and are definable only in respect to one another. In the physical sense, we may now regard as really valid only the synthesis, the reciprocal relation and reciprocal determination between space, time, and matter, whereas each taken for itself has ceased to be anything more than a mere abstraction."[5]

Local geometries, within and around the bodies by which they are created—in the sun's, for example, the fundamental curves are the planets' ellipses—: space is curved around a mass, in proportion to its magnitude and density; it would end up closing in on itself, to the point that not even light could exit it; in this system, separated from the rest of the universe, it would turn round and round. Everything—mass, light . . .—is nothing but the visible aspect of a magnitude, undefinable in itself, whose only index is its transformation: "the four 'dimensions' of the physical world are fundamentally equivalent to and interchangeable with one another."[6] Something, however, regulates this system of conversions: the principle of least action: to the three spatial dimensions corresponds a principle of momentum, to the temporal dimension, the principle of energy. Energy tends to be conserved according to the principle of least action and, like the mass to which it corresponds, possesses inertia: the opposition mass/energy lacks foundation, the conservation of both terms is governed by the same principle, linked to that of the conservation of impulse.

> What we define as the ultimate physical real has cast off all semblance of *thingness*: [. . .] this objectivity is not a problem of *presentation*; rather, it is a problem of pure *signification*. [. . .] Everything "substantial" is purely and completely transposed here into the functional: true and definitive "permanence" is no

longer imputed to an existence propagated in space and time, but rather, those magnitudes and relations of magnitudes now form the universal constants for every description of physical events. It is the invariance of such relations and not the existence of any particular entities that forms the ultimate stratum of objectivity.[7]

This semiotic functioning, without reference point, without ultimate truth, is nothing but relation, mobile, dynamic *gramme* in constant translation: "What we call the object is no longer a schematizable, a realizable 'something' in intuition with definite spatial and temporal predicates; rather, it is a point of unity to be apprehended in a purely intellectual way. The object as such can never be 'represented.'"[8] That is to say, "evading predication, the signifying complex, and all the semiotic practices it regulates, eludes the utterance of *something* about an *object*, and constructs for itself an inexhaustible and stratified domain of *décrochages* and combinations, which are exhausted in the infinitude and rigor of their marking."[9]

Gravitation and inertia, equivalent forces, govern the motion of bodies over great distances; their action is not uniform: it depends on the distance of those masses that determine the geometry of that region; for there is an infinity of mathematically possible (Riemannian) metrics: if there were a universal geometry, it would be the result of a knowledge of matter on a universal scale.

Motion/force, mass/energy, distance/duration no longer exist in themselves, they only signify something, and that something differs for different observers, who are necessarily in motion: the world cannot be apprehended except from my point of view and is inconceivable from a totalizing point of view, which would be no one's. That imaginary point, situated at infinity, compels the production of symbols, making them ever more general, and functions as its own limit: each illusory approach to this "universal metric" demands a new correction, indicates, with its own postulates, its *remainder*: the work—Joyce—multiplies its focalization,

indicates the substitution and dispersion of its "points of view," the convertibility of each into any other—time being one among them. The attempt to bring each new perception to utterance from that absolute and anonymous point situated, by definition, beyond the reach of any possible experience: *focus imaginarius*, which is at once the end of subjectivity and contingency, foundation and limit of the logos, silence.[10]

Or perhaps not—the final result will be the same, the "program" different—: the work—Joyce—does not attempt to attain a totalizing (imaginary) vision, nor to testify, through its vanishing to infinity, to the impossibility of such a vision, but rather renounces, *a priori*, the no man's point of view and unfolds in voluntarily regionalized fluxes, it "is said in masses in the discontinuous unity of its cuts," it "indicates the mobile and in spite of everything directed, dialogic absence of this fundamental language" (Sollers):[11] *exterior polylogue*—as opposed to the interior and centered monologue—scattered like a melodic multiplicity of timbres, dictions, accents. Languages emitted locally, unperturbed by the phantasm of synthesis: pulverization of the subject in history.

3. Big Bang

The universe is expanding;[12] it came into being at a given moment—fifteen billion years ago—through the explosion of the "initial" matter. The stars' spectrum shifts toward red, a sign they are moving further away; if they were coming closer, it would shift toward blue, but this phenomenon is never observed.[13] The universe is dilating: its bodies are moving apart, fleeing one another; some, in our galaxy, at six hundred kilometers per second, others, perhaps outside it, at two hundred thirty thousand: these are the quasars, discovered ten years ago by Maarten Schmidt.

Big bang: let there be a little sphere within which electrons, neutrons, and protons are pressed up one against another at

temperatures of several million degrees. Lemaître's "primeval atom," Georges Gamow's "ylem," this punctual, dense, and compressed state explodes: an hour later the temperature falls, neutrons and protons combine to form the first nuclei. Ten million years later, at five hundred degrees, neutral atoms come into being; a part of this gas thickens and is pulverized; the action of gravitational forces, at chance points, gives rise to galaxies and stars. The further they move apart, the more the emptiness of space increases: the density of matter is reduced, tends toward zero, a universe approaching its end. From its initial explosion there remains, for us, detectable, an index: a fossil ray, extremely weak but constant and which, by contrast with all other known rays, does not seem to come from any localizable source: it is identical in every direction, invariable, as if space itself were giving it off.[14]

Take a signifying universe expanding *materially*: it is not only its sense, its signified density—antecedent and impalpable—that expands but also its signifying dimension, graphic and phonetic: dispersion and enlargement of mark and sound in a space-time they irradiate, in the expanse, indissociable from their presence, that their mass at once creates and incurvates; blank or silence cease to be imperturbable, abstract supports: they are generated along with the matter in which they expand.

Uncentered work: its material irradiation reaches us from all directions, absent any identifiable or privileged emitter—archeological vestige of its initial explosion, beginning of the expansion of signs, constant and isotropic phonetic vibration, murmur of fundamental language: uniform friction of consonants, open undulation of vowels.[15]

Work without "motif": dilating, expandable to infinity, series of the pure, repeated gesture or *mark of zero*:[16] colors on a muffled gray ground—the uniform mixture of all colors, saturation and annulment of the prism—dimmed vestige of initial compactness; fossil of the chromatic *ylem*.

4. Steady State

If the Big Bang finds its confirmation in quasars—in the fact of their presence and in their growing distant—the very definition of these objects gives rise to a contradiction: quasars appear to us as stars, they must be found near us in the universe—and in this case, it becomes necessary to find another explanation for redshift—; on the other hand, they are moving at such speeds that given the expansion of the universe they could only be very far away, and in that case it becomes necessary to explain why they are perceptible. The light emitted by quasars is fluctuating, and the diameter of an object that emits rays of variable intensity cannot be greater than the period of those variations, so that a quasar must be, according to observation, of an average diameter of a light-month; our galaxy has a diameter of two hundred thousand light-years. How to explain that a much smaller body radiates much more energy? Maarten Schmidt thinks that, consistent with the theory of the Big Bang, the *décalage* of rays toward red is due to very high velocities and that the objects emitting them are extremely far away, ten billion light years from the earth, practically at the origins of the universe.

Otherwise the quasars are close—which explains their visibility—, they are not endowed with enormous velocities, nor do they incessantly move apart from one another: the universe—whether or not it is fragmentarily in expansion—is stable and immutable, its state is continuous; continuous, too, according to Thomas Gold and later Herman Bondi and Fred Hoyle, is the *creation of hydrogen out of nothing* in it; this hydrogen would suffice to form new stars and fill the vacuum created by the possible fleeing away of galaxies. Creation of matter out of nothing: universe in perpetual equilibrium, *with neither beginning nor end*, unlimited in past and future, in perpetual renewal, and this on the condition that a single atom of hydrogen is created per year in the volume occupied by a skyscraper, on the condition, also, of accepting that contrary to the

capital principle of physics—the conservation of matter—the latter is created and destroyed.

But then how to explain redshift? What if this *décalage* were of gravitational origin? If a ray of light emanates from an extremely dense source it should give up energy in escaping; this phenomenon could cause a *décalage* toward red. Observation shows that, to the contrary, the matter that has given off these photons is not very dense at all. What if this *décalage* were due, in effect, to very elevated velocities, but of nearby objects which, on account of an explosion internal to the galaxy, were being scattered in every direction? In that case, some would be moving away—their spectrum would shift toward red—and others would be coming closer—their spectrum would shift toward blue—: this phenomenon has never been observed.[17]

In these responses, and above all in the development of relativist cosmology, it is manifest that the solutions involving an initial singularity are inevitable. Nevertheless, a question lingers beneath the whole lucid development of the theory of the Big Bang: what was there before the *ylem*, from where does the primeval atom emerge? Is it the result of all the processes that are currently unfolding—expansion—but *in reverse*? The universe, in this case, would be a reversible one, pulsating with successive contractions and dilations. But how could these inverse and symmetrical processes occur over the course of a single temporality, how to mark a *before* and an *after* if everything—even time—turns around in the moment of the singularity?[18] Time that is not an empty preexisting frame in which matter expands, but is instead generated in its expansion. Or should it be said instead that the contraction did not precede the expansion but rather that what we have here, in reality, is an image in which past and future are inverted, *like left and right in the mirror?*

The work isomorphic to the Steady State—*H,* by Philippe Sollers, corresponds to its formal constitution—would contest not the scientific datum, the verification of the expansion of the

universe—today observable—, but rather its theological foundation, as apparent as the one that supported Galileo's circle and whose humanist substrate informs each of its resonances, as did the "perfect" orbit in the organization of Renaissance *tondi*.

Perhaps it is not a coincidence that the formulation of the Big Bang is due, like many of the theories that gave rise to the Baroque, to a dignitary of the Company of Jesus: the Belgian Father Lemaître; perhaps its theological foundation is present in its entire formulation: a punctual stage of genesis, metaphor of the word and semen/a stage of growth, metaphor of multiplication, of the dissemination of the original nucleus, but also of corruption and exile/a final apocalyptic blackout, dissolution into the void, absence of meaning.

The continuous formation of hydrogen, that is to say, the prime matter of the universe in its first phase, would be formalized, in the literary work, by a continuous creation of phonetic matter out of nothing—neither semantic support nor "foundation"—, matter whose meaning would be precisely the exhibition of its subsistence in the present, without a mark of origin—or marked with an origin from nothing—not even as the product of a difference whose mark would be no less foundational for establishing itself as pure achronic entropy. The textual universe thus obtained, without hiatus or agglutination, is a uniform and permanent production of matter: it emerges all over and according to the same rhythm, without centered or privileged emitter, without beginning or end. Nontheological matter whose presence is purely atomic, changeless, and unbroken breath—without punctuation, obligatorily, psychic mark of the *fiato*, typographic taring of the *pneuma*—, without separation of stanzas or paragraphs, without capital letters. A work that, like the steady state, takes on the consequences of a cosmological principle according to which for any observer and at any time, the universe—the text—should have, on a large scale, the same global appearance.

H/Steady State: matter created and destroyed, but always and everywhere; without assignable origin or global annulment, toward and out of nothing, without a singular *quantum*, without limits. Space without scansion; time disappearing, without fail, at the horizon. With the neutrality of *śūnyatā*, which the West discovers here, at the end of its parable, its parabola, their luminousness tends toward zero.[19]

V

Supplement[1]

1. Economy

What does a practice of the Baroque mean today? What is its deep meaning? Is it a desire for obscurity, a taste for the exquisite? I hazard to assert the opposite: to be Baroque today means to threaten, judge, and parody the bourgeois economy, based on the stingy administration of goods, at its very center and foundation: the space of signs, language, symbolic support of society, guarantee of its functioning, its communication. To waste, to misspend, to squander language exclusively for the purposes of pleasure—and not, as in household use, for the purposes of information—is an attack on that good sense, moralistic and "natural"—like Galileo's circle—on which the entire ideology of consumption and accumulation is based. The Baroque subverts the supposedly normal order of things, as the ellipse—that supplement of value—subverts and deforms the contour of the circle, which the idealist tradition takes for the most perfect.

2. Erotism

Baroque space, then, is the space of superabundance and squandering. Contrary to communicative language—economic, austere,

reduced to its functionality: serving as vehicle for information—, Baroque language takes pleasure in the supplement, in excess, in the partial loss of its object. Or rather: in the search, frustrated by definition, for the *partial object*. The "object" of the Baroque can be fixed with precision: it is what Freud, but above all Abraham, calls the *partial object*: maternal breast, excrement—and its metaphoric equivalent: *gold*, constituent *matter* and symbolic support of every Baroque—gaze, voice, *thing* forever foreign to anything man can comprehend, anything of self or other that he can assimilate or to which he can be assimilated, residue that we could describe as (a)lterity, to mark in the concept the contribution of Lacan, who calls this object precisely (a).

As residual quantity but also as fall, loss, or disaccord between reality and the phantasmatic image that sustains it—between the visible Baroque work and the limitless saturation, the suffocating proliferation, the *horror vacui*—the object (a) dominates Baroque space. The supplement—another volute, that "yet another angel" of which Lezama speaks—shows up as the confirmation of a failure: the one signified by the presence of an unrepresentable object, resistant to crossing the line of Alterity: *(a)lice* irritates *Alice* because the latter cannot get her to pass over from the other side of the looking glass.

The confirmation of failure does not entail the modification of the project but rather, to the contrary, the repetition of the supplement; this obstinate repetition of a useless thing—since it lacks access to the symbolic entity of the work—is what determines the Baroque as *play* in opposition to the determination of the classical work as *labor*. The exclamation provoked, without fail, by every chapel of Churriguera or Aleijadinho, every stanza of Góngora or Lezama, every Baroque act, whether it belongs to painting or confectionery—"So much work!"—implies a barely dissimulated adjective: so much *work wasted*, so much play and squandering, so much effort without functionality! It is the superego of the *homo faber*, the being-unto-work, that comes to expression here,

impugning delectation, the voluptuousness of gold, pomp, excess, pleasure.

Play, loss, waste and pleasure: that is to say, erotism as—purely ludic—activity that parodies the function of reproduction, transgression of the useful, of the "natural" dialogue of bodies.

In erotism artificiality, the cultural, manifests itself in play with the lost object, play that has its end in itself and whose purpose is not the conveyance of a message—that of reproductive elements in this case—but rather their squandering for the purposes of pleasure.

Like Baroque rhetoric, erotism presents itself as the total breakdown of the denotative, direct and "natural" level of—somatic—language, as the perversion that every metaphor, every figure entails. It is not a historical accident that the exclusion of figures from literary discourse has been advocated in the name of morals.

3. Mirror

If in terms of its utility Baroque play is null, the same does not hold of its structure. The latter is not just arbitrary, gratuitous appearance, an outrage expressing no more than its excess; it is rather a reflection reducing what it enfolds and transcends; reflection that repeats its intention—to be simultaneously totalizing and meticulous—but fails—like the mirror that centers and recapitulates the portrait of the Arnolfinis, by Van Eyck, or, like the Gongorine mirror, "if concave still faithful"—to capture the vastness of the language that circumscribes it, the organization of the universe: something in this structure resists it, opposes to it its own opacity, denies it its image.

This incompleteness of every Baroque on the level of synchrony does not prevent—but rather, on account of its constant readjustments, facilitates—the functioning of the diversity of Baroque styles as the signifying reflection of a certain diachrony: thus the European Baroque and the first Latin American Baroque present themselves as images of a mobile and decentered

but still harmonious universe; they establish themselves as bearers of a consonance—as consonant with the homogeneity and the rhythm of the logos that, from the outside, organizes and precedes them, even if that logos is characterized by its infinitude, by the inexhaustibility of its unfolding. The *ratio* of the Leibnizian city lies in the infinity of points from which it can be viewed; no image exhausts this infinity, but one structure can contain it *in potentia*, can *indicate* it as potency, which does not mean bearing it as residue.

This logos marks with its authority and equilibrium the two epistemic axes of the Baroque century: the god of the Jesuits—the word of infinite potency—and his terrestrial metaphor, the king.

To the contrary, today's Baroque, the Neo-Baroque, reflects in its structure the disharmony, the rupture of homogeneity, in the logos as absolute, the lack that constitutes our epistemic foundation. Neo-Baroque of disequilibrium, structural reflection of a desire that cannot attain its object, desire for which the logos has put in place no more than a screen dissimulating lack. The gaze, now, is not just infinite: as a partial object it has become an object lost. The route—real or verbal—not only leaps over innumerable divisions; we know that it aims at an end that constantly escapes it or, better, that this route is divided by that same absence around which it is in motion.

Neo-Baroque: necessarily pulverized reflection of a knowledge that knows it is no longer peaceably closed in upon itself. Art of dethroning and disputation.

4. Revolution

Syntactically incorrect by dint of its inclusion within itself of incompatible alien elements, by dint of its multiplication, to the point of "losing the thread," of the limitless artifice of subordination, the Neo-Baroque sentence—Lezama's, for example—displays in its incorrectness—false quotations, abortive attempts to "graft" in other languages, etc.—in its failure to "land on its

feet" and its loss of concord—our loss of a single, harmonious elsewhere, an elsewhere in our image, in sum a theological *ailleurs*.

Baroque that in its tilting action, in its fall, in its sometimes strident, motley, and chaotic *painterly* language, gives the metaphor for the contestation of the logocentric entity that, until then, had structured it from its place of distance and authority; Baroque that rejects all instauration, that metaphorizes the order disputed, the god called to judgment, the law transgressed. Baroque of the Revolution.

TWO

I

Zero

Colors/Numbers/Sequences
From the discourse elaborated by Frege we can derive the guidelines for a formal reading of the painting.[1] Literal application of the logical system, whose absence is surprising given the proliferation of metaphysical interpretations of and commentaries on the pictorial or sculptural fact. Ordinary thought is content to propose, in criticism, a metaphorical use of scientific formalization; this metaphor keeps the text, the painting, far from the rigor that society reserves for mathematical discourse, relegating to its antipodes any signifying practice still bearing the connotation of Romantic prejudices.

If, with Frege, we take zero as the extension of the concept *nonidentical with itself*, contradictory concept within whose domain no object can be included and whose only guarantee is in its refusal of existence to all the objects it designates, then noncolor, which likewise decrees in its domain the nonexistence of the object to which it refers, will occupy the place of the zero in a system of reading whose intention would be the elimination of any reference to a psychological entity as producer of visual signs and the

treatment of objective—chromatic—representations on the basis of a conceptual code.

The passage from noncolor to white would be carried out, following along with Frege, in the following way: *white follows noncolor inasmuch as white "belongs" to the concept "identical to noncolor."* The passage from noncolor to white could not take place without the recognition of an identity with itself of the initial contradiction involved in noncolor as such, just as the constitution of the one occurs by means of the identity with itself of a contradiction.

Contradiction: the zero as extension of the concept "non-self-identical."

Identity with itself of a contradiction: one poses that contradictory concept whose number is zero and seeks the extension of the concept "identical to zero": this is no longer the extension of a contradiction but that of the identity it has with itself. Its number is not zero but one.

The "natural" succession of colors, the metonymic series of the prism, is also produced, like that of the numbers, on the basis of a first leap, an original metaphor: the white metaphorizes noncolor, and this passage creates in its opening an infinite spectrum of contiguous chromatic displacements.

The passage from one color to the next—like the passage from an integer to its successor—is based upon the taking of white as the noncolor, just as the series of integers functions because zero is counted as one.

In this passage, and in the *empty fringe* that designates it, there remains the repeated mark of the production of the zero on the basis of non-self-identity: the mute echo, the white shadow of that circle—o—that exists because it delimits nonexistence within its domain. A set of notions whose very formulation involves such a contradiction that its very formulation becomes the guarantee of its nonexistence; Frege gives the example of the squared circle.

The sequence insists on these empty fringes, these receding traces of the zero, these blind marks, and not on the full elements that seem to form it, those which, in reality, no more than cover over the void that supports and organizes them and which can be reduced to their minimal expression: two. The two bears the mark of the zero and its excess as brought about by the constitution of the one on the basis of the identity of contradiction. It also bears the excess of the one in the difference of the identical concepts that it identifies.

The passage, the empty fringe, is the scansion of what, by its own nature, can be projected to infinity: infinity of numbering, since a greater number is always possible; infinity of the gap between each number and the one that follows it, which irrational approximation seeks in vain to caulk up.

This conception of scansion is the only way to realize a formal—objective and logical—reading of the sequences of Robert Morris. These fiberglass sleeves,[2] empty and "colorless" cubes, at once transparent and opaque, have been organized into sequences that indicate the empty fringes, projectable to infinity: these fringes are what structure them, not the forms, the "full" elements that serve as their pretext. The author makes this clear in a passage that eliminates any possible error—that of a reading at the level of content—and which, by indicating that his work is not a simple result of systems of production, unmasks the normative codes that serve as the basis for those systems and that coincide with the foundations of any mechanics of consumption: "Idealist type thinking places so much importance on form because it is taken as proof that the work is transcending itself as mere thing by revealing structure. Object-type art is not involved in this particular dualism of form and thing partly because it exists without a boundary to which its parts are adjusted and partly because the perception of its relationships constantly varies. It should also be clear from the above that object-type work is not based—as has been supposed—on a particular, limiting, geometric morphology

or a particular, desirable set of materials. Lumps are potentially as viable as cubes, rags as acceptable as stainless steel rods."[3]

Reflecting on the sequence should lead us to the practice of an intervallic reading, a deciphering not on the level of the full and present but on the level of the—negative—parameter that gives it its scansion, its double, its support: the *mark of zero*.

II

Circle

Sun in the Hand

A sun. The sun. But not the visible, astronomical one, the "center of the System," nor the symbolic one—assiduous king, *yang*, phallus, fire—, nor the one, sum of these first two, that, filtered through wickerwork covered with red lettering, throws yellow on the steps that lead down to the river. But rather another sun: the *genetic* sun, the one we carry in our hand, trace that precedes us and that, like speech or movement, has always been encrypted, without history or origin, in the helix of heredity.

To trace a circle is the most immediate, also the most universal and anonymous gesture, the hand's first drive, buried beneath millennia of technology, of culture, and that, in an instant—this knowledge having been annulled—reappears: the hand recovers its productive faculty, it *desires* again on its own account, independent of the totality of the body that includes it, a machine, free.

Or else—as Galileo observed—the circle is implicit in the arm's articulations. Circle—primary structure. Scope of the hunt. *Querencia*. Eye. Mouth. Ring-hoop-anus. Nothing: gesture without subject. Signature of the species. And then *zero*, the initial of the *O*ther.

Circle, forgotten since so manifest, invisible in its obviousness: Giotto, it seems, responded by drawing a perfect one, without aid of a compass, before the papal messenger sent to make inquiries about him; Feito has gone about stripping it of its textures, its initial, mute matter, to display it, red upon red, in its clarity: gesture as object, pure referent: neither sign nor symbol nor icon.

The "sun in the hand" does not exclude Feito's word from the Spanish of the plastic arts; it inserts his word into this idiom, not by way of the predictably anecdotal links that have been pointed out so often—"ardent" palette, rugosity and roughness of burnt matter, tauromachy, austerity or Baroque—, but by way of others that establish themselves between technique and its deciphering.

The division of the painting into two registers, one terrestrial and ordered, codified by the rules of linear perspective, and the other celestial, of indefinite depth, shimmering and fluid, which characterizes Spanish religious painting, persists, metaphorized, in the recent works of Feito. In Zurbarán, the interest of such compositions—accounts, for the most part, of divine apparitions in which the painting lets the viewer see the two simultaneous registers of a real scene and a miraculous vision—resides less in the spatial dichotomy they impose than in the modalities of the communication that is established between the terrestrial and celestial registers and, within each register, between the figures that inhabit it. These two registers do not always establish in Feito, as in his forebears, a vertical relation between the high and the low, the precise and the diffuse, the "terrestrial" and the "celestial," but rather a horizontal relation: two juxtaposed panels—which, however, should not be read as a diptych—impose not a "spatial dichotomy," nor a dialogue, but rather a simultaneous and binary reading.

The two surfaces—one of them almost always monochromatic and of a tone close to the dominant color in the adjoining one—demand autonomous "vanishing points"; they do not admit of totalization either in a global vision or in a formal dialectic. On

the contrary, at the same time that they assert their spatial concomitance, their optic simultaneity, they require a *disjunctive*, bifurcated reading. The monochromatic panel, almost always smaller than its pendant, is neither a predicate nor a subordinate of the latter, but rather its divergent. Neither its negative, nor its obverse: catalyst of a decentered, heterophoric, plural vision.

The two registers do not represent symbolic and communicating planes but rather stand as spaces irreducible to a single code, a single reading, juxtaposed in order to bring to expression precisely this irreducibility.

In some canvases the double code structures a single panel: stereo-morphy, one of whose centers of broadcast is to be found in the upper and another in the lower part of the painting, as in the aforementioned religious tradition. Under the "sun in the hand," the genetic hoop, there appears, supported on the "ground," firmly rooted, an "ideogram" composed of two frequently circular figures whose relation—not reducible to either a complementarity or an opposition—repeats, in the horizontal, abbreviated plane, the vertical relation of the two registers. Then a black stroke, orthogonal, authoritarian, in order to protect these two "figures," to cover them: closure, boundary, roof.

Within a single surface the two readings reappear, two bodies unsusceptible of dialectic, which no composition, no matter how daring, can dominate: the heavens no longer communicate with the earth; neither indulgent nor disdainful, the gods are no longer either merciful or deaf; no whirlwind of angels bears us aloft; at our side, no column of fire, no one to pierce us with arrows.

Just two languages, untranslatable, definitively compartmentalized and autonomous, whose adjacency only points up this autonomy. Neither epiphany nor negative theology: adherence and silence between the soul and her bridegroom.

God, in Feito's painting, is neither present nor absent: the problem is one of syntax.

III

Cycle

The "Screen" Effect

The work of David Lamelas—but would it not be better to avoid the concept of work, a concept in line with the practice of art and with its defects: hypostatized center of broadcast, determination of the product, aestheticism, etc.?—does not present itself either as a mimesis of its object, nor as the abandonment of this object in the face of a technology that produces it and that, thanks to that tautological illumination, would find itself at once exalted and fixed, raised to the rank of fetish.[1]

The object of Lamelas is the event, or rather: the work of Lamelas establishes and (as art object) annuls itself in an *analytic practice* of the event.

On the basis of linguistic models—the opposite of the "performative": the act, here, is a sentence, to do is to say—, the event will get broken up, separated into segments, dissolved into syntagms, reduced to an encounter between subject and predicate, to its actual framework, synthesized in a copular relation.

This practice equates the event with its analysis: in being read, it is (re)produced, made iterative, and thus this practice defines itself as rejection of description and context: only in this sense could

we speak, with regard to Lamelas, of conceptual art, or, more pertinently, of *language art*, since the grammatical model, operative in the constitution of the event, is revealed in it as *generative*.

On a screen, at the back of the room, the film is presented as a cycle, repeated without interruption—the end and the beginning of the tape are joined together—and reproduces with total neutrality, since the camera is fixed and there is no quest for form or framing, an event reduced to its simplest and least connotative expression: the succession, neither mechanical nor ritual, of a few gestures: someone walks, someone opens a door or closes a window.

By an analogy that doubtless is not due to chance, the statements of these actions coincide with those that, reduced to their basic structures, are used as paradigm sentences in the teaching of a language.

On the walls, or on other screens, three other projections: still images, passing at a well-regulated cadence: a collection of slides reproduces a series of instants from the actions filmed, taken during the shooting and concatenated according to the same simple succession. The narrative—since there is one, although reduced to its degree zero—is the same across the four projections, the signified of the four sentences is identical; just the *diegesis* of the three series of stills—the time inherent in each series, the rhythm apparently consubstantial with them—can coincide or not, in each showing, with the—arbitrarily normative—*diegesis* of the film. The event thus finds itself disarticulated on the level of its perception: its diegetic support is called into question, it does not unfold in a univocal, absolute sequence but instead always finds itself out in front of or lagging behind itself: relativized.

In Warhol's films, whose semblance of producing a denaturalized and critical perception is, in this sense, paradoxical, diegesis remains a realist, "figurative" value: our perception of the event and of the time of its utterance is never unsettling, always confirming: our sleep, like this sleeper's, lasts eight hours: the diegesis

joins us with the actors: our shower, our lovemaking, has the same duration as theirs. In the films of Lamelas, to the contrary, the analysis of the event and its separation, as a sentence, into constituents, always begins as a critique of the time over the course of which they unfold.

In *Cumulative Script*, the first sequence—a street, a man who approaches the camera, passes in front of it, recedes and disappears—is repeated, first mechanically—all that marks the repetition is the appearance of a different color—and then thematically—another street, another man, etc.—. This double repetition constitutes the second sequence, which in turn is repeated . . . up to the sixth. But these repetitions, instead of confirming the event, imposing it as a ritual gesture or an automatism, turn it into something insecure, stammering, they "trip up" its structure. This crossing out of the event is not due to the inexpressiveness of the recurrent sequence—reduced to a simple subject-predicate relation—nor to its insistence but rather to its position: the repetition intervenes at a moment of the principal sequence that does not allow it to be taken as flashback, nor as premonition, nor even as simultaneous action.

Cinema has naturalized its procedures of connotation to the point that these have disappeared as such: the succession of two sequences that unfold in different places is read directly as "at the same moment," etc. Lamelas inserts the recursive sequence into an a-signifying place: the reading of the narrative is thus disrupted by an untimely "grafting" that returns the connotative signifiers of the montage to their arbitrariness and insists upon their code, which is thus "exonerated."

It is this a-signification of the recurrent sequence in the topology of discourse that calls the event into question and causes it, upon its utterance, to be crossed out by an insistent and silent repetition that annuls its unity, its origin, and the possibility of its conclusion.

The combinatorics of narrative elements, although strict, reveals itself to be a-subjective: if the event, given the constitution

of the narrative, begins again, in this effect of beginning again it is the subject of enunciation that, every time and inevitably, ends up annulled.

Thus, the accumulation, achieved through the a-signifying repetition of an element, is absorbed back into pure quantity; its excess is no more than indicative: in repetition, the work can designate, can designate itself, but never speak.

A whole system of sounds has its part in Lamelas's shows: slide projectors, magnetic tape reels, etc. The presence of the motors, this uniform and endless murmur of the mechanical constitutes the *audio* of the silent sequences. It is the murmur of the signifying chain, moving along beneath the concatenation of narrative links.

The machine that turns with its tape made into a cycle, just as much as its murmur and the cones of white light that interrupt the passage of the images on the screen—everything that constitutes the work—displays its structure only in order to point it up as the support of a deception. What matters here is not the fact that there is deception but the necessity of organizing it. The point that truly functions as a sign, the point that shines, is not to be found *on* the screen—support of a normative temporality that the slides send back to its artifice, and of an object that, from the beginning of the projection, finds itself subjected, there, to critique—nor in what is *out in front* or *prior*—the concept that produces the work, the ideal matrix, the "program"—nor *behind*, in an encrypted content for which the screen would serve as mask and which a given hermeneutic could reveal for us—, but rather to the side, at that point at which the visual succession is annulled as signification, thus annulling the event that it (re)produces, failing, at the very moment at which the necessity of so doing is revealed, in its attempt to constitute itself as a syntagm. Point of minimal translation in which the act, in order to exist, has to find its sentence, in which the filmed narrative, in the empty repetition of its subjects and its predicates, is dissolved into pure

montage—whose articulation does not "pass" over to the side of meaning.

Lamelas shows the ephemeral appearance of the event, its unfolding on the surface of the screen and its annulment before it comes to be: the image is incapable of passing through its *mise-en-phrase*, the grammatical trial of the copula—it is this impossibility that characterizes every production of symbols.

The work will be either a record of unconnected, dissociated facts, *an expenditure without exchange*, or a pure linkage, a simulacrum of encounter, an equivalence that, upon establishing itself, is emptied out: relation without definition.

Other Writings

Metaphor Squared: On Góngora

Metaphor is that point where the texture of language grows thick, where it rises into relief and thus sends the rest of the sentence back to its flatness, its innocence. Leavening, bulge[1] in the continuous surface of discourse, metaphor returns everything that adjoins it to a certain degree of denotative purity. Purity. Let us underscore the moral implications of the word: metaphor as outside the "nature" of language, as infirmity: an imputation of guilt, sweeping up in its prohibition every figure of rhetoric, to the point that Saint Thomas prided himself on not making use of any.

But if for poetry, up until his time, rhetoric depraves what counts as nature, Góngora frees it of guilt, to the point that the first degree of utterance, linear and "sound," disappears for him. He takes as his point of departure a terrain already eroded, corroded *a priori*, one constituted by what one could call traditionally poetic metaphors, those which, for other poets, for literary language, are metaphorical discoveries—just as others take as their point of departure ordinary speech. Whence every figure, *per se*, attains to a supra-rhetorical register, takes its place in a *culteranista* sphere; by the simple fact of being uttered, it is a poetic power squared.

> If water be crystal, then crystal is water
> [*Si el agua cristal, el cristal agua*]

This metaphor squared can present itself, in its structure, as an inversion of the simple metaphor. Alonso has indicated[2] this bijective character: water metaphorized into crystal; crystal, then, sent back to water. But this sending back, this boomerang movement, bears an element that *marks* it; this is constituted by an adverbial quantity. Since we have witnessed the metaphorization of water into crystal, crystal will be given as a *sweetly solid* water (*dulcemente dura*).

> Crystal, snow, gold ...
> [*Cristal, nieve, oro* ...]

This reactive play of metaphor leads us to a contamination, a geometric multiplication, a proliferation of metaphoric substance itself; all of legible reality (legible: I shall return to this word) coincides, flees, and falls into order at that place where the *conceptos* of the metaphoric absolute intersect. Thus Alonso shows how, when we see the word *gold*, we can slip along an axis on which metaphor lets metonymy guide it, encountering every golden object imaginable: women's hair, honey, olive oil, wheat. Likewise with crystal, snow ...

Which evidently leads us to believe that the whole of the *Soledades* is nothing other than a great hyperbole and that all the rhetorical figures employed by Góngora have as their final and absolute signified hyperbole itself; one could ask whether the Baroque is not, in its essence, just an immense hyperbolic proliferation in which the axes of nature, in the sense in which this word is used above, have been effaced.

But where it is not a matter of transcribing an element of perception, where snow, gold, and crystal, in their multiplications, do not make up in its totality the reading of a real to be conveyed in all its density—for which no "metaphorical absolute" would

suffice, running instead the risk of homogenizing the totality or making it monochromatic, thus betraying it—there Góngora takes recourse, and it is in this that I take him to be the most contemporary of all poets, to the image of discourse itself.

Reality (the landscape) is no more than that: a discourse, a signifying chain, thus decipherable. The pilgrim sets foot in a landscape in the Renaissance style, where a river and islands are to be seen. How are we introduced to this whole? The islands are overgrown parentheses (*paréntesis frondosos*) in the period of the stream. . . . The river as period, islands as parentheses.[3]

The Negation of Terror

As the pure level of language is the one containing no figure—a level whose existence, to be sure, is contestable, this level consisting, as it does in large part, in naturalized figures—, an interval, a *distance*, opens between it and metaphorical language. A distance that is perhaps the very sign of literature and which, in Góngora, is taken to the limit. In Góngora, there is no terror—to borrow Paulhan's term for the refusal of rhetoric:[4] to such a point that the absent signified is sometimes untraceable or is dispersed across a network of possible signifieds. Among the poets of classicism, the gap between figure and meaning, their distance, is reduced; with Góngora—in the whole of the Baroque—it is driven to the limits of intelligibility. Some examples, now famous, suffice: birds are signified as *feathered zithers*; falcons as *rapid whirlwinds of Norway*; the owl as a *heavy globe of lazy feathers*.

Reading of the Real

> With her another mountain girl
> brought liquid crystal to touch the human kind
> along the lovely aqueduct of a hand
> which, scorning the one, was equal to the other.

> [*Otra con ella montaraz zagala*
> *juntaba el cristal líquido al humano*
> *por el arcaduz bello de una mano*
> *que al uno menosprecia, al otro iguala.*][5]

A mountain girl, then, is washing her face, or drinking river water, with her hand. Alonso has analyzed this metaphor as follows:

> the real series: water (a) face (b) hand (c)
> the imaginary series: crystal (a' b') aqueduct (c')

Two systems within which the metaphor will select its terms and arrange them in contiguity.[6] This is the very mechanism of poetry. But here again, in the domain of Gongorism, inversion, elaboration, artifice. One notes in reading the quatrain that it is the real series that is considered, *read*, from the perspective of the metaphorical series: it is the water and the face that are likened to the crystal (for their clarity), and it is the hand that is likened to the aqueduct (because it carries water from the stream).

The base category, the code of reading, is given by the symbolic (the imaginary, in Alonso's terminology); from there, one moves toward the real.

Poetry is an enterprise of culture, remaining within the domain of culture, and everything outside the cultural domain assumes, with regard to it, the quality of the referential (whence, of course, the resistance this poetry encountered for three centuries, and which has bestowed upon the adjective "Gongorine" a persistent pejorative meaning).

What is this code of reading, this mirror, "if concave still faithful," in which the real series comes to be reflected? It is a language composed of all the cultural elements of the Renaissance, above all mythological, astronomical, and literary references; it is a certain sense of the arrangement of nature, the ordering of the landscape in accordance with rigid conventions.[7]

Every concept is handled according to preestablished canons, rhetorically fixed rules regarding the *beautiful*; thus, the assiduous reader knows in advance where the system will get segmented, what elements Góngora will select from it to arrange the line, the verse; because, for him, poetry is not invented; on the contrary, it belongs to a world already formed, with fixed laws. Yet another radical difference between Góngora and "the poet."

Radial Reading
A poetry that is *tropic* in its constitution, which presents itself as an eluding (*e-ludere*) of any message, any speech in its everyday state. Verses, then, that put their cultural universe, their periphrastic meaning, on display.

Periphrasis: circle traced by the act of reading and whose center, always eluded, is by that very fact always present. A final signified like the "pathogenic nucleus" in Freud's sense, for in the longitudinal reading of discourse it is the regularly repeated *theme*—repeated as lack, as a point to be skirted, circumvented; moment when speech takes a tumble—and on account of this, detectable. The longitudinal chain of periphrastic discourse describes the arc of a circle; only a radial reading decrypts the absent center.

The central reference of the poem is nature. The trajectory, a bucolic one, sketches the contours of a cornucopia—fruits and flowers powerfully illuminated against a black background, *heavy-laden* horn, Italian Baroque.

Mirror
A virtual bar makes its way through the poem and divides the verse into two symmetrical parts, sending back to one another, one another's inversions, like the space reflected in a mirror and real space. Units of sound and sense are to be found on both sides of this bar.

One would have to see, moreover, whether this holds constant in all Spanish art and not only in literature. *Las Meninas* would

be the moment in which the mirror situated virtually outside the canvas withdraws from the physical surface of the painting, the canvas in the literal sense, all its importance, in order to impose its own axial presence: it is obvious that, without this virtual mirror, the painting could not come to be.

But in the case of the *Soledades*, and particularly in the *Soledad primera*, it has not been noticed that this bar crosses the narrative as well. If one considers that the castaway is welcomed as a son by the old shepherd, who is reminded by him of his drowned son, and that at the end of the poem he goes to a wedding—the poem as a whole being a sort of epithalamium—when he had taken to sea on account of a romantic frustration, one will easily be able to establish a symmetry:

<div align="center">
castaway/drowned man

successful marriage/failed marriage
</div>

which will then extend to the whole of the text, including perhaps the four *Soledades* had the author's original project been realized (the four ages of man: Childhood, Adolescence, Manhood, Old Age, or four solitary places traversed by the pilgrim: fields, rivers, forests, and wasteland).

The Pulsation of Meaning

> Let outer things throw their doors open
> to discourse, and discourse, in turn, to truths
>
> [*abran las puertas exterioridades
> al discurso, el discurso a las verdades.*][8]

Intermediate discourse, then, upon which outer things open, but which, in turn, is opened onto truths. Double back-and-forth movement that poses discourse as a bar, but as a pierced bar, discrete. Invaded by the exterior, and giving out on truths as if on an interior: pulsatory movement of meaning.

It is in this oscillation of the sign, this double opening, which creates a gap within discourse—within the line of verse as longitudinal chain—that one would have to "reestablish" the text of the *Soledades*.

The poem as exchange, as unstable substitution of signs, as their inexhaustible birth, at that site where the pulsation between "outer things" and truth takes place: the oscillating border of discourse.

Cubes

A persistent prejudice in our culture desires, in every artistic production, the obliteration of the *support*. This stubborn censorship is brought to bear, in painting, upon the canvas—the presence of fabric (text), the blank—and upon the body of materials—pigments, powders—; in literature, upon the page and upon graphism; in sculpture, upon the armature, the skeleton (geometric, hidden) that supports the object. The reason is that civilization—and above all Christian thought—has destined the body to oblivion, to *sacrifice*. Thence the fact that everything that refers to it, everything that, in one way or another, signifies it, attains the status of the transgressive.

The underlying webwork of our knowledge is destined to perpetuate this oblivion, this sacrifice. The canvas considered as material support, the body of the painting, and in sculpture the armature, must disappear in favor of an illusion of space, of an original logos which, not belonging to the object, would organize it from a distance.

If the art of Larry Bell throws us off at first, it is because, in an irreversible fashion and by its very *literality*, it abolishes any transcendental prejudice. Here, and on the basis of a privileged site (a

body; sculpture) art is contested as referent: for it is precisely the support, the armature, that constitutes the work. The cubes of Larry Bell, in their denotative presence, at once unite and transgress the oppositional dyads:

armature / sculpture
(hidden structure) / (visible form) theme/object

opacity/transparency

This operation produces its own space, a space which, like that of Artaud's cruel performance in Derrida's telling (and in fact there is a theatricality to these cubes, which would bear further reflection), is a "closed space, that is to say a space produced from within itself and no longer organized from the vantage of another absent site, an illocality, an alibi or invisible utopia."[1]

A grammarian of the eighteenth century, comparing language to a painting, identified "nouns with forms, adjectives with colors, and the verb with the canvas itself."[2] The blank canvas, and its analogue, the minimal spatial unit, the *cube*, would be, following this comparison, the primary bodies of a *verbal art*. The verb is the support of all attributes; the cube, the support of every possible form.

In showing us, underscored by its literality, this original unity, the *cube*, bringing art back to that nonrepresentation that is the original form of representation, Larry Bell compels us to call into question our conception of the object, of the artistic "product," of the relation between the "perceptible aspect" and the "conceptual aspect" of sculpture.

The Fury of the Paintbrush

Periodically, with the punctuality of revolutions—these two words, restored to their astronomical meaning, are the best suited to situate the return of the Baroque—, Rubens returns, as if his oeuvre, eloquent, monumental and grave, devoid of confidences, with no place reserved for the specular insertion of the ego, stood as contradiction or challenge, precise inverse of the postulates that have marked our century's art: the expressive, the private—with what that implies in terms of property rights over a symbolic production—, the individual—with what that supposes in terms of neurotic investment—, or the neutral—with what that provokes in terms of economy—, the universality of the rule—with what that involves by way of obsessive repression.

The heroic formats of Rubens, the helicoidal flight of his hardy, bejeweled figures, in mythological or Christian settings, impose and display the content, the very material of a repression: Protestant, doctrinal and austere, alert to the body's concealment, to order. In his paintings, more than in the rest of the Baroque, and more than in the northern Netherlands of the seventeenth century, nudes and delicacies appear as if in a zone of incandescence, borne on a violent and pedagogical backwash, the sumptuousness

of the Counter-Reformation. Not the nude allegorical of Truth but the desiring body, the body stripped bare, that commands, more than invites, the gaze to apply itself, as if with a paintbrush, to the canvas, smearing it with its white transparency: not the nourishment of the Eucharist, transcended or frugal, but burgherly density, abundance, which decenters and displaces the cold and syllogistic organization of the Flemish still life.

But also, and at the same time, bodies and foodstuffs appear as if breaking away from their referent: the bodies to which those giants, those corpulent majesties, refer are less real bodies than the bodies codified by Hellenic tradition. Like Góngora, who produces metaphors of metaphors and not metaphors on the basis of direct informative language, Rubens paints models of models, figures squared.

The body breaks away, surreptitiously, from its real anchoring, moves toward a free, unmotivated language, toward an arbitrary system of signification that will lead to the figurable by virtue of its cultural preexistence: the code of the canvas.

Energy of displacement: Rubens's production coincides with the moment in which the painter abandons the guild, ceases to be an artisan united to others by his office and sanctioned by the *doxa* of collective taste; exile of the painter's work, which permits him to unfurl a free-floating knowledge, face to face with the unknown: the same energy that drives seafarers to fill another blank space, that of the cartographic unknown.

In Rubens, the paintbrush erects itself into the signifier of this energy: spattering, dripping, smearing, thanks to the oil's fluidity: speed of jouissance, *furia del pennello*, fury of the paintbrush, which scarcely makes a metaphor of the *furia del pene*, fury of the penis. What was repressed by the iconoclastic furor of the Reform returns as an excess in liturgy: multiplied, golden.

To take shape, this erection of the paintbrush, this swelling of the stroke, must pass, as through a screen, opaque and resistant, through the organization of a law: the code fixed by Renaissance

techniques, the hierarchical disposition of the figures, the privileged path of the gaze through an invisible and structure-giving matrix, which the composition at once underscores and seals away.

That's how Rubens gets hard: this passage through the law. He puts the nuclei of his narrative sequences in the places prescribed by those frameworks or armatures cataloged by Bouleau:[1] secret geometries, undecipherable on a first reading of the composition, which sustain, with the Pythagorean rigor of their crisscrossing, like plans of cathedrals unseen beneath the snow, the whole mise-en-scène of the subject—the theme of the painting, the material signifier of the author. Inflexible matrices, authoritarian in spite of (because of) their concealment, which suck the figures in magnetically, amass them around anchor points; the theater of their gestures, the flare of their attire and their attributes, gets drawn along the ducts of this secret geometry. The more fully realized the canvas, the less perceptible these matrices will be, the better concealed.

The touch of the brush runs along the perimeter laid down by these lines of force; following them, it completes its own circuit, like blood through the veins or planets along their orbital paths, two discoveries made by Baroque curiosity, which project their form—circle dilated, anamorphosis of the circle: ellipse—on the form that supports Rubens' canvases. The dense red and the heavy igneous spheres pass through the body, through space—around the heart, around the sun—and at the same time they burn invisible ellipses into the canvas, with the fury of a brush strewing red fibrils, golden filaments.

This stroke—liberated, delivered over to the gesture's drive, but passing through a precise matrix, as if in order to transgress the limits of structure the most important thing were to keep it constantly present—refers us to the modus operandi of two contemporary painters; in their work the internal structure does not extend to the composition as a whole but only to the human body considered as limit or logos.

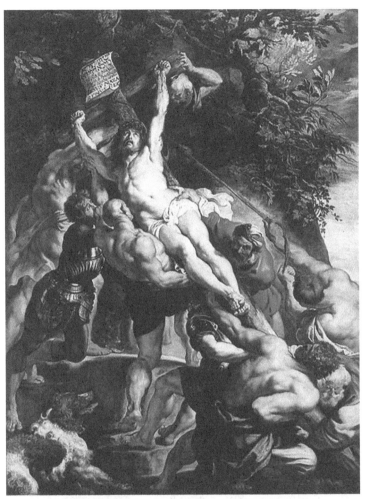

FIGURE 5: Peter Paul Rubens, *The Elevation of the Cross*, center panel, 1609–1610. Oil on canvas, 460 cm x 340 cm. Cathedral of Our Lady, Antwerp. Source: Wikimedia Commons.

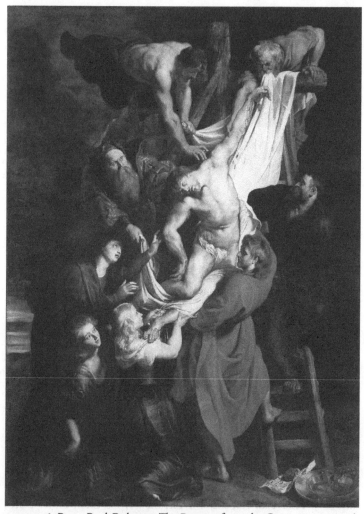

FIGURE 6: Peter Paul Rubens, *The Descent from the Cross*, center panel, 1611–14. Oil on canvas, 421 cm x 311 cm. Cathedral of Our Lady, Antwerp. Source: Wikimedia Commons.

In De Kooning lips, eyes, hands, fragments of the model's body or cuttings of photographs, pasted onto the canvas, direct the brushstrokes; they serve as the *simulacrum of a body* that must be erased/underscored, sacrificed/saved.

In Saura, the presence of the body as lacerated and reconstituted phantasm is, more than somatic, cultural: the model, which in the system of value-effects of Art History tends to bear the connotation of a privileged signifier, serves as here as *border*, or as victim for a provocation, as target[2] for the nervous bombardment of ink.

If we insert the reading of Rubens into the decryption—and the practice—of a return of the Baroque (the return of crisis and the monolithic state, the return of astronomy and biology), his painting can be discovered again, and as a supplement, now possible, it will begin to reveal for us, like successive scenes within the scene, the emergence of what then was censored: beneath the sumptuousness of Catholic spectacle, the animality of Greek myth—reading the crucifixions as combats of Lapiths and centaurs—and beneath this, the seminal fury of the brushstroke: metonymy of the phallus in the hand and the paintbrush.

Furious Baroque

Where should we situate, today, the effects of a Baroque artistic discourse? Or rather: the distorted reverberation, accentuated to the point of the excessive or the mannered, of the discourse provoked, in the seventeenth century, by a furious will to instruct, a desire to convince, to demonstrate beyond doubt—by force of theatrical illuminations and precise lineaments—what the word of the Council prescribed.

It is not a matter, however, of compiling what remains of the founding Baroque but rather—as has occurred in literature with the work of José Lezama Lima—to articulate the statutes and premises of a new Baroque that would incorporate the pedagogical self-evidence of the old forms, their legibility, their informational efficacy, and at the same time would seek to pass through them, to irradiate them, to sap them by way of their own parody, by that humor and that intransigence—frequently cultural in nature—that are proper to our time.

This baroque—furious, disputatious, and new—cannot emerge elsewhere than on the critical or violent margins of a vast surface, that of a language, ideology, or civilization, in the space—at once lateral and open, superposed, eccentric, and *dialectal*—of

the Americas: edge and contestation, displacement and ruin of the Spanish Renaissance surface, exodus, transplant and end of a language, of a knowledge.

The handling of information by Latin American artists, conceptual or otherwise, could be one of the most significant indices of this possibility, the possibility of a contemporary Baroque. Figuration, or the classical sentence, conveys a piece of information by the most simple means: straight syntax, the hierarchical arrangement of figures and the scenography of their gestures intended to bring out, without "perturbations," what is essential in the *istoria*, the *meaning* of the parable; the spectacle of the Baroque, on the contrary, postpones, defers to the maximum the communication of a *meaning* by means of a contradictory mechanism of the mise-en-scène, a multiplicity of readings that finally reveals, rather than a fixed and univocal content, the mirror of an ambiguity.

The same holds, transposed into the code of contemporary representation, in the work of South American conceptual artists. With one difference: the postponement of meaning—and more energetically, the critique of it—is obtained by working in a cold, meticulous way upon the specific support, upon the graphic signifier of information: on the level of product—newspapers folded, crumpled, torn up, stapled, or nailed—and on the level of production: operations involving the redesign, decomposition, and reorganization of journals and reviews, disruption or "de-creation" of mass media communication in order to generate false news or to demonstrate the extent of "professional" codification in news set forth as true, the factitious mechanics of any will to information.

Edge or margin of the surface: the procedures that the technique of the *center*—the European Baroque—had codified appear in isolation, marked by their own recurrence; here, on the periphery, they find themselves stripped of any functional pretext, expelled from the logic of representation, excluded from any simulacrum of truth.

If anamorphosis—point at which the perspectival system tips over, slips into illegibility, into a confusion of blurry strokes, limit and excess of its functioning—was used in the founding Baroque to encode an informational supplement—frequently moral: allegory or *vanitas*—it reappears in the South American Baroque reduced to pure critical artifice, pointed up, beyond any didactic aim, as a procedure. Its "nature" as a trick is exposed: neither the deceiving seashell that will reveal, when of the ambassadors nothing remains but hollow splendor, the simulacrum of representation traded in for pure surface, the grave and grayish, sermonizing skull, nor the landscape that, as we shift position, as we withdraw from the frontal point of view, taken for normative and unique, will have to be reinterpreted, integrated into a new sequence: no, the head—I speak of a *Portrait* by Hugo Sbernini—is seen frontally and sectioned into multiple fields in schematically Archimboldesque fashion, but in *The Gentleman with the Nostalgic Smile*, the anamorphic points of view, incompatible, are not synthesized in any totalizing image, intimidating or otherwise; they do not lead us to any supplementary knowledge; they simply develop, before our gaze, the appearance and derision of the human figure, in the unfurling and folding back on itself of a body assimilated to pure depthless surface. The body can adhere to, can be inscribed upon a ribbon, one that can always undulate, turn back upon itself; the face's axis of symmetry appears slightly displaced, dislocated; this proportion, undone—this appearance dissolved as if by a slight subsidence—leads not to the revelation of an image that had been sealed off, supplanted by the screen of frontal vision, but to the revelation of anamorphosis as a purely rhetorical artifice: the slightest discalibration throws it out of focus, reduces it to a squinting mask, blocks it from making meaning.

As to that other facet of the Baroque—Caravaggio's—, the realist attitude likewise lacks today the meaning it had in the theatricalized field of chiaroscuro: it is no longer a matter of summoning reality *into* the painting, submitting it to brutal light, illumination

Furious Baroque 111

in contrast, in order to extract from it, from its symbolic configuration or its mythological or biblical referents, a lesson, nor is it a matter of revealing, by over-expression, the arbitrary magnification or hypertrophy of a detail, a moral truth opposed to the simulation that the painting configures, but rather of *realizing the painting* to such a point that it is accredited and justified as a new fragment of objective reality, thus affirming, contrary to what American hyperrealism would seem to imply, that so-called reality is worth no more and no less than this, that there are no hierarchies, in verisimilitude or ideology, when the illusion is planned and configured with the same stubborn meticulousness as the reality that, at this degree of pinpoint exactitude, no longer precedes it.

There remains, as simple confirmation of the Baroque, as its return—but this time the return not of a transplanted Baroque but one of an already South American "origin"—, the renewal of group work, the evangelical dream of the collective, the cellular organization of an ideal order: architectural projects, plans for communities, precise and rational cities: the phalanstery paradigm.

Ideological Baroque that, although actuated by a different urgency and a different subversiveness, is not at odds—though it may not know this—with the Jesuit activity of yesteryear.

The Heir

I. The Efficacious Sign

> Hölderlin is the pre-cursor of poets in a destitute time. This is why no poet of this age can overtake him. The precursor, however, does not go off into a future; rather, he arrives out of that future, in such a way that the future is present only in the arrival of his word.
>
> —Heidegger, "What Are Poets For?," 1946[1]

Lezama is, in our space, that precursor; his work is the one that, coming forth from the future, returns to us or invites us to summon it, so that, in its advent, the future may make itself present. Thus he who lived in the vocation of the word made flesh, of time turned enemy, subverts with his word, which makes its way back toward us, the very direction of time. But how should we provoke this return, how can we manage to make the precursor—without his renouncing that function, the function of a guide—become again familiar, contemporary? How to restore for ourselves the vast fiction of *Paradiso*, reactivate it in the reality of our present and anchor it once more in the reality of our destitute time?

A meditation on Lezama, on the possible inheritance of his word, cannot avoid these lines of questioning, nor omit to link them with another one: the one concerning the possibility and pertinence of the Baroque today, concerning a probable emergence of the Neo-Baroque out of his work, in the Caravaggio light of his scenography, or in the incandescent ellipse of his theatricality.

But, to elucidate the possibility of this Neo-Baroque, to trace its helices and volutes, we first must inquire into the textual foundation of what then already could bear the name of the first Baroque, the one that bursts forth in the violent light of the Counter-Reformation and animates the Tridentine impulse.

What takes place in the Council? Above all, a new structuring of religious history, a new division of its eras, which entails a novel utterance [*enunciación*] of the phenomena, if we consider that these are what we perceive with ease in the vast Christian iconography, the most succinct representation of the gospels, their illustration. The Counter-Reformation thus uncovers the weaknesses of the first utterance [*enunciado*], the fatigue of literality, in order to bestow upon them a vitality or a pedagogical fury—anything in order to convince—unheard-of, the brio of the Baroque.

The seventh session of the Council is the most revealing one. At issue are the sacraments, above all baptism and confirmation. The Tridentine Fathers favor, against the Lutheran conception of faith, what they call—without realizing that in this they are promulgating an entire semiology of the Baroque—the *efficacious sign*: "the sacraments are operative *by the very fact of their execution*."[2] The entire ritual, the whole scenography that governs the execution of the sacraments, thus accrues a particular privilege: "They also drew up the decree concerning the Sacrifice of the Mass, in which it is taught that the Sacrifice of the Mass is the memorial and representation of the Sacrifice of the Cross, with the same Sacrificer and the same offering, the two sacrifices differing only in the mode of the offering."[3]

The critique of the sign and the new utterance of religious phenomena entail, of course, a radical revision and reexamination of earlier texts: the Fathers, in rejecting, for example, "the conception of original sin as the disposition to evil,"[4] and in considering nature, in itself, as not sinful, perform a genuine subversion with respect to the fundamental texts of the Church; "they do so as well in authorizing the Vulgate and admitting its theological use, granting it the status of official and sufficient text, capable of establishing dogma."[5]

But there is more: the lectureship of sacred Scripture is instituted; preaching becomes obligatory, and, above all, "bishops are granted control over preachers, even when the latter belong to a religious order";[6] the church even begins to monitor monks' whereabouts, thus putting an end to the "gyrovagues" who led an itinerant, almost nomadic life.

If I have dwelled upon the acts of the Council and upon the new perception of the texts and the foundations of the Church at work in them, upon the origin of that pedagogical and theatrical crusade which will continue to this day to constitute the Baroque, it is in order to ground this "style" in the very moment of its conception and to elucidate the equivalence of the Lezaman gesture, in its radicality, with the founding gesture of the Council. The same furious rereading and reshaping of history, the same passion for the *efficacy of the sign*. We find the same creative and critical impulse, with a—very Cuban—supplement, in what can be considered the foundation of the Neo-Baroque: here, the theological foundations of history, or its signifying sequences, do not get reshaped; instead, other cycles are superimposed on them, cycles invisible to empirical chronology, to causality, but more efficacious, more real, even, than those that model the progression of events, the development of civilizations. These *imaginary eras* generate and sustain visible history, the history of names, acts, and dates, and at the same time transcend it to include it in a vaster cycle, comparable to the *kalpa* of the Buddhists, in which

poetry justifies the apparently illogical concatenation of actions and gives them their full meaning: "The conviction that the image expressed itself just as much in the imaginary eras, in historical periods that, without producing great poets, lived to the fullest a great poetry. From Virgil to the appearance of Dante no great poets emerge; and yet, it is an epoch of great poetry. It's the period of the Merovingians, and all of Europe is full of spells and wonders. The common man is convinced that Charlemagne conquered Zaragoza at the age of two hundred and twenty, like the men of the Old Testament; the pilgrimages begin, as does the construction in stone of the great symbols."[7]

The literary sign, too, recovers in Lezama its Tridentine efficacy, since it is the only one, among us, that functions *by the very fact of its execution*: *Paradiso* does not turn on the construction of its characters, nor the fitting together of a meticulous fiction; nor a teleology nor, of course, a thesis; but rather on the mise-en-scène, or the ritual execution, of a particular sign, that sign which by reason of its phonetic density, its concentration, and its drama functions on its own, by the very fact of its utterance. The characters and the intrigue are nothing but excesses, overflows, reverberations of this efficacious sign that in a certain sense can be identified with the *supra verba* of which Lezama speaks: a word that does not present itself upon the page, on a neutral, two-dimensional, denotative, and functional surface, conveyor of one more element of information, but that possesses, on the contrary, "its three dimensions of expressivity, concealment, and sign."[8] Like the Council,[9] *Paradiso* amplifies history in the hyperbole of the imaginary eras; it also performs a reexamination of the texts by their filtration through the maieutics of the dialogues, which are frequently a settling of philosophical or religious accounts, and other diagonal cuts, electric arcs in the succession of names and ideas, with the function of focalizing the story on a particular relation of coincidence or opposition: "Let me dive into the Hellespont or the pool of Siloam, but now you're beginning to

look like a Marcionite who wants to unite Plato, Euclid, and Aristotle with Christ, Peter, and Paul. At the end of the creative life, Nietzsche adds to the malignancies of European culture you've already mentioned in his last work, *Ecce Homo*, and justifiably attacks the historical sense and the scientific spirit."[10]

II. Gold

> I am telling you all that precisely because I just got back from the museums, and because the Counter-Reformation was ultimately a return to the sources and the baroque the parading thereof. The baroque is the regulating of the soul by corporal radioscopy. [. . .] For the time being, I am only speaking of what we see in all the churches in Europe, everything attached to the walls, everything that delights, everything that is delirious. It's what I earlier called obscenity—but exalted.
>
> —Lacan, *Encore*[11]

Paradiso is the sumptuous display of this return to the sources, which are, in this case, those of the first Baroque—but a return in which the Gongorine props return to us in the form of exalted obscenity. The motley figures of Greco-Roman mythology are cataloged in the *Soledades* with heraldic acuity: they are oneiric coats of arms, possessing an opaque, nocturnal knowledge, which go about weaving, in the wake of the castaway's adventure, the rural choreography of a dance or the joy of a wedding, a whole hieroglyphic density, the images of an initiation and a deciphering.

These improbable or chimerical characters appear—their first appearance among us—in the *Espejo de paciencia*; but they appear there, as Cintio Vitier has pointed out, superimposed, in Arcimboldian fashion, upon tropical flora and fauna, in a painterly metonymy, whose displacement, there already, is the displacement proper to our dreaming, and whose constitution, there already, is the constitution of the island imaginary.

They return, at last, in *Paradiso*, but not as recognizable mythological entities, nor as naughty little divinities assimilated to guardian orishas, but as *traits*, details, particular focalizations in which the text spurts, jumps, goes from delight to delirium, transforming plain Cuban reality into a *grotesque* scenography, marvelous and teratological. This return to the mythological, assimilated to the hypertrophy of a fragment, to its abrupt illumination, is exhibited in *Paradiso* as an exaltation of obscenity: segmented body, fetish that acquires the majesty of a phallic colossus: "Farraluque's phallic configuration was extremely propitious for that retrospective penetration, for his barb had an exaggerated length beyond the bearded root. With an astuteness worthy of a Pyrenean ferret, the Spanish girl divided its length into three segments, motivating, more than pauses in her sleep, the true hard breathing of proud victory. The first segment comprised the hardened helmet of the glans [*glande*], joined to a wrinkled fragment, extremely tense, extending from its lower contour and the glans [*balano*] stretched like a string waiting to be plucked."[12]

If we could put to diachronic use three of the essential points of Lacanian topology, assigning them to the three symbolic periods, we might hazard the following hypothesis: if *A* predominates in the Lacanian algorithm, we are in the symbolic space of *Classicism*; if we privilege $ in the same schema, we are in Romanticism; if, finally, *(a)* is at the fore then we come into the apogee of the Baroque.

"The Other is the big Other (*A* in Lacan) of the language that is always already there. It is the Other of universal discourse, of everything that has been said insofar as it is thinkable. I would say that it is also the Other of the library of Borges, the total library. It is also the Other of truth, that Other that is a third with respect to every dialogue, because, in the dialogue of the one and the other, there is always present that which functions as point of reference for agreement and disagreement alike."[13] This Other of the total

library ends up establishing itself as a code. It is at the site where the code is found that the message is elaborated, just as it is at the site of Classicism that tradition and subversion alike are generated: the Big Other, then, is the place of Classicism.

The structure of the Lacanian subject involves a doubling, or rather that sort of division that brings with it the function of the double; something splits it, unsticks it, and for that very reason associates it symbolically with the Romantic hero, unsettled by an opacity, incapable of transparency with regard to himself. Its symbol is $.

Finally, the object *(a)*, fundamentally and definitionally lost: it operates in "the division in which the subject is verified in the fact that an object traverses it without them interpenetrating in any respect, this division being at the crux of what [. . .] goes by the name of object *(a)*."[14] An object that finds itself put in relation with the residual, for example, with what occupies the irreducible bottom of the Klein bottle, with the opaque, with something that falls from the body and repeats it as its own materiality: *the gold and its double*, the overloaded pomp of the Baroque and, even more, that of the Neo-Baroque of *Paradiso*, seem to subsist under the sign of this *(a)*, like a miniaturization and a reflection of the other A in the Lacanian algorithm, that of the Great Code and the total library.[15]

Paradiso is like the parenthesis that encloses this object *(a)*, the mounting within which gleams this diminutive, dark, and irregular pearl. Apotheosis and ridicule of baroque gold and its residual, nocturnal double, but with a proviso: involved in its very definition is this object's fall into opacity, the concealment that is also its illegibility. This is also what splits the subject's unity and marks in it an insurmountable flaw: an absence to itself. In *Paradiso*, every elevation—even in the ceremonial and liturgical sense of the term—comes followed or backed by its own double, by the descending metaphor that contradicts and completes it, by its snide, parodic other. That laughter, furtive and subversive,

like a Yoruba mask laughing between sugarcane leaves, is, besides, one of the most Cuban traits. There is a passage among us, in the colonial era, from the suave laughter observed already by the discoverer to a frank republican laughter, later arriving, in *Paradiso*, at this little knit-browed chortle, violent but stifled, that has the same virulence, the same energy of *choteo* and condemnation as a guffaw but that never makes it to outburst, to explosion, to cartoonish and syncopated explicitness.

This particular hilarity is what, as underside of the composure and the straightened bearing of the first Baroque—which represents a return to equilibrium and not, on the contrary, a moderation of the excess and rapid volute of Mannerism—turns *Paradiso* into a book that founds. The golden exaltation and its underside, homage and profanation, the praise and mockery heaped upon a single character: a whole system of bivalences, arrows pointing in opposite directions, programmed contradictions and asymmetries: "One of the oarsmen, indiscreetly jabbed by midnight chocolate, got up to give his intestinal snake a turn. With the stealthy breeze that pitied the spasmodic contractions, he sought the advantages of the toilet, next to the sleepers' room, near the stone staircase leading down to the Sneffels basement. Freed of his running cargo, his ears grew sharp as he came out of sleep. He heard in Syracuse, in the so-called Ear of Dionysius, the echoes that magnified breathing into a lowing. He heard an oily slipping along the last steps. He made out Baena Albornoz, a towel wrapped around his waist, going off in search of the novice, who was waiting for him with his Pompeian lance at the ready."[16]

The epiphany radiates its own fragmentation, as if magnetically attracted by what descends, what falls, by an *antipodal lover*. Gold and residue united by the same gravitational pull and always in the same image, invisible counterparts: "The lard that cared for the gilding of the crullers turned over on top of the eyes of the hooded ones. A door on one of the balconies overlooking the

square, flying open in the shock of the shouting, made the canary's water run off, falling on the faces of the accursed ones like the urine of contempt, the infinite transformation of the rage of a bird locked in its golden cage. The morning, leaping from yellow to watercress green, sang to deafen the horsemen who were parrying with the fruit cart and the canary's cage."[17]

III. The Heir

> Hence the presentation of what is original has in full the character of a discovery. A discovery, however, that in an incomparable—in the deepest—way is combined with recognition. It is the recognition of the unheard-of as something at home in immemorial nexuses. The discovery of the actuality of a phenomenon as the discovery of a representative of forgotten nexuses of revelation.
>
> —Walter Benjamin, *Trauerspielbuch*[18]

> Benjamin interpreted the various forms of baroque aesthetic—ornament, scroll, fragment—as so many projections into space of a petrified temporal dynamic. In this sense, baroque forms express nothing: they are pure variations, arbitrary signs that refer to nothing, like a play of hieroglyphs hiding no meaning.
>
> —Stéphane Mosès, *The Angel of History: Rosenzweig, Benjamin, Scholem*[19]

The heir is the one who deciphers, who reads. Inheritance, more than a gift, is a hermeneutic obligation. Heir is he who, thanks to the flash of a deciphering, takes possession, in an instant, of a body of knowledge. When he translates the enciphered stone, when he reads it, Champollion—so present, and not by chance, in Lezama—inherits in that moment, and transmits to us, the millenary night of the hieroglyphs, the knowledge inscribed in the basalt; Freud, when he reads the unfinished images of our physical

night and the wordplay that traverses them, discovers and inherits a space, a place, that of the unconscious. Lezama is the decipherer of the *island night*, of the nocturnal hieroglyphs, incandescent doodles in the dense air of the archipelago, which, like little souls or fireflies, populate and magnetize these islands adrift in the sea. This reading, which has its basis in a theology of Augustinian extraction, constitutes the space of the Americas as an open, gnostic space and culminates in a teleology. I do not doubt that the force of the image constructed by Lezama in that teleology—which frees the islands from myth, from the European dream they were, from the utopian prism through which they were seen, in order to incarnate them in their identity, to engross them in themselves—is present in everything that today, upon the basis of theology, seeks to liberate, to rid us of the superimposed archaic image. At the same time, the entry into this gnostic space is the disappearance of the European—the congealed—Baroque, the first Baroque, an entry into another proliferation that is, above all, *another intensity*: "'The congealed forms of the European Baroque—and every proliferation expresses a damaged body—disappear, in the Americas, into that gnostic space that the New World knows on account of the sweep of its landscapes, on account of its excessive gifts.' Thus from the beginning the myth of insularity, which was not a phenomenon to be sought in our lyric, as Juan Ramón supposed, but the reminiscence of the mythical image of the American island, fits into that landscape of generous transmutations, that space where the formal Spanish seed opens upon a tradition of stones turned warriors, objects turned images, like the army of the Inca Viracocha, and upon an unknown futurity."[20]

The inheritor, then, in deciphering, lays a foundation. Interpretation is a basis. But if Lezama, like Hölderlin, is the precursor, the one who comes before his time, the one who returns

from the future, how to inherit now not that which precedes us but that which succeeds us, that which will come after us and which no one can surpass? Perhaps by *deciphering against the tide*, bringing about, through our reading, the coming of the word, so that the future turns into a present, into presence. To inherit Lezama is to practice this form of listening, without precedent or parallel, that escapes gloss and imitation. To divine, more than to decipher; to include, to graft meaning, even if behind the play of its hieroglyphs meaning is an excess, an overload, and one which, like the landscape, is known to these signs by that amplitude, those excessive gifts; to deconstruct, more than to give structure.

The characters, the situations, the perverse and textual miracles of *Paradiso* have to reverberate, have to be unfolded, reactivated in another space, fluorescent and separate, in order to endow them thus with a supplement of life, a root of eternity. This is what I tried to do, by projecting into a fiction, the novel *Maitreya*, a secondary character, Luis Leng, who barely occupies a few lines of *Paradiso*.

But perhaps to inherit Lezama is, above all, to take on his *passion*, in the two senses of the word: indestructible vocation, dedication, and suffering, agony. To know that the decipherer, precisely because he contests and disturbs the established code, is condemned to indifference, or to something worse than frank aggression and frontal attack: to derision. Any detail whatsoever can serve as a bloodstained banner to his detractors—his sexuality, for example—; any of his texts, the fruit of nightless nights, years of withdrawal and silence, can be cast as a "butterflying about,"[21] any of his evasions as an intrigue.

Heir is also he who, in the lightning flash of reading, seizes possession of this solitude and takes it on with the certainty that, were it not for alienation, contemporary life would not attain its logos. "What certain truth with which to approach the present

day, for were it not for alienation, contemporary life would not achieve its logos. Were alienation suppressed, life would be turned into a snowy plain, in the same way that Saint Augustine, in his time, demanded the existence of heretics, and much later Gracián, with bitter tolerance, accepts that 'this world coheres in incoherences.'"[22]

—Saint-Léonard, 1988

Fractal Baroque

As always, we begin with a triangle, one whose vertices are: an idea, seemingly very simple, the kind that anyone could have thought up, like the egg of Columbus; an author; a book. The triangle—by an at first unforeseeable fecundity, which nothing would have allowed us to discern—is multiplied, and its multiple occurrences end up making themselves felt just about everywhere, becoming the measure of a multitude of experiences. More than that: this idea, this man, this book soon become the emblem of the era, a diagram of passing time. This is what is happening today with the *fractal*, with the particular twist that its dissemination is inscribed in its very principle.

The author, of course, is Benoît Mandelbrot, the nonconformist physicist specializing in "irregular figures and variations"; the book is *Fractals: Form, Chance, and Dimension*;[1] the idea is that of giving form to a mathematical monster, one which, stepping into the bullring, I will try my best to tame.

Adequation of the Geometric to the Living

It made its first appearance more than a century ago. One finds it in a letter marked by paradoxical calligraphy—the

characters look like the legs of flies, stretched forward, and the accents close back onto themselves into globes—a letter from Cantor to Dedekind, in which the very notion of dimension is called into question: a surface, for example a square, can be put into one-to-one correspondence with a continuous "curve," for example, the side of the square. From this writing, with its insistent contrasting figures, there thus proceeds an idea that today is not only in the midst of revolutionizing "hydrology, the study of turbulence, anatomy, botany"[2] but is even propagating itself—and here it concerns us more directly—into the art of literature.

In the interim, at the end of the nineteenth century, the monster in question appeared once again. It is already no coincidence that it was in the era of Art Nouveau, of pregnant volutes and vegetal curves, the era when Gaudi, Gallé, and Klimt came into their own, that the mathematician Peano traced space-filling curves: obstinate figures, growing more and more cramped, that finally fill a polygon, passing through all its points without ever intersecting. At the time, these diagrams seemed to belong to the realm of perverse recreations; we will see that today, they have come to be seen as the geometric model of numerous realities.

Monsters of the same kind apparently continued to multiply, precisely because no name, no symbol, had been assigned to them, because they had been recorded in no registry, and because, in short, they were thus bound to remain repressed. Along comes Mandelbrot, who enunciates the fractal as such: a set of figures somewhere between surface and volume, whose outline is fragmented and in which each fragment has the same structure as the whole. Take, for example, the internal surface of the lung: on the one hand, it constitutes the entire volume, and vice versa; on the other hand, from the bronchi to the least of the alveoli it repeats the same obstinate design. Or take a snowflake—such, at least, as the mathematician Von Koch proposed to construct it—; one begins with an equilateral triangle, to each side of which a similar triangle gets attached, and so on,

the operation repeating itself to infinity: what one thus obtains is the fractal object par excellence.

We see the idea in its simplicity: on the one hand, a fragmented form which occupies, to the maximum, and in all its dimensions, a given space; on the other, the structural identity—homothety—between the total figure and the least of its parts, in a game of endlessly diminishing scale. A simple idea, but one endowed with considerable operative force, in the sense that one encounters again here the very ancient idea of an adequation of the geometric to the living in particular and the concrete in general.

It was by the roundabout path of a practical experience that Mandelbrot found himself the theorist of a new way of apprehending the world: a cartographer, analyzing the irregularities of coastlines and the impossibility of assigning them a whole number, he thought of the Latin *fractus* and constructed the generalized concept of the *fractal*.[3] Which permits one to formalize—or, as they say, to model—a number of natural objects that until that point resisted any attempt to give them form. Such as the cauliflower . . . or, as it would seem, gruyère. But equally, and at the other end of the scale, one can ask—and some have—whether the universe, whose "model" is subject to ceaseless revision, as none of those that are proposed fails to leave a remainder, might not itself be a fractal object. Turbulences, the branches of the Nile, and the grouping of galaxies would have, then, the same primordial model.

Dialogue of the Deaf

More than once since the beginning of the twentieth century, art and science have entered into an intimate dialogue, which is also to say a dialogue of the deaf. The kind that reveals itself, necessarily, to be the most fertile of all. Just think of all the painters, of different tendencies—from Duchamp to Matta—who had the ambition of representing what, in the rigor of its definition, could

be nothing other than unrepresentable: the fourth dimension, not to mention those that follow. Nothing, then, but a mathematical "caprice"—in the same sense as the *Caprices* of Goya—, but one that rattles the tradition of representation.

The same encounter is in the process of repeating itself with regard to the fractal. The loudest-whirring computers and the most seductive synthetic images are liable to produce, in as many varieties as one desires, minutely programmed fractal objects, capable of competing with those that nature, in its capacity of designer and tinkerer, has spent millennia developing. It is well known that composition by computer on screens placed side by side is one of the obligatory sights on any stroll through what one could call, after the manner of the Chinese classics, the Garden of Electronic Paintbrushes. There's no reason the representation of the fractal shouldn't be multiplied there.

But there is more. Some artists, painters, and writers, not too numerous, it's true, have set out in search of something else, no longer a simple reproduction but the construction of fractal systems as aesthetic principle: what one could baptize a *fractal art*. It is evident that, beyond the sometimes fairly obscurantist recourse to the prestige of a scientific term for the sake of its aura, the meditated and measured relation of a poem or canvas to the ideal objects of Mandelbrot cannot be anything other than metaphorical. What exactly could we call a poem or story with a homothetic structure and an irregular principle, if not one constructed in such a way that the paragraphs, verses, words, and phonemes are nested, repeating, at their respective scales, the same distributions and the same arbitrary figures, from the whole down to the element. A limit case, clearly theoretical, and incompatible with the structure of language, with its disjoint levels, which will never be able to give more than an approximation. But the challenge is sufficiently stimulating for the Brazilian poet Horacio Costa to take it up in his *Book of Fracta*. Doubtless the approximation comes more naturally in painting—but for the indefinite transplantation

of forms into the increasingly minute. And it is not an accident that one of the classic examples of the fractal is Hokusai's waves. The painter Carlos Ginzburg confronts the problem in his latest canvases, in which every fragment and every conglomerate of fragments reflects in its way the same asymmetrical montage that engenders the entire painting.

One could, again, consider Bauhaus architecture, with its repetitive, nested right angles to have already offered a kind of advance hint of homothety. But certain inflatable volumes, whose envelopes repeat, in dividing themselves, the initial form, would be a more exact approximation of the fractal. On reflection, it becomes blindingly, or rather deafeningly obvious that in the moments of the greatest serialist rigor in which arbitrary choices of scale in pitch, intensity, timbre, and attack were combined, and this from beginning to end of the piece, often by means of the reduction of the set to each of its parts—what remains today, still, Stockhausen's project—something like the law of the fractal was fully operative.

Let's not go too quickly, and let us be wary of any facile symmetry: it is more than probable that, upon rigorous reflection, we will discover again the same misunderstanding into which the paintings of the fourth dimension fell. Where? In the unpredictability of fractal forms, perhaps. In what they owe to chance, and to the way chance puts holes in every kind of project.

But what we can retain from these various efforts is that they manifest a *horror vacui* whose modulus is a paradoxical figure, foreign to rational geometry: in which they rejoin two of the principles of the Baroque. Their limit in this direction is that if their complexity grew to the extreme, there would remain nothing recognizable in them, and that if they were to proliferate to infinity, to the infinitesimal, there would be nothing left in them to read, see, or hear: of a square through all of whose points there had passed nested similar polygons, there would remain nothing, in the end, but a black form, featureless. And as to a volume, it

is hard to see what it could mean to fill it with a pleated surface, which would effectively annul any interior space. One has to stop before the blackout. No plenum to see, hear, or conceive, without its vacuum.

Or again: the fractal is after all nothing other than a realization of what Deleuze designates as the *fold*, and one could write: a fold of folds. But here as everywhere, what for science can be an infinitely repeated constitutive act cannot, for perception, be anything but a global effect: art cannot be endless.

Notes

INTRODUCTION

1. François Wahl, "Biography of a Few Paintings (For Rubén Gallo)," trans. Richard Sieburth and Françoise Gramet, *The Princeton University Library Chronicle* 73, no. 3 (2012): 443.
2. Severo Sarduy, *Cartas*, ed. Manuel Díaz Martínez (Madrid: Editorial Verbum, 1996), 29. Unless otherwise noted, all translations are mine.
3. Sarduy to his family, February 17, 1960, Severo Sarduy Family Correspondence, Special Collections, Princeton University Library.
4. Sarduy to his family, March 26, 1960, Severo Sarduy Family Correspondence, Special Collections, Princeton University Library.
5. Sarduy to his family, June 17, 1960, Severo Sarduy Family Correspondence, Special Collections, Princeton University Library.
6. Sarduy, "c'est chez nous . . ." in Severo Sarduy, *Obra completa*, vol. 1, ed. Gustavo Guerrero and François Wahl (Madrid: ALLCA XX, 1999), 29.
7. Sarduy to his family, June 30, 1960, Severo Sarduy Family Correspondence, Special Collections, Princeton University Library.
8. Sarduy to his family, October 10, 1960, Severo Sarduy Family Correspondence, Special Collections, Princeton University Library.
9. Sarduy to his family, May 21, 1961, Severo Sarduy Family Correspondence, Special Collections, Princeton University Library.
10. Sarduy to his family, November 20, 1961, Severo Sarduy Family Correspondence, Special Collections, Princeton University Library.
11. Included in this volume, alongside another essay of the same period, "Cubes." Both appeared in the 1975 French edition of *Barroco*.
12. Juan de Jáuregui, *Discurso poético*, (Madrid, 1624), 9.

13. José Lezama Lima, "Serpent of Don Luis de Góngora," in *A Poetic Order of Excess: Essays on Poets and Poetry*, trans. James Irby and Jorge Brioso (Los Angeles: Green Integer, 2019), 236.
14. Roberto González Echevarría, *La ruta de Severo Sarduy* (Hanover, N.H.: Ediciones del Norte, 1987), 102.
15. Roland Barthes, "The Baroque Face," trans. by Susan Homar, *Review: Literature and Arts of the Americas* 53, no. 1 (2020): 22; translation modified.
16. Barthes, "The Baroque Face," 22.
17. Barthes, "The Baroque Face," 23.
18. Barthes, "The Baroque Face," 22.
19. Roberto González Echevarría, "Severo Sarduy (1937–1993)," *Revista Iberoamericana* (1993): 757.
20. Roberto Fernández Retamar, "Calibán," *Casa de las Américas* 68 (1971): 146; Roberto Fernández Retamar, "Una aclaración necesaria a propósito de unas palabras de Roberto González Echevarría," *Revista Iberoamericana* 60, no. 168–69 (1994): 1179–82.
21. Sarduy to Manuel Díaz Martínez (undated) in *Cartas*, ed. Manuel Díaz Martínez, 35.
22. Sarduy to Manuel Díaz Martínez, April 24, 1967, in *Cartas*, ed. Manuel Díaz Martínez, 37.
23. Leonardo Acosta, "El 'barroco americano' y la ideología colonialista," *Unión* 11, no. 2–3 (1972): n. 37, 63. The essay was later included as "El barroco de Indias y la ideología colonialista," in *El barroco de Indias y otros ensayos* (Havana: Casa de las Américas, 1984), n. 37, 51. For a different valorization of this state of affairs, see the striking image of Sarduy's *passaporte ausente* as stamped with the "authentic seal" of a "chthonic tattoo" in Haroldo de Campos, "Para um tombeau de Severo Sarduy," in Severo Sarduy, *Obra completa*, vol. 2, ed. Gustavo Guerrero and François Wahl (Madrid: ALLCA XX, 1999), 1723.
24. Sarduy, "Un Proust cubain," *La Quinzaine littéraire*, no. 115 (April 1971): 3.
25. Acosta, "El 'barroco americano,'" 59.
26. Acosta, "El 'barroco americano,'" 59.
27. Severo Sarduy, "The Baroque and the Neobaroque," trans. Christopher Winks, in *Baroque New Worlds: Representation, Transculturation, Counterconquest*, ed. Lois Parkinson Zamora and Monika Kaup (Durham: Duke University Press, 2010), 270–91. Originally included

in César Fernández Moreno, ed., *América Latina en su literatura* (Paris: UNESCO, 1972), 167–84. Haroldo de Campos has claimed priority as the originator of the term on the basis of his 1955 essay "A obra de arte aberta." There he uses *neo-barroco*, without developing its possible significance, as an alternate name for Pierre Boulez's "conception of the *open artwork* as a 'modern Baroque.'" Haroldo de Campos, "A obra de arte aberta," in Augusto de Campos, Décio Pignatari, and Haroldo de Campos, *Teoria da poesía concreta* (São Paulo: Edições Invenção, 1965), 33.

28. Sarduy reused the closing section of "The Baroque and the Neobaroque," with additions as *Barroco*, I.V. I quote from this passage as translated in the present volume.

29. Roland Barthes, *The Pleasure of the Text*, trans. Richard Miller (New York: Farrar, Straus & Giroux, 1975), 8.

30. Sarduy to his family, November 30 & December 12, 1972, Severo Sarduy Family Correspondence, Special Collections, Princeton University Library.

31. Monika Kaup, "Neobaroque: Latin America's Alternative Modernity," *Comparative Literature* 58, no. 2 (2006): 128.

32. See Severo Sarduy, *Nueva Inestabilidad* in *Obras III: Ensayos* (Mexico City: Fondo de Cultura Económica, 2013), 343–95.

33. See, for example, *Barroco*, 50–59 in the present volume, where Sarduy repeatedly treats repression and foreclosure as equivalent.

34. Lois Parkinson Zamora and Monika Kaup, "Baroque, New World Baroque, Neobaroque: Categories and Concepts," in *Baroque New Worlds*, 10.

35. Sarduy, "The Baroque and the Neobaroque," 271; Eugenio d'Ors, *Lo barroco* (Madrid: Tecnos, 1993). On Sarduy's engagement with d'Ors, see the third section of the present introduction.

36. See *Barroco*, 10 in the present volume.

37. Severo Sarduy, *Nueva Inestabilidad*, in *Obras III: Ensayos*, 377–78, n. 1; Severo Sarduy, "El barroco après la lettre," interview by Alberto Cardín and Biel Mesquida, *Diwan*, no. 5–6 (1979): 89.

38. See for example Rolando Pérez, "Entre literatura, artes visuales y ciencia: la imagen de pensamiento de Severo Sarduy y Ramon Dachs," in *Cámara de eco. Homenaje a Severo Sarduy*, ed. Gustavo Guerrero and Catalina Quesada (Mexico City: Fondo de Cultura Económica, 2018), 140.

39. *Nueva Inestabilidad*, in *Obras III: Ensayos*, 377–78, n. 1.

40. "What strikes me," writes Alain Badiou, "without denying the comparative and metaphorical exuberance of Sarduy's prose, is the extraordinary *discipline* of his project. This is a discipline that we can rightfully compare to that of children, when they agree on a game's rules. As a matter of fact, to change everything sordid into a superior game is certainly one of Sarduy's ambitions. And it is to the abstract complexity of the rules of composition of this game that we should assign the word 'baroque', certainly not to the proliferation of images." (Alain Badiou, *The Age of the Poets and Other Writings on Twentieth-Century Poetry and Prose*, trans. Bruno Bosteels (New York: Verso, 2014), 184).

41. Sarduy, "El barroco après la lettre," 90.

42. See, e.g., *Obras III: Ensayos*, 345; 377–78, n. 1; 383–84.

43. Fernand Hallyn, *The Poetic Structure of the World: Copernicus and Kepler* (New York: Zone Books, 1990), 58.

44. For some typical readings of *retombée*, see Catalina Quesada, "Vagabundas azules y enanas blancas: principios de astronomía aplicada," in *Cámara de eco: Homenaje a Severo Sarduy*, ed. Gustavo Guerrero and Catalina Quesada (Mexico City: Fondo de Cultura Económica, 2018), 32; Omar Calabrese, *Neo-Baroque: A Sign of the Times* (Princeton, N.J.: Princeton University Press, 1992), 10–11; Rolando Pérez, *Severo Sarduy and the Neo-Baroque Image of Thought in the Visual Arts* (West Lafayette, Ind.: Purdue University Press, 2012), 54–56; Rolando Pérez, "Entre literatura, artes visuales y ciencia: la imagen de pensamiento de Severo Sarduy y Ramon Dachs," in *Cámara de eco*, 140–41; Françoise Moulin Civil, "Invención y epifanía del Neobarroco: Excesos, Desbordamientos, Reverberaciones," in *Obra completa*, vol. 2, 1655.

45. The "untranslatability" of *retombée* is hence local to Spanish and easily explained. For obvious reasons the corresponding Spanish expression—*lluvia (radioactiva)*, (radioactive) rain—is not available for the same semantic development undergone by its French and English counterparts. The translator of the 1980 Italian edition had no difficulty finding a more or less workable equivalent: *ricaduta*, whose history tracks with that of *fallout* and *retombée(s)*.

46. E.g., "La significance est une opération dont la structure n'est qu'une retombée décalée." Julia Kristeva, *Sēmeiōtikē: recherches pour une sémanalyse* (Paris: Éditions du Seuil, 1969), 279; see also the characterization of existentialism and the Nouveau Roman as "retombées culturelles"

in the unsigned introduction to the collective volume *Théorie d'ensemble* (Paris: Éditions du Seuil, 1968), 8.

47. Françoise Wegener, *Entretien avec Severo Sarduy* ("Le baroque? Une guerre entre le cercle et l'ellipse"), *Le Monde*, March 7, 1975, 16. Sarduy worked for Radio France and wrote a number of radio plays, translated into English by Philip Barnard in Sarduy, *For Voice* (Latin American Literary Review Press, 1985). See also Anke Birkenmaier, "Severo Sarduy y la radio," in *Cámara de eco*, 234–55.

48. Sarduy, "El barroco après la lettre," 89.

49. Quoted in Jorge Brioso, "Introduction," José Lezama Lima, *A Poetic Order of Excess*, 9. See José Lezama Lima, Letter to Carlos Meneses (August 3, 1975), in "Homenaje a Lezama Lima," *Revista de la Biblioteca Nacional de Cuba José Martí* 29, no. 2 (May–August 1988): 91.

50. Severo Sarduy, "Las estructuras de la narración," interview by Emir Rodríguez Monegal, *Mundo Nuevo*, no. 2 (August 1966): 24.

51. Gustavo Guerrero, "Algunas notas sobre Sarduy y su Neobarroco," in *Le néo-baroque cubain* (Paris: Presses de la Sorbonne Nouvelle, 1998), 91.

52. Alejo Carpentier, "The Baroque and the Marvelous Real," in *Magical Realism: Theory, History, Community*, ed. Lois Parkinson Zamora and Wendy B. Faris (Durham, N.C.: Duke University Press, 1995), 100.

53. Carpentier, "On the Marvelous Real in America," in *Magical Realism: Theory, History, Community*, ed. Zamora and Faris, 84.

54. Carpentier, "On the Marvelous Real in America," in *Magical Realism: Theory, History, Community*, ed. Zamora and Faris, 88; translation modified.

55. Eugenio d'Ors, "Historia y Geografía," *ABC Madrid* (May 21, 1926): 4, 7.

56. D'Ors, "Historia y Geografía," 7.

57. D'Ors, "Historia y Geografía," 7.

58. Eugenio d'Ors, *Coupole et monarchie: Suivi d'autres études sur la morphologie de la culture* (Paris: Libraire de France, 1926), 64.

59. Ángel Guido, *Fusión hispano-indígena en la arquitectura colonial* (Buenos Aires: El Ateneo, 1925); *Redescubrimiento de América en el arte* (Buenos Aires: El Ateneo, 1944).

60. Guido, *Fusión hispano-indígena en la arquitectura colonial*, 92.

61. Pál Kelemen, *Baroque and Rococo in Latin America*, vol. 1 (New York: Dover, 1967), x.

62. D'Ors, *Lo barroco*, 35.

63. Alejo Carpentier, *El siglo de las luces: Obras completas de Alejo Carpentier*, vol. 5 (Mexico City: Siglo Veintiuno Editores, 1990), 214. See also Steve Wakefield, *Carpentier's Baroque Fiction: Returning Medusa's Gaze* (Woodbridge, U.K.: Tamesis, 2004), 34, and Guadalupe Silva, "Contrapunto cubano: Teorías del barroco en Alejo Carpentier y Severo Sarduy," *Zama: Revista del Instituto de Literatura Hispanoamericana*, no. 6 (2014): 155.

64. Carpentier, "The Baroque and the Marvelous Real," in *Magical Realism: Theory, History, Community*, ed. Zamora and Faris, 106.

65. Alejo Carpentier, "Questions Concerning the Contemporary Latin American Novel," trans. Michael Schuessler, in *Baroque New Worlds*, 262.

66. Sarduy, "The Baroque and the Neobaroque," 281; translation modified.

67. Sarduy, "The Baroque and the Neobaroque," 281.

68. Sarduy, "The Baroque and the Neobaroque," 272.

69. Eugenio d'Ors, *La vall de Josafat: Obra catalana d'Eugeni d'Ors*, vol. 11 (Barcelona: Quaderns Crema, 1987), 196.

70. Eugenio d'Ors, *El secreto de la filosofía* (Barcelona: Editorial Iberia, 1947), 136.

71. Eugenio d'Ors, *Goya* (Madrid: Libertarias/Prodhufi, 1996), 255.

72. D'Ors, *Goya*, 257.

73. Enric Jardí, *Eugeni d'Ors: Vida i obra* (Barcelona: Aymà, 1967), 186.

74. D'Ors, *Lo barroco*, 24.

75. The Spanish original of *Lo barroco* was published only in 1936, but it appeared in French translation the year prior. See Eugenio d'Ors, *Du baroque*, trans. Agathe Rouart-Valéry (Paris: Gallimard, 1935).

76. António Ferro, *Oliveira Salazar: el hombre y su obra* (Buenos Aires: Editoriales reunidas, 1942), 20.

77. Ferro, *Oliveira Salazar*, 20–21.

78. D'Ors, *Lo barroco*, 80.

79. See *Barroco*, 78 in the present volume.

80. See *Barroco*, 47–49 in the present volume.

81. The crucial texts are "The Serpent of Don Luis de Góngora" (1953) and "Baroque Curiosity" (1957), in *Baroque New Worlds*, 212–40. Together they form a diptych. "Serpent" shows the loss of landscape

in Góngora: "The circumstance of the Counter Reformation makes of Góngora's work a Counter Renaissance. It removes the landscape whose center his luminosity might occupy. The Jesuit baroque [. . .] had already surrounded him with [. . .] a landscape in plaster" (Lezama Lima, *A Poetic Order of Excess*, 227). "Curiosity" shows a landscape regained in the Americas. There, when "the tumult of the Conquest and the colonizer's parceling out of the landscape have receded into the distance," Gongorism transcends its merely "verbal character" to become a form of life, "a second nature," for the "Baroque gentleman [. . .] now established in his own landscape" (Lezama Lima, in *Baroque New Worlds*, 214; translation modified). In the rather paternalistic conceit with which "Curiosity" closes, this "gentleman [. . .] participates in, watches over and protects the two great syncretisms at the root of our American Baroque, the Hispano-Incaic and the Hispano-Negroid" (Lezama Lima, *Baroque New Worlds*, 238; translation modified: I restore here Lezama's original and unpleasant expression). Lezama's quip in "Curiosity" about the New World Baroque as *contraconquista* needs to be read in the full context of the development beginning with the similarly structured and much less frequently quoted statement in "Serpent." For a careful consideration of the Baroque for Lezama, see Maarten van Delden, "Europe and America in José Lezama Lima" in *Baroque New Worlds*, 571–92.

82. José Lezama Lima, "Baroque Curiosity," 212. The reference is to d'Ors's statement that "The sea is sublime. This, in the language of the arts, is equivalent to saying that it is Baroque; Wölfflin has noticed the essential Baroque quality [*barroquismo*] of the pictorial genre known as 'marine.'" D'Ors, *Lo barroco*, 108.

83. José Lezama Lima, "Corona de las frutas," *Lunes de Revolución*, vol. 40 (1959): 22.

84. Lezama Lima, "Corona de las frutas," 22.

85. Lezama Lima, "Corona de las frutas," 22–23.

86. Lezama Lima, "Corona de las frutas," 23.

87. Lezama Lima, "Baroque Curiosity," 222; translation modified.

88. Sarduy, "El barroco après la lettre," 99.

89. D'Ors, *Lo barroco*, 35.

90. Sarduy, "El barroco après la lettre," 99–101. For Sarduy's analysis of transvestism and transsexuality as hypertelic undermining of naturalized femininity, see *La simulación* in *Obra completa*, vol. 2, 1267–69.

91. Jacobo Machover, "Conversación con Severo Sarduy: 'La máxima distanciación para hablar de Cuba,'" in *Le néo-baroque cubain*, 71.

92. On the place of Lacan in Sarduy's work, see especially Rubén Gallo, "Sarduy avec Lacan: The Portrayal of French Psychoanalysis in *Cobra* and *La simulación*," *Revista Hispánica Moderna* 60, no. 1 (2007): 34–60.

93. See *Barroco*, 58 in the present volume.

94. Gustavo Guerrero, "Reflexión, ampliación, cámara de eco: Entrevista con Severo Sarduy," *Obra completa*, vol. 2, 1838–39.

95. Aside from the canonical texts by Louis Althusser and Gaston Bachelard, works consulted on this theme by Sarduy include Dominique Lecourt, *Pour une critique de l'épistemologie* (Paris: François Maspero, 1972) [Dominique Lecourt, *Marxism and Epistemology: Bachelard, Canguilhem, and Foucault*, trans. Ben Brewster (London: NLB, 1975)] and François Wahl, *Qu'est-ce que le structuralisme? 5. Philosophie. La philosophie entre l'avant et l'après du structuralisme* (Paris: Éditions du Seuil, 1968).

96. Severo Sarduy, "Tanger," in *Tel Quel*, no. 47 (1971): 86.

97. Severo Sarduy, "Tanger," 86.

98. "I do not rank real art among the ideologies, although art does have a quite particular and specific relationship to ideology." Louis Althusser, "A Letter on Art in Reply to André Despre," in *Lenin and Philosophy, and Other Essays*, trans. Ben Brewster (New York: Monthly Review Press, 1971), 221.

99. Severo Sarduy, "The Baroque and the Neobaroque," 271; translation modified. Winks translates both *epistémico* and *epistemológico* as "epistemological," thus obscuring Sarduy's distinction.

100. Heinrich Wölfflin, *Renaissance und Barock: Eine Untersuchung über Wesen und Entstehung des Barockstils in Italien* (Munich: Theodor Ackermann, 1888), 58.

101. See *Barroco*, 7–8 in the present volume.

102. Sarduy, "El barroco après la lettre," 89–90.

103. Wölfflin, *Renaissance und Barock*, 58.

104. François Wahl, "Le poète, le romancier et le cosmologue," in Sarduy, *Obra completa*, vol. 2, 1682.

105. Severo Sarduy, "Mudo combate contra el vacío," interview by Ana Eire, *Inti: Revista de literatura hispánica*, no. 43 (1996): 363.

106. Sarduy, *Obra completa*, vol. 2, 1422.

107. Sarduy, *Obra completa*, vol. 2, 1422.

108. Sarduy, *Obra completa*, vol. 2, 1427.

Notes to pages xxxii–7 139

109. Sarduy, *Obra completa*, vol. 2, 1423.
110. See *Barroco*, 26 in the present volume.
111. See *Barroco*, 35 in the present volume.
112. François Wahl, "Severo de la rue Jacob," in Severo Sarduy, *Obra completa*, vol. 2, 1520.
113. Walter Benjamin, *The Correspondence of Walter Benjamin, 1910–1940*, ed. Gershom Scholem and Theodor W. Adorno, trans. Manfred R. Jacobson and Evelyn M. Jacobson (Chicago: University of Chicago Press, 1994), 256.
114. Walter Benjamin, *Origin of the German Trauerspiel*, trans. Howard Eiland (Cambridge: Harvard University Press, 2019), 10–11.
115. Benjamin, *Origin of the German Trauerspiel*, 25.
116. Friedrich Nietzsche, "On the Baroque," in *Baroque New Worlds*, 44; translation modified.
117. Gilles Deleuze, *The Fold: Leibniz and the Baroque*, trans. Tom Conley (Minneapolis: University of Minnesota Press, 1993), 38.
118. Deleuze, *The Fold*, 37.
119. Walter Benjamin, *The Arcades Project*, trans. Howard Eiland and Kevin McLaughlin (Cambridge: The Belknap Press of Harvard University Press, 1999), 463.
120. See Bill Marshall, *André Téchiné* (Manchester: Manchester University Press, 2013), 21.
121. See *Barroco*, 47 in the present volume.
122. "The Fury of the Paintbrush," included in the present volume, along with the following subchapter, "Furious Baroque."
123. See "The Fury of the Paintbrush" in the present volume.
124. Included in the present volume. It was included as "Un heredero" in José Lezama Lima, *Paradiso*, ed. Cintio Vitier (Madrid: ALLCA XX, 1988), 590–97; published as "El heredero," *Filología*, 24 (1989): 275–85; and collected in Sarduy, *Obra completa*, vol. 2, 1405–13.
125. See "The Heir," 113 in the present volume.
126. See "The Heir," 117 in the present volume.
127. See "The Heir," 122 in the present volume.

ECHO CHAMBER

1. Ratified history [*histoire sanctionnée*] (history of the scientific in scientific practice); lapsed history [*histoire périmée*] (history of the interventions of the non-scientific upon scientific practice). Cf. Gaston

Bachelard, *L'activité rationaliste de la physique contemporaine* (Paris: Presses Universitaires de France, 1951); and Dominique Lecourt, *Pour une critique de l'épistémologie* (Paris: François Maspero, 1972), 34. [Dominique Lecourt, *Marxism and Epistemology: Bachelard, Canguilhem, and Foucault*, trans. Ben Brewster (London: NLB, 1975), 140.]

THE WORD "*BARROCO*"

1. Quatremère de Quincy, *Dictionnaire historique d'architecture* (Paris: Librairie d'Adrien le Clere, 1832). [Translation mine —Trans.]
2. Eugenio D'Ors, *Du Baroque* (Paris: Gallimard, 1968), 84.
3. According to the definition A. J. Greimas gives in the preface to Louis Hjelmslev, *Le Langage* (Paris: Éditions de Minuit, 1966).
4. Victor L. Tapié, *Le Baroque* (Paris: Presses Universitaires de France, 1961), 9. Italics mine. [Translation mine —Trans.]
5. Gérard Farasse, "La portée de l'Abricot," in Roland Barthes et al., *Le texte: de la théorie à la recherche* (*Communications*, no. 19) (Paris: Éditions du Seuil, 1972), 186. [Translation mine —Trans.]
6. Farasse, "La portée de l'Abricot," 186. [Translation mine —Trans.]
7. The passage from Galileo to Kepler is the passage from the circle to the ellipse, from *what is traced around the One* to *what is traced around the plural*, passage from the Classical to the Baroque: "The rupture that dismisses the collection of all sets—and prevents it from being included among them—institutes a limit, and it is around this limit, it is on the basis of its effect, that the fantastical symphony of the one and the infinite, the singular and the dispersed, shall play out, duality felt and traced in the body, and which shall be expressed subsequently as the duality of power-law and desire, between everything *that revolves around the One* (paternal function, "union" in a community, "unity" of action) and *what evolves, instead, on the side of the plural*—or of the *plurien*—(sexual relations where the bodies are at least two in number, whatever it is that goes unknown for them; schizophrenia, in which the body breaks into pieces, is multiplied)." Daniel Sibony, "L'infini et la castration," *Scilicet*, no. 4 (Paris: Éditions du Seuil, 1973), 82. [Translation mine —Trans.] I suppress the author's italics and add my own in order to assimilate the circle and the ellipse to the two terms the author opposes.
8. Eugenio Battisti, *Rinascimento e barocco* (Turin: Einaudi, 1960), 276. [Translation mine —Trans.]
9. Battisti, *Rinascimento e barocco*, 278. [Translation mine —Trans.]

10. Gérard Genette, "L'or tombe sous le fer," in *Figures* (Paris: Éditions du Seuil, 1966), 33. [Translation mine —Trans.]

COSMOLOGY BEFORE THE BAROQUE

1. Jacques Merleau-Ponty and Bruno Morando, *Les trois étapes de la cosmologie* (Paris: Robert Laffont, 1971), 46. [*The Rebirth of Cosmology*, trans. Helen Weaver (New York: Knopf, 1976), 27.]
The Platonic prestige of the circle is anchored, evidently, in Pythagorean teaching; rather less cited is its anchoring in Heraclitus, for whom the meaning of the circle, identical to its meaning for Plato, can be read—as Cassirer has done in *La philosophie des formes symboliques*, vol. 2 (Paris: Éditions de Minuit, 1972), 165. [*The Philosophy of Symbolic Forms, Volume 2: Mythical Thinking*, trans. Steve G. Lofts (New York: Routledge, 2021), 148, 162, 161]—as a symbolic inversion with regard to Buddhism, in which for the first time recourse is taken, systematically, to this figure as a privileged signifier.

"In the *Questions of Milinda*, King Milinda asks Saint Nagasena for a metaphor for the transmigration of souls. Nagasena draws a circle on the ground and asks, 'Has this circle an end, great king?' 'No, my lord, it does not.' 'So moves the cycle of births.' 'Is there then no end to this chain?' 'No, there is none, my lord.'"

"As with Buddha, Heraclitus has a fondness for the image of the circle [. . . in whose] circumference, [. . .] the beginning and the end are one. However, whereas for Buddha, the circle serves as a symbol of the endlessness and hence aimlessness and senselessness of becoming, for Heraclitus, it serves as a symbol of perfection. The line returning to itself indicates the uniformity of form, the figure as the basic determining law of the universe—and similarly, Plato and Aristotle made use of the figure of the circle to ground and form their intellectual image of the cosmos."

This is not the only case of a "flip" in the deductions made from the same concept, between Buddhism and Heraclitus: the same occurs with the concept of the mutability of form, cause for retreat, for flight, in Buddhism—Siddhartha chooses ascesis upon seeing an old man, a sick man, and a dead man; for Heraclitus, in contrast, the logos only manifests itself as broken apart into its oppositions; these must be conserved: "The oppositions unite themselves and from opposites is created the most beautiful harmony," "a unification of opposing tensions, like that of the bow and the lyre"; "disease makes health pleasant and good,

hunger satisfaction, weariness rest." In Heraclitus opposites, reversed, become equivalent: "It is always one and the same that dwells in us." His aim is not to dissolve them, to annul them as representatives of impermanence, but rather to underscore them as relative opposition, temporal sign of the *harmonia palintropos*, mark of the logos.

If in this brief archaeology we stop at the Buddhist stratum, it is not because we consider it foundational: instead of the wheel and the circle of *saṃsāra*, we could have recalled the cobra coiled on itself, the Vedic solar circles (cycles) and, before that, intuitions inscribed in genetic knowledge: eye, mouth, anus. Body: world of nine wells.

"The metaphor of the wheel, never radically separate from that of the ring or the sun, forming together with it a strict textual system from which we will not emerge, is effective for describing the movement and design of a world as of a text. [. . .] Circular and also circulatory paradigm that regulates the circulation and exchange of opposed elements, of identity and difference. The wheel and the sun's course involve the metaphorical image of this exchange that can be understood as dialectic itself." Wheel, ring, and circle (resonance of what has no *telos* and return of the cyclic, in which "what is closest is also already, in itself, the furthest away") operate as *annulation* of metaphysics—which is thus reduced to nothing, formed into a ring—annulation of the paradigm whose dissemination or *heliology* traverses all of Occidental discourse, from Plato to Nietzsche. These textual revolutions and orbits—their dialogue with their astronomical equivalents remains to be investigated—are analyzed by Bernard Pautrat, *Versions du soleil: figures et système de Nietzsche* (Paris: Éditions du Seuil, 1971), 12. [Translation mine —Trans.]

2. Like Zarathustra, Er, the Pamphylian of the *Republic*, comes from Persia. The same heliologic model unites the two discourses, opposed on the wheel, of Plato and Nietzsche.

3. Plato, *The Republic*, Book X, 616c et seq. Here I give Albert Rivaud's synthesis in *Timée; Critias* (Paris: Société d'édition "Les Belles Lettres," 1925), 53. [Translation mine —Trans.]

4. Albert Rivaud, "Études platoniciennes," *Revue d'Histoire de la philosophie* (January–March 1928): 1–26. [Translation mine —Trans.]

5. An essential mark is inscribed in the cosmology—as idealist as it is foundational—of the *Republic*: that of the system of knowledge where it makes its appearance. The rainbow column, the notion of axis, and, formulated later, that of a set of solid and crystalline heavenly spheres, were

already, in the moment of their conception, unviable in another context: in ancient China a theory of infinite and empty space had already been formulated, one that could not produce its effect—that is to say, dissolve the European conception—until after Galileo. Cf. Joseph Needham, *The Grand Titration: Science and Society in East and West* (London: Allen and Unwin, 1969), 59. Crudely positivist temptation—and thus opposed to the functioning of *retombée*—: to consider the Chinese formulation or the formulation, cited below, of Aristarchus of Samos as scientific "truths" more pertinent than others, on the basis of their subsequent confirmation. In the strict sense—science considered in terms of its conceptual coherence at a given moment—these theories, irrefutable today, were no more scientific in the moment of their formulation than their opposites, which were consonant with—and thus valid for—the *episteme* of their time.

6. *The Republic of Plato,* trans. Francis MacDonald Cornford (New York: Oxford University Press, 1951), Book X, 614b.

7. The armillary sphere, as a model of the ideal sphere, comprehends the perceptible heavenly sphere and, as it were, "knows more than it does"—but less than the ideal, perfectly numerical figure as whose support it serves; just as, in the other scene, death knows more, in its inclusive exteriority, in this system of inclusions, of *comprehensions*.

8. The fountain, the play of water as the sole mobile element, and, all around, its ordered reflection, are the best isomorphism of the *Almagest*: "One constitutive element of the Madrasa courtyard is the fountain—rectangle or basin—that occupies its center, with a small jet of water. The only place, one can tell right away, of movement, reflection, dispersion. Acoustic and visual mobility. Fragmented mirror. In a set of abstract, fixed forms, devoid of any furniture, it is the index of variety, of the instant. Incomplete, centered, unstable figure of a discourse uttered once and for all—with no instance of utterance. Impoverished moment, but sole moment of saying in a place full of the said." François Wahl, *De la Medersa au Tafilalet.* [Translation mine —Trans.]

9. Merleau-Ponty and Morando, *Les trois étapes,* 48. [*The Rebirth of Cosmology,* 29].

10. Nicholas Copernicus, *De revolutionibus orbium coelestium* [*On the Revolutions of the Heavenly Spheres*], I.I, chap. VIII, cited in Alexandre Koyré, *Galileo Studies,* trans. John Mepham (New Jersey: Humanities Press, 1978), 134.

11. Alexandre Koyré, *Études Galiléennes* (Paris: Hermann, 1966), 170. [*Galileo Studies*, 135.]

12. More than beginning or invention of perspective, one would have to speak of its mutation or second concretion: Panofsky has demonstrated—above all in "Perspective as Symbolic Form"—how the Antiquity and the Renaissance had two distinct conceptions of spatiality conceived as an *a priori* form of knowledge: a discontinuous, antithetical, finite conception—that of objectivism—which engenders a curved perspective, with a fishbone convergence on a vanishing axis; bodies, endowed with their own light and shadow, appear as disconnected and isolated realities, without that common denominator that will be homogeneous space, or its symbolic expression: the single vanishing point. The space that corresponds to this perspective is only the absence of bodies and does not seem to extend, in the representation (by juxtaposition) of these bodies, any further than the limits of the represented: everything takes on an unreal, almost spectral quality, as if extracorporeal space could make itself felt only at the expense of solid bodies—as if, in so doing, it drew away from them, vampirically, their true substance.

This compartmentalized space is succeeded by another one, homogeneous, which corresponds to modern subjectivism and will prevail up to the time of Cubism, symbolized, in its representation, by convergence on a point that, although well defined in the picture, is ideal; all the orthogonal lines coincide at that single point, which corresponds to the progressive geometrization of the universe, even in its expression by the three Cartesian coordinates.

13. Hubert Damisch, *Théorie du nuage* (Paris, Éditions du Seuil, 1972), 233. [*A Theory of /Cloud/: Toward a History of Painting*, trans. Janet Lloyd (Stanford, Calif.: Stanford University Press, 2002), 169.]

14. G. C. Argan and N. A. Robb, "The Architecture of Brunelleschi and the Origins of Perspective Theory in the Fifteenth Century," and Pierre Francastel, *Peinture et société: naissance et destruction d'un espace plastique, de la Renaissance au cubisme*, cited in Damisch, *Théorie du nuage*, 235. [*A Theory of /Cloud/*, 171.]

15. Merleau-Ponty and Morando, *Les trois étapes*, 49. [*The Rebirth of Cosmology*, 29.]

16. Françoise Choay, "Notes préliminaires à une sémiologie du discours sur la ville," H.C., 5. [Translation mine —Trans.]

17. [In English in the original. —Trans.]

18. Alberti investigates the geometral laws of perspective, and in that field, where all the era's interest in vision is centered, Lacan sees a *retombée* of the institution of the Cartesian subject, which is also a kind of geometral point, a perspectival point. Cf. Jacques Lacan, *Le Séminaire, Livre XI* (Paris: Éditions du Seuil, 1973), 81. [In line with the decision most prevalent among Lacan translators, I retain the Desarguean expression *géométral* in English. —Trans.]

19. No matter—we insist—if this correlate precedes it: *De revolutionibus orbium coelestium, libri sex* appears in 1543; the first perspective plan of Florence, drafted by Alberti, is from 1483; Leonardo's plans—for Cesare Borgia—are from 1502.

A *décalage* of the epistemological break can also take place in the opposite direction, as occurred, for example, in urban space: "What is essential [. . .] is to apply to the urban instrument, or, more generally, to instrumental space, the methods of the technological worldview. But there is no need to be surprised if this technological approach sometimes appears to reverberate with ancient echos. It is founded on sciences that precede it in time, with regard to which it is delayed, and whose epistemological breaks do not coincide with its own: thus the concept of set was elaborated almost a century before serving as a basis for the technological practice of industrial societies; for the practitioners of the nineteenth century, such as Haussmann, it was available only virtually." Françoise Choay, *Connexions* (Paris: H.C., 1970), 30. [Translation mine —Trans.]

Retombée need not respect causalities (as common sense teaches us to expect: the humanist conceptual corpus, grown natural, which functions as such) but rather, paradoxically, shuffles them [*barajándolas*], spreading out on the table, *en dépit du bon sens*, its autonomy, which sometimes—as in the following example—annuls them, or their cooperation: "Huyghens' clock, which alone gave experimental science its precision, is merely the organ that fulfills Galileo's hypothesis concerning the equal gravitational pull on all bodies—that is, the hypothesis of uniform acceleration that confers its law, since it is the same, on every instance of falling. It is amusing to point out that the instrument was completed before the hypothesis could be verified by observation, and that the clock thereby rendered the hypothesis useless at the same time as it offered it the instrument it needed to be rigorous." Jacques Lacan, *Écrits* (Paris: Éditions du Seuil, 1966), 286–87 [*Écrits: The First Complete Edition in*

English, trans. Bruce Fink (New York: W. W. Norton, 2006), 237], and Alexandre Koyré, ["An Experiment in Measurement"], *Proceedings of the American Philosophical Society* 97, no. 2 (April 1953)—cited by Lacan.

20. Jean T. Desanti, "Que faire d'un espace abstrait?" in *Connexions*, 84. [Translation mine —Trans.]

21. Paolo Portoghesi, *Borromini nella cultura europea* (Rome: Officina Edizioni, 1964), 15. [Translation mine —Trans.]

22. Orthogonal projections—François d'Aguillon, 1613; projective bases—Gérard Desargues, 1642; analytic geometry—Descartes and Fermat, 1639; representation of geometric magnitudes as aggregates of primitive elements—Bonaventura Cavalieri, 1635.

23. Alexandre Koyré, *Études Galiléennes*, 212, note 2. [*Galileo Studies*, 222, note 115.]

24. Galileo Galilei, *Dialogue* I. [Cited in Koyré, *Galileo Studies*, 156–57, after Stillman Drake's translation in *Dialogue Concerning the Two Chief World Systems, Ptolemaic and Copernican* (Berkeley: University of California Press, 1962), 19. Original in *Le opere di Galileo Galilei*, vol. 7 (Florence: Tip. di G. Barbèra, Edizione nazionale, 1897), 43.]

25. The same reasoning is to be found in *De motu*, in the *Dialogue*, and in the *Discourses*, cited by Koyré in *Études Galiléennes*, 208. [*Galileo Studies*, 156.]

26. Charles Bouleau, *Charpentes: La géométrie secrète des peintres* (Paris: Éditions du Seuil, 1963), 122. [*The Painter's Secret Geometry: A Study of Composition in Art*, trans. Jonathan Griffin (New York: Harcourt, Brace & World, 1963), 117.]

27. Yves Bonnefoy, *Rome, 1630* (Paris: Flammarion, 1970), 173–74.

28. [Sarduy is referring here to Jean Paulhan, *The Flowers of Tarbes, or, Terror in Literature*, trans. Michael Syrotinski (Urbana: University of Illinois Press, 2006). —Trans.]

29. Galileo Galilei, "Considerazioni al Tasso," in *Opere*, IX, ed. Antonio Favaro, (Florence: Giunta, 1890–1909), 63. Cited in Damisch, *Théorie du nuage*, 88. [*A Theory of /Cloud/*, 59.]

30. Galileo, "Considerazioni al Tasso," in *Opere*, IX, 129. Cited in Damisch, *Théorie du nuage*, 187. [*A Theory of /Cloud/*, 135.]

31. Damisch, *Théorie du nuage*, 187. [*A Theory of /Cloud/*, 134.]

32. Damisch, *Théorie du nuage*, 188. [*A Theory of /Cloud/*, 135.]

33. Roland Barthes, "Tacite et le baroque funèbre," in *Essais critiques* (Paris: Éditions du Seuil, 1964), 108.

34. Marquetry and Baroque: "Nothing less fluid, less molten, more abrupt than the vision expressed there. Certainly this universe offers at first a profusion of colors, substances, sensible qualities, and what astounds upon first contact is its wealth; but soon these qualities organize themselves into differences, these differences into contrasts, and the world of sense is polarized according to the strict laws of a sort of *geometry of matter*." Genette, "L'or tombe sous le fer," 29–30. [Translation mine —Trans.]

35. Baroque language could be compared to that "basic language" (*Grundsprache*) in which the hallucinations of Senatspräsident Schreber are expressed, and which Lacan identifies with the *autonymous* messages of which linguists speak: the object of communication is the signifier and not the signified. The message, in the Baroque, is the relation of the message to itself; in the "basic language" of the chief justice—which, like that of the Baroque, is somewhat archaic but always rigorous [*sic*: paraphrasing Schreber, Sarduy reproduces a slip from Lacan's *Écrits*, where *rigoureux* appears in place of Schreber's *kraftvoll=vigoureux*. —Trans.] and rich in euphemisms—the relation between the beings emitting these words is analogous to the connections of the signifier; their nature, moreover, is purely verbal: they are the "entification" of the speech they support. Jacques Lacan, *Écrits*, 537–38. [*Écrits: The First Complete Edition*, 450.]

36. Giuseppe Conte, *La metafora barocca* (Milan: U. Mursia, 1972), 76, 95. [Translation mine —Trans.] I consider this "Baroque," centered on metaphor, to be a pre-Baroque, reserving the name of Baroque proper for art isomorphic with Keplerism and *(de-)centered* in the ellipsis.

BAROQUE COSMOLOGY: KEPLER

1. The attachment to a form always conceals an attempt at ideal totalization: one postulates a sameness of matrix, an *agreement* of primary sensible structures—static or dynamic—with a common model or generator thus promoted to the rank of ultimate, *ergo* ontological signified. If the reduction to the circle seems crude to us today, the temptation of a positivist reading remains: one dealing with purely formal interactions—that is to say, forgetting, evading, or repudiating the instance of the subject, its insertion into the symbolic field where the enunciation of these forms is carried out. Today, a deciphering of this kind would lead us to assert that if a figure traverses us and models the Cosmos,

it is without a doubt the spiral: DNA is configured as a double helix; the Milky Way has spiral arms. The helicoidal Mannerism put forward by the *contrapposto*, which deforms and propels figures, and the Borrominian Baroque, in drafting the helix-towers of Sant'Ivo alla Sapienza, would have brought about the appearance in reality—the passage into the space of representation—of this primary paradigmatic structure.

But rather than confirm or falsify this isomorphism, one would have to investigate the logocentric basis of all isomorphic reduction; this investigation, this transcending of isomorphic thinking, requires the negation/integration of the formal models, just as the transgression of metaphysics implies that its limits are still active; the transcendence of metaphysics is carried out—Derrida asserts—as an aggression and transgression reliant on a code to which metaphysics is irreducibly linked.

2. 1. The planets describe ellipses one of whose foci [*centros*] is the center of the sun; 2. The line that joins the center of the sun to the center of the planet sweeps out equal areas in equal periods of time; 3. The ratio of the cube of the semimajor axis to the square of the period is the same for all the planets.

3. "This very cogitation—the infinitude of the Universe—carries with it I don't know what secret, hidden horror; indeed one finds oneself wandering in this immensity, to which are denied limits and center and therefore also all determinate places." (Kepler cited in Alexandre Koyré, *From the Closed World to the Infinite Universe* (Baltimore: Johns Hopkins Press, 1968), 60–61). Pascal, as is well known, felt the same horror, but with a difference: for him, the vertigo of the infinite engenders its vortex: where there is no place, where place is lacking—there, exactly, the *subject* is found.

4. One of the possible "tabular models" would consider the "decentering," the "double center"—a present center that could be assimilated to the signifier and a virtual center that could be assimilated to the signified, etc. I apply to this figure a textual operation proposed by Julia Kristeva, *Sēmeiōtikē = Recherches pour une sémanalyse* (Paris: Éditions du Seuil, 1969).

5. A subsequent text will have to investigate the *retombée* of the parable/parabola and the hyperbol(a/e); this one limits itself to disseminating the ellips(e/is), foundation of the Baroque.

6. Choay, *op cit*, 93, n.1. [Translation mine —Trans.]

Notes to pages 43–50 149

7. Portoghesi, *Borromini nella cultura europea*, 11. [Translation mine —Trans.]

8. Portoghesi, *Borromini nella cultura europea*, 11. [Translation mine —Trans.]

9. Lewis Mumford, *The City in History: Its Origins, Its Transformations, and Its Prospects* (New York: Harcourt, 1961), 365.

10. Lewis Mumford, *La Cité à travers l'histoire* (Paris: Éditions du Seuil, 1964), 465. I borrow from the same author the simultaneity of historical events. [I follow the French translation of Mumford ("Car c'est dans l'empreinte qu'il a laissée sur des formes vivantes que se retrouve son histoire"), as the figure on which Sarduy relies here is not present in the original. —Trans.]

11. Like *The Feast in the House of Simon* at the Chicago Art Institute.

12. Giovanni Paolo Lomazzo, *Trattato dell'arte della pittura, scultura et architettura* (Milan: Pietro Tini, 1585), book 6, ch. 4, 296. [Translation mine —Trans.]

13. I employ here a Lacanian definition of metonymy, as articulated by François Wahl in Tzvetan Todorov, *Dictionnaire encyclopédique des sciences du langage* (Paris: Éditions du Seuil, 1972), 442.

14. José Lezama Lima, "Sierpe de don Luis de Góngora," in *Lezama Lima (Los grandes todos)* (Montevideo: Arca, 1968), 192–93. ["Serpent of Don Luis de Góngora," in *A Poetic Order of Excess: Essays on Poets and Poetry*, trans. James Irby and Jorge Brioso (Los Angeles: Green Integer, 2019), 222.]

15. Lezama Lima, "Sierpe de don Luis de Góngora," 215. ["Serpent of Don Luis de Góngora," 254.]

16. Lezama Lima, "Sierpe de don Luis de Góngora," 196. ["Serpent of Don Luis de Góngora," 227.]

17. Upon the *Soledades*, Lezama projects the metaphor of the *dark night*, in what he considers a textual complementarity: Góngora/Saint John of the Cross: "What that penetration by luminosity lacked was San Juan's dark night, since that ray of poetic knowledge without an accompanying dark night could only display a lightning bolt of falconry upon a plaster cast. Perhaps no nation has ever had its poetry posited in such a concentrated way as at that Spanish moment when Góngora's metaphorical ray, evidencing its painful incompletion, needs and calls out for that amicably enveloping dark night. [. . .] The survival of baroque Spanish poetry will consist in the ever contemporary possibilities

of Góngora's metaphorical ray enclosed within San Juan's dark night." Lezama Lima, "Sierpe de don Luis de Góngora," 204, 209. ["Serpent of Don Luis de Góngora," 238, 245.]

The function of the positive beside the negative—the object and its night—as complementarity and alternation, could be assimilated, more than to any element of classical thought—despite the Aristotelian connotations which we have pointed out—to a system of conflicting dualities in whose juxtaposition there is a to-and-fro movement and which would be legible by way of the Hegelian dialectic or through its origins in Renaissance thought: Bruno.

18. Lezama Lima, "Sierpe de don Luis de Góngora," 200. ["Serpent of Don Luis de Góngora," 233.]

19. Another economic reading of the ellipse, a new approach to the figure: "The development of commodities, which makes them appear as something double-faced, use value and exchange value, does not make these contradictions disappear but creates the form in which they can become mobile. This is, for that matter, the only method for resolving real contradictions. It is, for example, contradictory for a body to fall constantly upon another and yet to flee it constantly. The ellipse is one of the forms of motion by which this contradiction is at the same time resolved and realized." Phillipe Sollers, *Nombres*, 2.98 (Paris: Éditions du Seuil, 1968), 142–143. [Translation mine —Trans.]

20. The dialectic that governs the appearance of the centers is comparable to the one that opposed the hidden god of Port Royal to the solar god of Versailles; it exceeds the aesthetic, moral or sociopolitical meaning that has typically been bestowed upon it.

21. *Dictionnaire de la langue française par E. Littré* (Paris: Hachette, 1875).

22. Dámaso Alonso attributes this eliding function to metaphor proper. My use of ellipsis, which exceeds the strictly rhetorical, can encompass it as one of its particular cases. Cf. Luis de Góngora, *Las Soledades,* ed. Dámaso Alonso (Madrid: Sociedad de Estudios y Publicaciones, 1956).

23. [The translations of Góngora are mine. —Trans.]

24. [Sarduy mistakenly quotes here Dámaso Alonso's gloss on another related poem by Góngora. The gloss on this passage of *Las Soledades* runs as follows: "The hunters came mounted on fiery and swift Andalusian

steeds, horses born (according to ancient belief) from the union of the lecherous zephyr with the mares of Baetica; once their fecund mother had clothed with limbs the breeze that had impregnated her, the wind now having been turned into a fine horse, the river Guadalete offered them the grass of its banks, like a flowery ambrosia, for grazing. As soon, then, as he raised his head to look upon the rising sun, the Andalusian horse, flaring his fiery nostrils to let out the great smoke-cloud of his breath, greeted with several whinnies the rays of the day-star." —Trans.]

25. [The original text contains a typographical error here, with Spanish *represión* in place of French *répression*. For *Unterdrückung* and *Verdrängung* and their standard equivalents in English, French, and Spanish, see Jean Laplanche and Jean-Bertrand Pontalis, *The Language of Psychoanalysis*, trans. Donald Nicholson-Smith (Routledge, 2018). —Trans.]

26. Severo Sarduy, "Sur Góngora. La métaphore au carré," in *Tel Quel* 25 (1966): 91–93. [Included in this volume under the later title "Metaphor Squared: On Góngora."]

27. These quotation marks are more than necessary: it matters little, of course, whether the poet knows it [*lo conozca*] or not—trap of psychologism; what does matter is to know whether it is or is not inscribed in a decipherable manner in the signifier, whose chain, if one may put it in this way, "knows" the poet well [*"sabe" bien al poeta*].

28. The definition of these Freudian concepts is taken from Jean Laplanche and J. B. Pontalis, *Vocabulaire de la Psychanalyse* (Paris: Presses Universitaires de France, 1967).

29. The symptom in question is, of course, one that functions as a signifier—which is to say, one that differs from the "natural index" that constitutes the notion of symptom in medicine.

30. Lacan insists on this total identification: "If the symptom is a metaphor, it is not a metaphor to say so." Jacques Lacan, *Écrits*, 528. [*Écrits: The First Complete Edition*, 439.]

31. [Sarduy appears to be thinking of the Lacanian dictum, "a signifier is what represents the subject to another signifier." Jacques Lacan, *Écrits*, 819; *Écrits: The First Complete Edition*, 649. —Trans.]

32. Jacques Lacan, *Écrits*, 167–68. [*Écrits: The First Complete Edition*, 137].

33. Jacques Lacan, *Écrits*, 295. [*Écrits: The First Complete Edition*, 244].

34. Jacques Lacan, *Écrits*, 295. [*Écrits: The First Complete Edition*, 244].

35. Jacques Lacan, *Écrits*, 371–72. [*Écrits: The First Complete Edition*, 310].

36. Michel Foucault, *The Order of Things: An Archaeology of the Human Sciences* (New York: Vintage Books, 1994), 8.

37. Miguel de Cervantes, *Don Quixote*, trans. Edith Grossmann (London: Vintage Books, 2005), part 2, ch. 3.

38. Francisco Javier Sánchez Cantón, *Guía completa del Museo del Prado* (Madrid: Peninsular, 1958), 46.

39. "Du regard, ça s'étale au pinceau sur la toile, pour vous faire mettre bas le votre devant l'oeil du peintre" [Some gaze gets spread out in brushstrokes on the canvas, to make you lay yours down before the painter's eye.] Jacques Lacan, "Hommage à Marguerite Duras," in *Cahiers Renaud-Barrault* (Paris: Gallimard, 1965). [Sarduy, forcing Lacan's meaning somewhat, translates *mettre bas* (which can mean "to calve, to drop, to whelp"; to be read here, however, in the transitive sense of "laying down," as in the laying down of arms) as *dar a luz*, to give birth. —Trans.]

COSMOLOGY SINCE THE BAROQUE

1. A lacuna appears, here, in these notes. The scientific model whose dissemination has been pointed up is not the purely astronomical one but rather the cosmological. If from Baroque cosmology on, postulates and discoveries succeed one another, if, for example, the rejection of Galilean thought ends up forming itself into the Newtonian notion of time and the dogmatization of its correlate, Euclidean space, etc., nothing comes to subvert it until the intervention of Special Relativity, in 1905, just as nothing subverts perspectival space, even if it had come in for much criticism, until it is relativized in *Les Demoiselles d'Avignon*, in 1907. We do not assert, of course, the nonexistence of cosmology in the "classical" period—between the late seventeenth and the late nineteenth century—, but rather its retreat, its withdrawal, as circumscribed by a more rigorous and mathematical, more "scientific" practice: Physics. One example of this retreat, and of the resultant lack of *retombée* in Classicism, is the Kantian rejection: it gives the Newtonian laws of universal gravitation a cosmological scope, but grants no rational validity to the cosmological questions par excellence—which today we can no longer even formulate in the same way—: limits of space, origin of time. There is, then, a classical cosmology, but "implicit and shamefaced," without

detectable *retombée*: thence our lacuna. For motives that the text itself, I hope, makes clear, I adopt in this exposition the first person.

2. The cosmological ideogram of relativity would be an infinite series of parallels, measurable pairwise, whose origin would be that of the universe, simplified thus for the sake of legibility.

3. Whose prefiguration could be found in Leibniz's *Monadology*: each monad, lacking "windows through which anything could come in or go out," is alone in the world, isolated; only God "enters into conversation, and even into society" with it, "by communicating to [it] his views and will in a particular manner"; each one is the center of a space, a series of perspectives that are its own, and to some extent enfolds its world as a reflection of God and "region of eternal truths." G. W. Leibniz, "The Principles of Philosophy, or, the Monadology," § 7; "Discourse on Metaphysics," ch. 35, in *Philosophical Essays* (Indianapolis: Hackett, 1989), 214, 66; translation modified. These points would be dispersed, reduced to their autonomy, were it not for the fact that each one maintains a simple and solitary dialogue with the *Monas monadum*, and it is this "respective dependence of each one before God" that establishes the communication between them. Without the totalizing crown of the *Monas monadum* we would have a plurality of the same order as the one postulated by relativity. There is in the *Monadology* an *infinitist drive very typical of the Baroque*, which the excessive crown of the *Monas monadum* contains. Excessive: it contradicts the principle of economy in communication by duplicating the communications of the monads amongst themselves, requiring them to pass by way of its mediation. In contradicting the principle of least expenditure, the crown, which requires waste, the "longest possible path," functions as a Baroque entity. Thence its paradox: it contains the Baroque—by preventing disconnected plurality—with the Baroque—by requiring wastefulness. Cf. Michel Serres, *Hermes ou la communication* (Paris: Éditions de Minuit, 1968), 154.

4. Merleau-Ponty and Morando, *Les trois étapes*, 195. [*The Rebirth of Cosmology*, 170.]

5. Ernst Cassirer, *La philosophie des formes symboliques* (Paris: Éditions de Minuit, 1973), vol. 3, 519. [*The Philosophy of Symbolic Forms. Volume 3: Phenomenology of Cognition* (New York: Routledge, 2021), 546–47.]

6. Cassirer, *La philosophie des formes symboliques*, vol. 3, 511. [*The Philosophy of Symbolic Forms. Volume III*, 538].

7. Cassirer, *La philosophie des formes symboliques*, vol. 3, 520–21. [*The Philosophy of Symbolic Forms. Volume III*, 547–48.]

8. Cassirer, *La philosophie des formes symboliques*, vol. 3, 520. [*The Philosophy of Symbolic Forms. Volume III*, 547.]

9. Julia Kristeva, *Sēmeiōtikē*, 323.

10. In the discourse of mathematics we could find an isomorphism: the finite numbers can only be defined from another position, the infinite, and this in turn only from the transfinite: the name always emerges outside of the named and thus entails a cut: castration. In this system, in contrast to the one I propose on the basis of relativity, there is no residue—nor, at the limit, any object—: in place of the remainder is the position of the namer. Cf: Sibony, "L'infini et la castration."

11. Philippe Sollers, *H* (Paris: Éditions de Seuil, 1973), back cover description.

12. I abridge the exposition of these opposing theories of contemporary cosmology, the Big Bang and the Steady State. Their topicality is such that they no longer belong to the exclusive preserve of science; the arguments for and against them are set out daily in the press.

13. In the world of sound, we do not hear a locomotive's whistle in the same way when it is approaching and when it is receding: it shifts toward a lower or higher pitch.

14. It was Gamow himself who had the idea of detecting this residual ray; he put it forward in an article published in 1956 which at the time did not arouse the least curiosity; ten years later, Robert Dicke asserted that a very sensitive radio antenna could detect the echo of the primeval explosion and began to construct equipment to this end. Meanwhile, with an antenna set up for a satellite communication project, two physicists at the Bell Laboratory—Arno Penzias and Robert Wilson—had unbeknownst to them already achieved it: inexplicably and from all points of the sky, the antenna picked up this irradiation, vestige of the "origin."

15. The work of Marcel Pleynet is founded upon this contradiction, which it points up as specific to poetic production and throws off balance in favor of the larger amplitude of the French vowel spectrum, the chromatic register of *e*'s (as in the Spanish Baroque an imbalance in favor of *a*'s and *o*'s can be detected), flattening out consonantal material to the point of reducing it to a uniform, frictionless ground. *Stanze* (Paris: Éditions du Seuil, 1973).

16. Cf. "Zero: Colors/Numbers/Sequences," included in this volume.

17. Quasars can be catalogued according to their luminosity and the extent of their redshift: the greater the latter, the greater their velocity, their distance, and their number; since they were more numerous earlier than they are now; there are few in our vicinity. The rays they emit never take longer than twelve billion light years to reach us: they date from three billion years after the formation of the universe. Their life is short—a million years—; it is not known how they disappear.

18. This before and this after can be interpreted, as Peirce did in another domain, in terms of inscription: the before is that which is not inscribed, that which is nothing; the after is the same nothing but inscribed. Of course, one cannot arrive at what there was "before" through the simple analytical operation of removing from what has come "after" everything that constitutes the character of that "after," since the "before" thus determined is nothing but the before of that "after," nothing but an imaginary specification of that "after." The "before," in that sense, is nothing but a crossed-out "after"; it is, precisely, this inscription of the "before" in the form of this crossing-out that characterizes, that founds the "after" as such. "Intervention au Séminaire du Dr. Lacan," in *Scilicet*, no. 4 (Paris: Éditions du Seuil, 1973), 56.

The emergence of the "punctual state" to which the Big Bang refers, the kick-start of the series—of any series—can be understood as the passage from the *absolute zero,* the order in general of potentiality, to the *zero of repetition,* in other words, the identity with itself of contradiction, in Frege, whose mark is inscribed in the series of integers. Cosmology would be the material version of the passage from *contradiction* to *the identity with itself of contradiction,* or to follow the metaphor I have made in "Zero: Colors/Numbers/Sequences," the passage from noncolor to white, zero of repetition that, in order to generate the series of colors, is taken as one.

Passage from the potential to the temporal and also from potential to realization, passage in which the author of the article on Peirce sees a paradox: potentiality is realized only individually, but, in consequence of this, it is destroyed "as infinite possibility across the board [*tous azimuts*]"; what is potential contains, indistinctly, all the points of a set; its realization, to the contrary, is individual: the first effect of this passage, then, is foreclosure: it indicates immediately the limits of the potential, institutes its borders. The before and the after are thus signified on three levels: germinal nothing/trace of foreclosure (*trait forclusif*)/infinite repetition of the trace, that is to say, series.

19. This notion, like many others relating to Buddhism, has been elucidated—foundational gesture in the West—in the work of Octavio Paz.

SUPPLEMENT

1. This Supplement can be found, almost in its entirety, in another piece on the Baroque, much more regional in scope (it is limited to Latin America), to which it serves as the provisional conclusion: Cf. Severo Sarduy, "El Barroco y el Neobarroco," in César Fernández Moreno, ed. *América Latina en su literatura* (Paris: UNESCO, 1972), 167–84 ["The Baroque and the Neobaroque," trans. Christopher Winks, in *Baroque New Worlds: Representation, Transculturation, Counterconquest*, ed. Lois Parkinson Zamora and Monika Kaup (Durham: Duke University Press, 2010), 287–90. The translation that follows is, however, mine. —Trans.]

ZERO

1. Gottlob Frege, *Die Grundlagen der Arithmetik* (Breslau: W. Koebner, 1884), § 74–77 [*The Foundations of Arithmetic: A Logico-mathematical Enquiry into the Concept of Number* (Evanston, Ill.: Northwestern University Press, 1980)]; Yves Duroux, "Psychologie et logique" and Jacques-Alain Miller, "La suture (Éléments de la logique du signifiant)," in *Cahiers pour l'Analyse*, vol. 1 (Paris: Le Cercle d'épistémologie de l'École normale supérieure, 1966).
2. [In English in the original. —Trans.]
3. Robert Morris, *Minimal Art* (The Hague: Gemeentemuseum Den Haag, 1968), 61.

CYCLE

1. Not even a parodic mimesis of the kind performed today by the harmless *retombée* of ready-mades.

METAPHOR SQUARED: ON GÓNGORA

1. [The first published versions of this essay have "underside" (*envers, reverso*) instead of "bulge"; in reviewing the text for the 1975 French edition of *Barroco* Sarduy seems to have noticed and corrected the inconsistency in his metaphor. —Trans.]
2. Luis de Góngora, *Las Soledades*, ed. Dámaso Alonso (Madrid: Sociedad de Estudios y Publicaciones, 1956).

3. One would have to read verse 197 of *Soledad primera* in the same way: "If just a bit of map so much unfolds for them" [*si mucho poco mapa les despliega*]. The totality of the terrain is contained in a fragment. The pilgrim *reads* this "map"; Góngora takes recourse to a graphic syntagma.

4. [See Jean Paulhan, *The Flowers of Tarbes, or, Terror in Literature* (Urbana: University of Illinois Press, 2006). —Trans.]

5. *Soledad primera*, 243–46.

6. Roland Barthes, "Éléments de sémiologie," III.3.7 in *Recherches sémiologiques: Communications* 4 (Paris: Seuil, 1964). [*Elements of Semiology*, trans. Annette Leavers and Colin Smith (New York: Hill and Wang, 1968), 86–88.]

7. [In the 1966 text, this paragraph continues, "There are notions to be eliminated ('vulgar' animals, ill-omened things: the word chickens, for example, must be avoided, thus: 'black, crested fowl,/ whose lustful spouse, their sentinel,/ the hearth's sun-herald is, melodious,/ who— coral-bearded—not of gold/ doth gird, but of purple, his turban.')." Sarduy suppresses this in the text included in the 1975 French edition of *Barroco*, presumably because the same material is covered in *Barroco*, 51–54. — Trans.]

8. "Húrtale al esplendor, bien que profano,/ Altamente debido,/ La atención toda, no al objeto vano,/ Ciego le fíes el mejor sentido:/ Abran las puertas exterioridades/ Al discurso, el discurso a las verdades." Góngora, "Canción Veinte y tres. Al sepulcro del rey Felipe III."

CUBES

1. Jacques Derrida, *Writing and Difference*, trans. Alan Bass (Chicago: University of Chicago Press, 1980), 300.

2. Michel Foucault, *The Order of Things: An Archaeology of the Human Sciences* (New York: Vintage Books, 1994), 95. [Translation modified.]

THE FURY OF THE PAINTBRUSH

1. Charles Bouleau, *Charpentes: La géométrie secrète des peintres* (Paris: Éditions du Seuil, 1963). [*The Painter's Secret Geometry: A Study of Composition in Art* (New York: Harcourt, Brace & World, 1963)]. Several works of Rubens, including *The Elevation of the Cross* and *The Descent from the Cross*, are interpreted on the basis of the formats 9 12 16 and 4 6 9, points of the sides of the rectangle that, projected as if in sheafs, fix the framework. An *s* form, which determines the position of the figures,

twists around point 9 in the first of these paintings. In *Barroco* I sought to read *The Exchange of Princesses*, in the Galérie Médicis in the Louvre, on the basis of the Keplerian ellipse, in opposition to the circle of Galileo, which organizes the works of Raphael.

2. [*Blanco*: there is also a sense here of the figure as a blank space. —Trans.]

THE HEIR

1. Martin Heidegger, "What Are Poets For?," in *Poetry, Language, Thought*, trans. Albert Hofstadter (New York: Harper & Row, 1975), 142. [Translation modified.]

2. Hermann Tüchle, C. A. Bouman, and Jacques Le Brun, *Nouvelle histoire de l'Église III: Réforme et Contre-Réforme* (Paris: Seuil, 1968), 171. [Translation mine —Trans.]

3. *Nouvelle histoire de l'Église*, 180. [Translation mine —Trans.]

4. *Nouvelle histoire de l'Église*, 185. [Translation mine —Trans.]

5. *Nouvelle histoire de l'Église*, 170. [Translation mine —Trans.]

6. *Nouvelle histoire de l'Église*, 171. [Translation mine —Trans.]

7. José Lezama Lima, "La imagen como fundamento poético del mundo," interview by Loló de la Torriente, *Bohemia* 55, no. 39 (1963). I take this definition from a magazine interview because it is one of the first, and also one of the clearest.

8. José Lezama Lima, *A Poetic Order of Excess: Essays on Poets and Poetry*, trans. James Irby and Jorge Brioso (Los Angeles: Green Integer, 2019), 79. [Lezama's statement runs in full: "The poet makes use of all of Pythagoras' words or varieties, but he also goes beyond them. He manages to express a kind of *supra verba* which is actually the word in all its three dimensions of expressivity, concealment and sign." Here Sarduy refers to "la *supra verba* de que habla Lezama," apparently misparsing the Latin in Lezama's elliptical expression ("a kind of [entity] beyond words"). —Trans.].

9. The second period of the Council was opened in April of 1552 and lasted one year. The French prelates did not take part. On account of the papal war against Parma, the King of France even threatened to convene a national council. How not to see, in this absence of the French at the origin of the Baroque, the first manifestation of a rejection that culminates in the expulsion of Bernini and that has not ceased to be present, even in the long period required for *Paradiso* to impose itself, beyond the circle of initiates?

10. José Lezama Lima, *Paradiso*, trans. Gregory Rabassa (Normal, Ill.: Dalkey Archive Press, 2000), 305.

11. Jacques Lacan, "On the Baroque" in *On Feminine Sexuality: The Limits of Love and Knowledge. Book XX. Encore 1972–1973*, trans. Bruce Fink (New York: W.W. Norton & Company, 1998), 116.

12. Lezama Lima, *Paradiso*, trans. Rabassa, 202. [Translation modified.]

13. I use the definitions given by Jacques-Alain Miller in *Cinco conferencias caraqueñas sobre Lacan*, trans. Juan Luis Delmont-Mauri (Caracas: Editorial Ateneo de Caracas, 1982), 22.

14. Jacques Lacan, *Écrits: The First Complete Edition in English*, trans. Bruce Fink (New York: W. W. Norton, 2006), 4. [Translation slightly modified.]

15. We could think, at first blush, that instead of the algorithm, a reference to Hegel would suffice. As Romanticism (here we use the terms Romanticism, Classicism, and Baroque in the usual sense and not in the overly broad sense that they have in the *Aesthetics*—has been related, traditionally, to the unhappy consciousness, Classicism could occupy the place of the Master and the Baroque that of the Slave; this symbolic distinction would suffice.

We soon see the poverty of these approximations, caught in a dialectical movement, in comparison with the ones that a structural rapprochement of the Lacanian type can offer.

To limit ourselves to the example of the Baroque, it is not enough to say the slave is the one who has a direct relation to matter, to the object he produces and cannot possess. The object of the Baroque is, by definition, a lost object, lost, even, to the transparency of discourse, to intelligibility. This object (*a*), fugitive, unattainable, dividing the subject, can only be encircled, circumscribed, encased by Baroque discourse. Hence its double presence, as Baroque gold and its reverse, in *Paradiso*, and hence also the meanders of the language that serves as its sieve.

16. Lezama Lima, *Paradiso*, trans. Rabassa, 243–44.

17. Lezama Lima, *Paradiso*, trans. Rabassa, 222.

18. [I retain here Sarduy's attribution, which is, however, not strictly correct. Sarduy is quoting not from *Origin of the German Trauerspiel*, but rather from earlier draft material included in the notes to this text in the *Gesammelte Schriften* (Frankfurt am Main: Suhrkamp, 1991), GS I.3 936. Sarduy appears to have found the passage in an essay by Stéphane Mosès

("Le paradigme esthétique de l'histoire chez W. Benjamin," in *Jerusalem: Revue psychanalytique et culturelle*. Éditions DAF (Autumn 1986): 26–38), and he is translating from Mosès's inaccurate translation. I translate here from Benjamin's German. —Trans.].

19. Stéphane Mosès, *The Angel of History: Rosenzweig, Benjamin, Scholem* (Stanford, Calif.: Stanford University Press, 2009), 99.

20. Cintio Vitier, *Lo cubano en la poesía* (Havana: Editorial Letras Cubanas, 1958), 311.

21. [See sections 1 and 6 of the introduction to this volume. —Trans.]

22. José Lezama Lima, Letter to Severo Sarduy, July 21, 1969 [in *Como las cartas no llegan . . .*, ed. Ciro Bianchi Ross (Havana: Ediciones Unión, 2000), 177. For the letter in its entirety, as well as Sarduy's commentary, see Severo Sarduy, *El Cristo de la Rue Jacob*, in *Obra completa*, vol. 1, ed. Gustavo Guerrero and François Wahl (Madrid: ALLCA XX, 1999), 94–102. —Trans.]

FRACTAL BAROQUE

1. Benoît Mandelbrot, *Les objets fractals: forme, hasard et dimension* (Paris: Flammarion, 1975). [*Fractals: Form, Chance, and Dimension* (San Francisco: W. H. Freeman, 1977). See also Mandelbrot, "Les Objets fractals" in *La recherche* 9, no. 85 (1978): 5–13.

2. Benoît Mandelbrot, "Des monstres de Cantor et Peano à la géométrie fractale de la nature," in *Penser les mathématiques: séminaire de philosophie et mathématiques*, ed. François Guénard and Gilbert Lelièvre (Paris: Seuil, 1982), 226.

3. [See Benoît Mandelbrot, "How Long Is the Coast of Britain? Statistical Self-Similarity and Fractional Dimension," *Science*, New Series, vol. 156, no. 3775 (May 5, 1967): 636–38. Sarduy falls prey here to a misunderstanding of Mandelbrot's intellectual biography. The mathematician never worked as a cartographer, nor did he discover the fractal concept while working on the coastline paradox. Rather, as Mandelbrot noted later in annotations to the original paper, he was searching for a way to prove the importance of his "notion" when he "stumbled one day upon Richardson's empirical data on coastline lengths, and recognized instantly that a study of coastlines might lend itself to a 'Trojan horse manoeuver.'" Benoît Mandelbrot, "How Long Is the Coast of Britain?," *Yale Department of Mathematics* (website), accessed February 15, 2024, https://users.math.yale.edu/~bbm3/web_pdfs/howLongIsTheCoastOfBritain.pdf. —Trans.]

Cultural Memory in the *Present*

David D. Kim, *Arendt's Solidarity: Anti-Semitism and Racism in the Atlantic World*
Hans Joas, *Why the Church?: Self-Optimization or Community of Faith*
Jean-Luc Marion, *Revelation Comes from Elsewhere*
Peter Sloterdijk, *Out of the World*
Christopher J. Wild, *Descartes' Meditative Turn: The Practice of Thought*
Eli Friedlander, *Walter Benjamin and the Idea of Natural History*
Helmut Puff, *The Antechamber: Toward a History of Waiting*
Raúl E. Zegarra, *A Revolutionary Faith: Liberation Theology Between Public Religion and Public Reason*
David Simpson, *Engaging Violence: Civility and the Reach of Literature*
Michael Steinberg, *The Afterlife of Moses: Exile, Democracy, Renewal*
Alain Badiou, *Badiou by Badiou*, translated by Bruno Bosteels
Eric Song, *Love against Substitution: Seventeenth-Century English Literature and the Meaning of Marriage*
Niklaus Largier, *Figures of Possibility: Aesthetic Experience, Mysticism, and the Play of the Senses*
Mihaela Mihai, *Political Memory and the Aesthetics of Care: The Art of Complicity and Resistance*
Ethan Kleinberg, *Emmanuel Levinas's Talmudic Turn: Philosophy and Jewish Thought*
Willemien Otten, *Thinking Nature and the Nature of Thinking: From Eriugena to Emerson*
Michael Rothberg, *The Implicated Subject: Beyond Victims and Perpetrators*
Hans Ruin, *Being with the Dead: Burial, Ancestral Politics, and the Roots of Historical Consciousness*
Eric Oberle, *Theodor Adorno and the Century of Negative Identity*
David Marriott, *Whither Fanon? Studies in the Blackness of Being*
Reinhart Koselleck, *Sediments of Time: On Possible Histories*, translated and edited by Sean Franzel and Stefan-Ludwig Hoffmann
Devin Singh, *Divine Currency: The Theological Power of Money in the West*
Stefanos Geroulanos, *Transparency in Postwar France: A Critical History of the Present*
Sari Nusseibeh, *The Story of Reason in Islam*
Olivia C. Harrison, *Transcolonial Maghreb: Imagining Palestine in the Era of Decolonialization*
Barbara Vinken, *Flaubert Postsecular: Modernity Crossed Out*
Aishwary Kumar, *Radical Equality: Ambedkar, Gandhi, and the Problem of Democracy*
Simona Forti, *New Demons: Rethinking Power and Evil Today*
Joseph Vogl, *The Specter of Capital*

Hans Joas, *Faith as an Option*
Michael Gubser, *The Far Reaches: Ethics, Phenomenology, and the Call
 for Social Renewal in Twentieth-Century Central Europe*
Françoise Davoine, *Mother Folly: A Tale*
Knox Peden, *Spinoza Contra Phenomenology: French Rationalism from Cavaillès to Deleuze*
Elizabeth A. Pritchard, *Locke's Political Theology: Public Religion and Sacred Rights*
Ankhi Mukherjee, *What Is a Classic? Postcolonial Rewriting and Invention of the Canon*
Jean-Pierre Dupuy, *The Mark of the Sacred*
Henri Atlan, *Fraud: The World of Ona'ah*
Niklas Luhmann, *Theory of Society, Volume 2*
Ilit Ferber, *Philosophy and Melancholy: Benjamin's Early
 Reflections on Theater and Language*
Alexandre Lefebvre, *Human Rights as a Way of Life: On Bergson's Political Philosophy*
Theodore W. Jennings, Jr., *Outlaw Justice: The Messianic Politics of Paul*
Alexander Etkind, *Warped Mourning: Stories of the Undead in the Land of the Unburied*
Denis Guénoun, *About Europe: Philosophical Hypotheses*
Maria Boletsi, *Barbarism and Its Discontents*
Sigrid Weigel, *Walter Benjamin: Images, the Creaturely, and the Holy*
Roberto Esposito, *Living Thought: The Origins and Actuality of Italian Philosophy*
Henri Atlan, *The Sparks of Randomness, Volume 2: The Atheism of Scripture*
Rüdiger Campe, *The Game of Probability: Literature and Calculation from Pascal to Kleist*
Niklas Luhmann, *A Systems Theory of Religion*
Jean-Luc Marion, *In the Self's Place: The Approach of Saint Augustine*
Rodolphe Gasché, *Georges Bataille: Phenomenology and Phantasmatology*
Niklas Luhmann, *Theory of Society, Volume 1*
Alessia Ricciardi, *After La Dolce Vita: A Cultural Prehistory of Berlusconi's Italy*
Daniel Innerarity, *The Future and Its Enemies: In Defense of Political Hope*
Patricia Pisters, *The Neuro-Image: A Deleuzian Film-Philosophy of Digital Screen Culture*
François-David Sebbah, *Testing the Limit: Derrida, Henry,
 Levinas, and the Phenomenological Tradition*
Erik Peterson, *Theological Tractates*, edited by Michael J. Hollerich
Feisal G. Mohamed, *Milton and the Post-Secular Present: Ethics, Politics, Terrorism*
Pierre Hadot, *The Present Alone Is Our Happiness, Second Edition:
 Conversations with Jeannie Carlier and Arnold I. Davidson*
Yasco Horsman, *Theaters of Justice: Judging, Staging, and
 Working Through in Arendt, Brecht, and Delbo*
Jacques Derrida, *Parages*, edited by John P. Leavey
Henri Atlan, *The Sparks of Randomness, Volume 1: Spermatic Knowledge*

*For a complete listing of titles in this series, visit the
Stanford University Press website, www.sup.org.*